THE **BetterPhoto** Guide to

Exposure

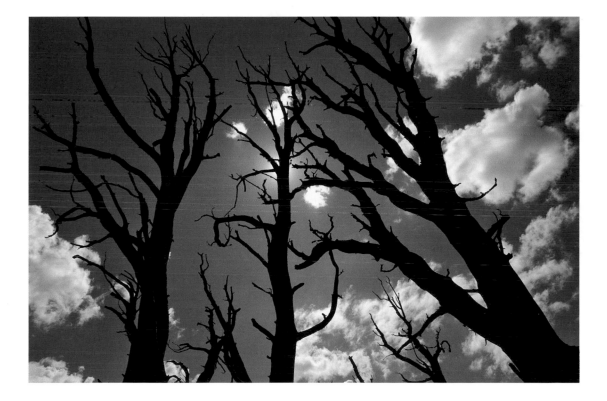

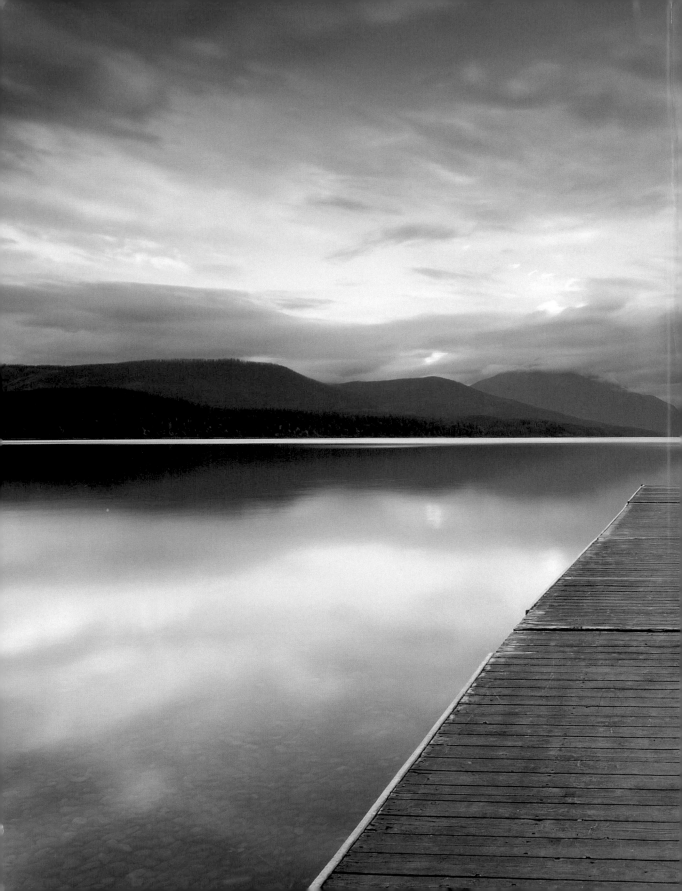

THE BetterPhoto Guide to

Exposure

SEAN ARBABI

AMPHOTO BOOKS

AN IMPRINT OF WATSON-GUPTILL PUBLICATIONS
NEW YORK

Library of Congress Control Number: 2008932372

ISBN 978-0-8174-3554-7

Senior Editor: Abigail Wilentz
Project Editor: Stephen Brewer
Production Director: Alyn Evans
Design by Thumb Print New York, Inc.

1 2 3 4 5 6 7 8 / 15 14 13 12 11 10 9 8

First Edition

Printed in China

Acknowledgments

I want to thank so many who assisted me with this, my first book, as well as throughout my career. As they say, you can never accomplish anything without the help of others.

To my wife, whom I've been with for more than fifteen years, the best years of my life: You've always let me be the person that I am, never stopped me from following my dreams, and supported me in every way. We created a wonderful family together, and I thank you with all my heart.

To my beautiful daughters: You bring me smiles every day and make me want to be the best person I can be. I hope I can transfer the visions I've seen around this planet to create an appreciation for this world in your lives.

For all my friends and family who keep me sane, make me laugh, and add so much to life: You all mean the world to me.

To Jim Miotke and the entire BetterPhoto.com staff: You not only help me to expand my business teaching photo enthusiasts around the world, but you provide consistent positive attitudes and great vision with BetterPhoto.com. I look forward to great success for years to come.

To the various clients I've had the pleasure to work with over the past eighteen years as a commercial photographer: Thank you for all of the articles, assignments, photo shoots, and stock sales. Each and every one of you has allowed me to live my dream, and I thank you for your business.

And finally to Victoria, Abigail, and the Amphoto crew: Big thanks for the opportunity to author this book, for believing in this project, and for your patience and assistance. You've helped to create a fantastic book, of which I am incredibly proud.

To my daughters,
who see the world in
new ways every day

Contents

Introduction

I BEGAN MY photographic journey at the age of eleven when I picked up a 110 camera (the late 70s version of a compact camera) and took candids of my family—capturing Dad in his underwear and Mom with a nighttime facial mask. From that point on I always knew I'd be a photographer. Don't ask me why. It was just more of an assumption than a calculated decision. In high school I actually received an F in photography, something I like to tell my workshop students and lecture audiences. Although my grade had more to do with discipline than with the quality of my work, and my wanting to take my own photos instead of following class lessons, it still proves that you can arrive at any destination even from the worst of starting points.

So, after eighteen years capturing images around the world as a pro, and more than ten years of teaching workshops, why choose to write my first book on exposure, especially in the day and age of "fix it in Photoshop"? One reason is that the subject always came up in all of my lectures, telling me it was a difficult topic for most to grasp. I've had students who have been shooting since the 1950s but still don't understand exposure, yet exposure is the basis for all great images. Another reason is that I've been forced to learn exposure in order to shoot fast and capture the best scene possible on each frame. When you only have one chance to get the shot, you don't have time to review your exposure—you just need to know how to get it right in the first place. Get it in camera, I always say, or at least as much as you can.

From the camera obscura of the nineteenth century to the latest digital systems, without the appropriate exposure, a scene just cannot stand up as well, or be as powerful, striking, or memorable. What was so hard about writing this book was limiting myself. Exposure connects to every part of photography, from lighting to composition, mood to the message, subject matter to weather conditions. And the technically correct exposure is not necessarily always the best one to use. Pete Turner, a well-known commercial photographer, once said, "Don't forget manual settings on your camera. You can create a mood by not using the automatic, perfect exposures."

As true as this is, when teaching exposure you can't just stop here. People want specific information, yet that is hard to provide, since exposure depends on a myriad of specific conditions. Some try to apply photographic tables or the flow-chart approach, and although this may work in theory, it rarely does in a variety of real-life situations.

The goal for my book is to lay out various methods of exposure. Instead of listing tons of mathematical equations for exposure, I attempt to address topics in a real-world fashion, since so much of photographic exposure is scenario driven. I offer tips and techniques and explain the general rules, yet so many intangibles play a huge role that there is no way to show someone how to expose well for every situation. By giving you a base to build from, ideas to use, and an understanding of certain tools and components, you can then make personal decisions depending on the scene in front of you, while creating images with your own style—and do it not just once, but over and over.

Besides helping you find your personal vision through exposure, I hope to slow you down and get you thinking about every aspect of your image, one by one. That's what exposure does: It hones you in, forces you to take your time with a scene, bringing some of the art back to photography. I've seen many photographers incorporate numerous camera functions when they don't necessarily understand what each does or why they even chose the particular setting. When workshop students inform me they've "used their top-of-the-line digital camera with a custom White Balance in Aperture Apriority, with an EV step value of −1, at

ISO 400, shooting in raw, Matrix metering, while using the color space of Adobe RGB for the maximum color palette" on the shots I'm critiquing, I usually ask the rest of the class if anyone likes the image. My point being that all of these functions may be important, but simply applying them won't create a better final scene.

Henry David Thoreau once wrote, "Men have become the tools of their tools." As is often the case, photographers get caught up in every little technical aspect and lose touch with the goal—to produce amazing images. It's definitely critical to have the technical knowledge, as well as an understanding of your tools and how they work, but when it comes down to it, who cares how you captured the moment? It only matters that you did.

Photography has been around since 1839, described back then as "mirrors with a memory." As the camera's "memory" has evolved from film to digital, with technology and the vernacular of the art changing fast, the basic concept of photography remains much the same. If you bombard yourself with so many features while trying to learn a difficult topic such as exposure, it can only make things more complicated. Because of this, I've set up each chapter of the book with a step-by-step approach. By trying to stay within your knowledge base, working slowly, and shooting each assignment and practicing until you truly understand each aspect, you will improve much faster.

When possible, cut as many variables to keep things simple and maintain focus on the topic at hand. Get to know your specific camera functions by reading the manual, since the more you know your system, the easier it will be to use. Although quality equipment is nice, it isn't necessary and doesn't replace great decision making or a trained eye. The best approach is to learn the technical aspects of the craft and the features of your camera, and then apply them in the real world. Do this, and you'll slowly find a method that works best for you. It may seem like a long process, but so is perfecting any art.

As you read each chapter, also keep in mind my philosophical approach to photography, using Deepak Chopra's metaphor for life: "Every mistake is an opportunity." So, when you blow an exposure, instead of being frustrated, think of it as a chance to expand your creativity and increase your knowledge. This way, you can use the book's lessons to make mistakes and your portfolio a place for your successes.

I also recommend reading sections over and over. As with any book, movie, show, or lesson, so many small details can be overlooked the first time around. Finally, and I think most important, enjoy the journey—the more you appreciate the small details, the more fun you will have. The beauty of photography is not only the successes but the entire lifelong process of learning, including the progression of your art. Sure, we all have frustrating moments with our lack of knowledge, fiddling with our equipment, or losing the shot to specific circumstances, but if you can't find the positives in capturing the world on this medium, whether ten thousand miles away or in your backyard, there's no reason to be doing it.

I turn forty this year, and I have spent almost half my life as a professional photographer. Yet the anticipation of creating high-quality images still motivates and inspires me, and it probably always will. The beauty of any art rarely gets old. If all of my images were easy to capture and came out perfect with every click of the shutter, it might not be as fun. By studying methods as well as my images themselves, and going with my gut most of the time, I have reached a place that makes my proud. A student once said to me, "I never thought I could get so excited by a blade of grass." This is what the art is all about, especially in outdoor and travel photography, in which I specialize—to notice the beauty of the world, catch the details, and stop a moment in time, recording it for all to see and appreciate.

And it all starts with exposure.

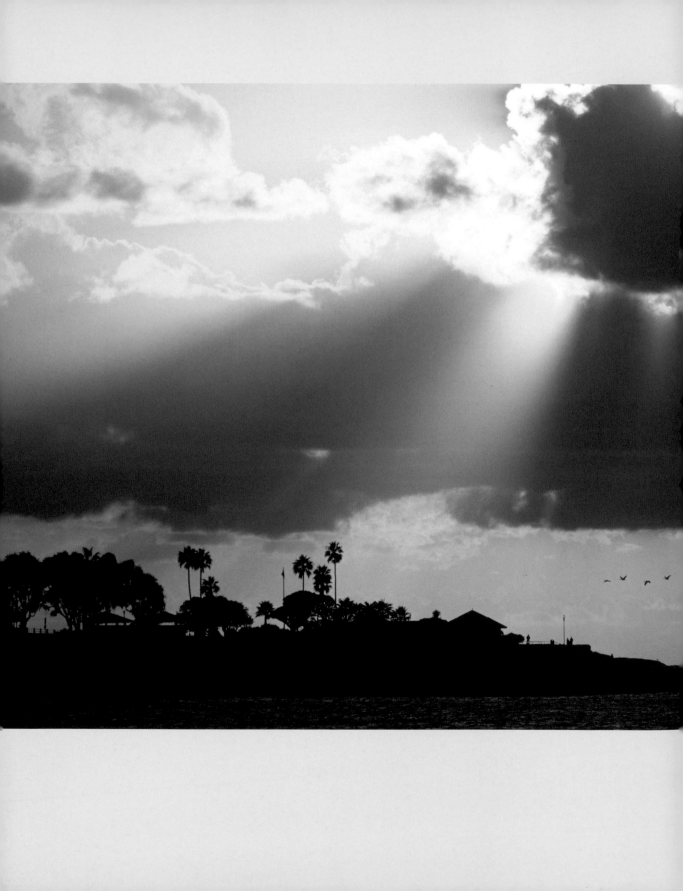

Exposing Exposure

CLICK. You just snapped off a shot. Whether you've captured a good photograph or a disappointing one, you may not know how you did it. That's because many photographers fly blindly and don't understand the concept of exposure. And that's okay. It's normal for most recreational photographers not to have learned every facet of photography, especially exposure. It's why so many take workshop courses—and maybe even why you bought this book. In fact, despite a lack of information on this sometimes complex subject, many students possess a great artistic eye and produce wonderful photos. Frankly, though, this isn't usually enough.

But with knowledge of exposure, whether gleaned from a book or a class or a more advanced photographer you may know, comes the ability to capture quality images consistently, with more creativity, better control, and a firm comprehension of photographic equipment. An expertise at manipulating exposure is partially why photographers such as Ansel Adams and Brett Weston became such masters of their art. So try not to be overwhelmed by the subject of exposure—just having this book in hand means you're willing to learn about and conquer exposure and not, like some do, ignore it. Because, quite simply, there's just no getting around a poorly exposed image.

What Is Exposure?

The primary function of a camera is to collect and record light. Exposure, in photographic terms, is recognized as *the total amount of light permitted to enter a camera and received by the image sensor (or film plane) through the course of capturing an image.*

Exposure is usually *determined* by a subject's brightness, or luminosity; by its tonal value; and by the contrast ratio within a scene. Exposure is *controlled* through camera settings such as aperture and shutter speed. It is also affected by the sensitivity of your image sensor, otherwise known as ISO.

WHY EXPOSURE MATTERS

Solid exposures are vital for producing great images. They can help create a mood, emphasize light and form, enhance color, separate tones, and add subtly to detail. Expose for too long and your image will be washed out, or *overexposed.* If your exposure is too short, your picture will be *underexposed* and appear dark. An excellent image can be ruined by a bad exposure, but a good exposure is often the basis of an amazing photo.

For example, if I am photographing a white egret, which happens to be against a dark back-

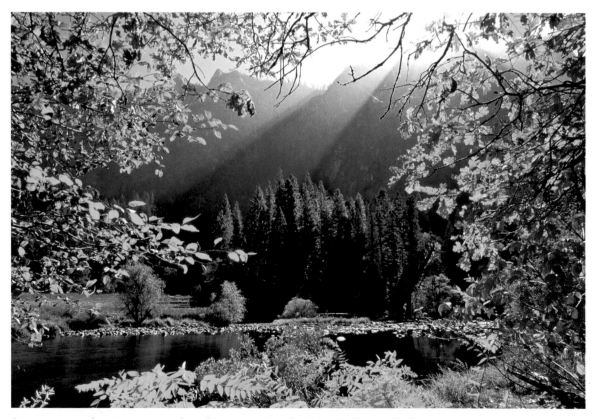

Documenting a dramatic scene, such as this one I captured in Yosemite National Park, can be difficult. By understanding my photographic tools and how to manipulate them, I was able to navigate my way to a solid exposure and get the shot before the light was gone.
1/15 SEC. AT ƒ/22, ISO 100, 24MM F2.8 LENS

ground, unless I understand how to expose the contrasting scene, I will most likely lose the subtle detail in its white plumage (see photo below).

The key to capturing solid exposures is to learn the fundamentals, how the process works, and how you or your camera can be fooled. Then it's time to practice, play, and practice some more. Your mistakes, or exposure errors, can be your best tool for learning and understanding how to expose better.

Another reason exposure matters is because of the fact that photographic moments are fleeting.

Sometimes light changes so quickly that a facial expression comes and goes in a split second, or an amazing event occurs without a moment's notice. If you're not ready or don't know how to expose the scene, it's often gone before you shoot it.

Combine the factors of finding a nice scene, getting into position, reading the light, and nailing your exposure and you will create images you never would have before. Add in the element of getting lucky, and you can produce something extraordinary. Or as Ansel Adams once so eloquently put it: "Chance favors the prepared mind."

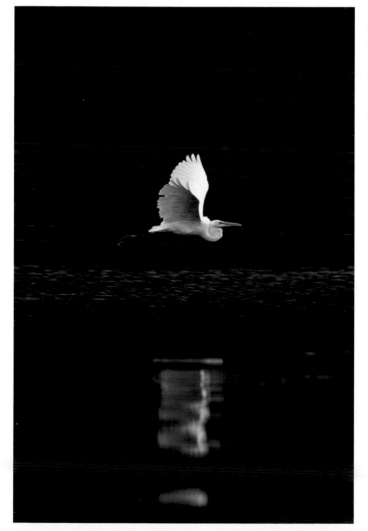

Photographing from a canoe along southwest Florida's Lee Island coast, as the late afternoon light shaded the background mangrove forests, I used every bit of my exposure knowledge to capture this white egret in motion.
1/125 SEC. AT ƒ/2.8, ISO 100, 80–200MM F8 LENS, AT 200MM

Shutter Speed

Shutter speed, a main component of exposure, is the rate at which the shutter, a mechanism inside the camera, opens and closes to expose a scene. This is the same whether the image is being exposed on film or onto a digital image sensor.

Shutter speed controls two aspects of exposure:

❏ The amount of light entering the camera and lens—this is measured by your meter

❏ The speed at which the scene is shot—this is measured in time (seconds, minutes, hours).

Some photographers refer to a faster shutter speed as *shorter* and a slower speed as *longer.* Throughout this book, and to avoid any confusion, I refer to speeds as faster or slower and only use the terms *shorter* and *longer* to refer to exposures.

Examples of shutter speeds are listed in the table on the opposite page. Although all camera systems vary, most range from 1/4000 sec. as the fastest, down to a thirty-second time exposure as the slowest shutter-speed setting. The majority of models include B, which stands for *bulb,* a setting permitting you to hold the shutter open as long as you wish—whether for one minute, one hour, or one day.

CAPTURING MOTION

Still photographs are exactly what they are: still. One of the difficult aspects of the two-dimensional medium of photography is to show within a scene a feeling of motion or movement, action or energy. Document a child's first bike ride, and if you do so using a shutter speed that doesn't illustrate his or her motion, it may not give you the best feel of the moment. Take a picture of a moving car with a faster shutter speed and it may look like it's not moving at all.

Slow shutter speeds are not only used in low-light conditions—such as indoors, sunsets, and general nighttime scenes—when additional exposure time is needed, but they are also intentionally used to blur a moving subject. Whether you are shooting the flow of a river, the movement of bicyclists, or even the motion of the stars, a slow shutter often provides an artistic effect as well as a solution to the dilemma of incorporating motion.

TIP HOW TO FIGURE OUT THE BEST SHUTTER SPEED TO SHOW MOVEMENT

I'm often asked what the best shutter speed is for capturing motion. Many experts say somewhere between 1/60 sec. and 1/15 sec., which works well in many cases. Truthfully, though, there's no universal slow speed for all situations. When I'm asked the question, I often answer with questions I ask myself:

❏ **How fast is my subject moving?** Is it my daughter running at 5 mph, or is it a race car traveling at 100 mph?

❏ **How close am I to my subject?** Am I 5 feet away, where any little action can move my subject quickly out of frame, or am I 100 feet away, where more time is needed to distinguish movement?

❏ **What lens am I using?** Is it a wide-angle lens providing a large area of coverage, and therefore possibly requiring a longer exposure, or is it a telephoto lens, which easily recognizes every little movement?

Because of all these variables, I don't believe there's any default slow shutter speed that best illustrates motion. And that's part of the unpredictability—and beauty—of photography: Different conditions present unique challenges that can never make you absolutely sure of what you'll get in the end.

Another technique available to you when using a slow shutter is *panning,* in which you follow your moving subject with your camera as the shutter opens and closes. As with the no-default motion-capture discussed in the box on page 18, there's no universal pan setting, although the same recommendations do apply (1/60 sec. to 1/15 sec. as a solid starting point to test).

Although you still have to think about the speed of your subject, the distance, and the lens, panning is nonetheless a wonderful way to capture motion while losing much of the surroundings. If done right, you'll end up with your subject appearing fairly sharp while the background has a motion-blur effect. Once again, you don't entirely know what you'll get every time, but there's a good chance you'll produce some excellent images.

Compositions can be tougher while you pan, since your viewfinder is closed during the shot. So depending on the movement of your subject, only one part may end up in focus, your entire subject may be sharp, or nothing at all may end up in focus.

Shutter Speeds
(in seconds or fractions thereof)

In 1/3-stop increments (also known as 1/3-step EV values), ranging from the fastest at the top left to the slowest at the bottom right.

1/8000	1/6400	1/5000	**1/4000**	1/3200	1/2500	**1/2000**	1/1600	**1/1250**	**1/1000**	1/800
1/640	**1/500**	1/400	1/320	**1/250**	1/200	1/160	**1/125**	1/100	1/80	**1/60**
1/50	1/40	**1/30**	1/25	1/20	**1/15**	1/13	1/10	**1/8**	1/6	1/5
1/4	1/3	1/2.5	**1/2**	1/1.6	1/1.3	**1**	1.3	1.6	**2**	2 .5
3	**4**	5	6	**8**	10	13	**15**	20	25	**30**
1 min.	**2 min.**									

Notice the shutter speeds in bold listed as one-stop increments. What is a stop, and what do these increments mean on the table?

If we begin with the fastest shutter speed of 1/8000 sec., and recognize that each speed thereafter (in bold) is half or approximately half of the previous one (such as 1/4000), then we can also see that the shutter remains open twice as long as the prior speed. This change in brightness of doubling or halving the amount of light entering the camera is often referred to as one stop, (for instance, from 1/500 sec. to 1/250 sec. amounts to one stop brighter).

Jump two shutter speeds (in bold—for example, 1/500 sec. to 1/125 sec.), and that's two stops. Many digital camera menus offer the option of setting your shutter speeds, as well as your apertures, in 1/3-stop (as in the table, such as 1/500, 1/400, 1/320, 1/250), 1/2-stop (1/500, 1/350, 1/250), or 1-stop increments.

Note that there can be shutter settings between the numbers listed in the table if you set your camera to 1/2-stop increments (such as 1/750 sec. or 1/45 sec.), as well as speeds listed that may not be available in your camera (for example, 1/8000 sec. or 1 minute).

What often works for me is to hold my camera steady, rotate my body with a level motion as my subject passes, and press my shutter release hard enough to get the exact moment I want but gentle enough not to shift the camera too much. That said, we all move and shoot in our own unique ways, so you'll probably come up with your own effective panning method soon enough.

A third method using a slow shutter is *zooming*—that is, moving your zoom lens during the slow exposure. You can start at any millimeter length on your lens and zoom in or out. Be aware, though, that with this method it's tougher to get your subject in focus as well as to predict a scene's final overall outcome. But software programs such as Photoshop offer zoom options that are much easier to control and set. (I discuss editing in Photoshop in Chapter 8.)

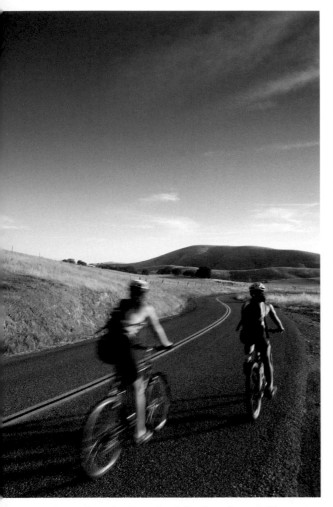

On a ride in the Sierra foothills of northern California, I wanted to add some movement to a biking scene. I was able to accomplish this by using a slower shutter speed.
1/15 SEC. AT ƒ/16, ISO 100, 24MM F2.8 LENS

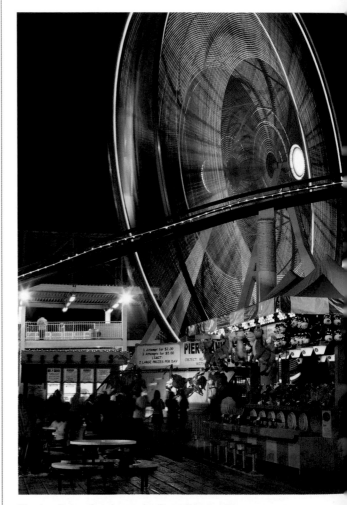

The low light of night on the Santa Monica Pier gave me the shutter speed to put the Ferris wheel in motion.
8 SEC. AT ƒ/5.6, ISO 100, MEDIUM-FORMAT 50MM F5.6 WIDE-ANGLE LENS

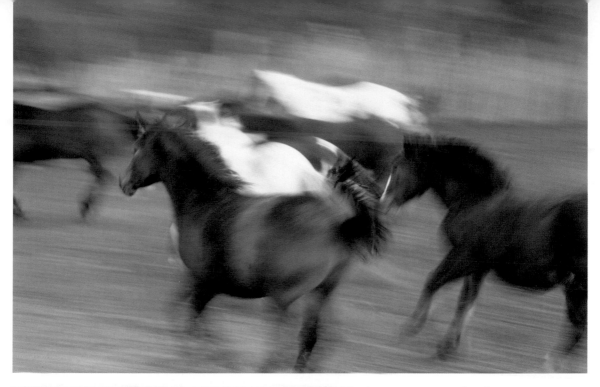

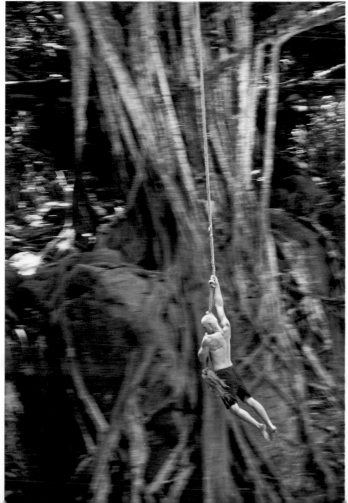

Here are two examples of panning, one documenting a human subject high up, the other an equine group a bit closer to the ground. At left, while I was in Kauai, Hawaii, on a jungle trek, I got some great shots of our guide, who decided to play Tarzan while holding onto a rope swing. Wanting to show movement, I slowed my shutter speed and panned with him as he swung. Panning with some magnificent horses at a New Mexico dude ranch (above), I was able to capture the beasts' power and energy—at the same time losing much of the busy background.

TOP: 1/15 SEC. AT ƒ/16, ISO 100, 80–200MM F2.8 LENS
LEFT: 1/30 SEC. AT ƒ/11, ISO 100, 80–200MM F2.8 LENS

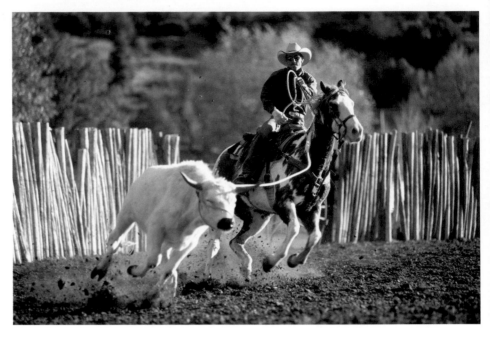

In this photo, I wanted the opposite effect than the one obtained in the image of the running horses on the previous page. My goal was to stop this wrangler in the act of roping a calf, and a fast exposure gave me the desired result.

1/1000 SEC. AT ƒ/2.8, ISO 100, 80–200 MM F2.8 LENS

STOPPING THE ACTION

Fast shutter speeds can work for many circumstances but are used mostly for freezing rapidly moving subjects such as athletes, vehicles, water, or wildlife.

What is considered a fast shutter speed? Most deem any setting above 1/60 sec. to be fast, but it's all relative and subjective. If you want to stop an ant in motion, then 1/125 sec. should do the job. But change the ant to a bird in flight traveling 60 mph, and 1/125 sec. may not be fast enough. For this reason, the same questions are asked when you want to freeze motion as when you want to capture it:

❏ How fast is my subject moving?

❏ How close am I to my subject?

❏ What lens am I using?

❏ How much light am I working with? Since fast shutter speeds require lots of light, knowing how fast you can shoot is an important variable in the decision-making process.

An additional factor to note when shooting stop-action imagery is the limited amount of focus you often have, usually due to the low depth of field your aperture (and possibly also your lens) is providing. This issue is addressed on page 25.

GETTING TIME EXPOSURES RIGHT

Time exposures usually start at around 1-second shutter speed and continue into minutes or even hours. Using slow shutter speeds can add a dynamic quality to your images, again through light and motion.

If you are able to meter a time exposure—as I was in the right-hand photo on page 21—most of the general rules of metering apply for a properly exposed scene. Nevertheless, since time exposures are often taken during the darker periods in the day (dawn, dusk, twilight, or night), there is a point when the light gets so low that your internal meter can't record the levels, or offer a recommended exposure, for the scene (this is noted in the photo on page 22). This is an example of an instance when either photographic experience or exposure value can assist with time exposures.

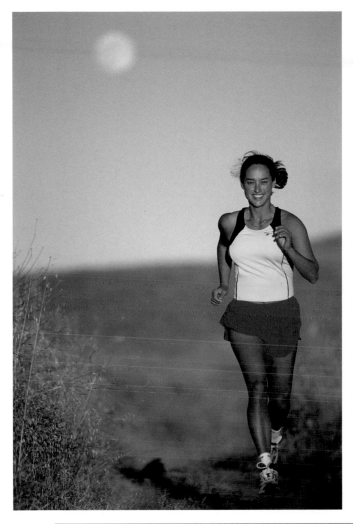

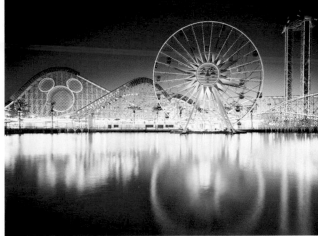

▲ To document Walt Disney's California Adventure at twilight for VIA magazine, I waited until the dusk light in the sky balanced with the lights of the park (through metering) to create this scene
30 SEC. AT ƒ/5.6, 100 ISO, MEDIUM-FORMAT 50MM F5.6 WIDE ANGLE LENS, A TWO-STOP GRADUATED NEUTRAL DENSITY FILTER

◄ My aim on this cover shoot for Runner's World was to freeze the athlete in motion. Knowing I was photographing in the late afternoon reminded me of the light levels I was working in. By using the fastest shutter I could employ, I was able to stop the runner in mid-stride.
1/500 SEC. AT ƒ/4, ISO 100, 300MM F4 LENS

Exposure Value

Exposure value (EV) is a concept developed to deal with unusual lighting situations that are difficult to meter. If you don't have any experience testing time exposures under varying circumstances, using a tabulated exposure value offers a great start. For instance, if you are aware that a certain time exposure setting, measured from the light of a full moon, gives you a good exposure of a landscape at night, you can then capture this type of scene under the same conditions without having to resort to your meter. What you're doing is referring to an internal chart, a chart created from your own experience.

However, as there are so many variables in lighting conditions, not all exposure values will be dead accurate. But at least EV will give you the basis from which to start your exposure. For more on EV, see page 32, and for expanded information on time exposures and night photography—including proper exposures, exposure values at night, and reciprocity failure—see chapter 6.

Shooting at midnight, I knew once the light of the full moon crept into Yosemite Valley that it would brighten Yosemite Falls and the north valley wall. My exposure was set through experience, but the "moonbow" in the falls was blind luck.

5 MINUTES (ON BULB) AT ƒ/5.6, ISO 100, MEDIUM-FORMAT 125MM F3.2 LENS

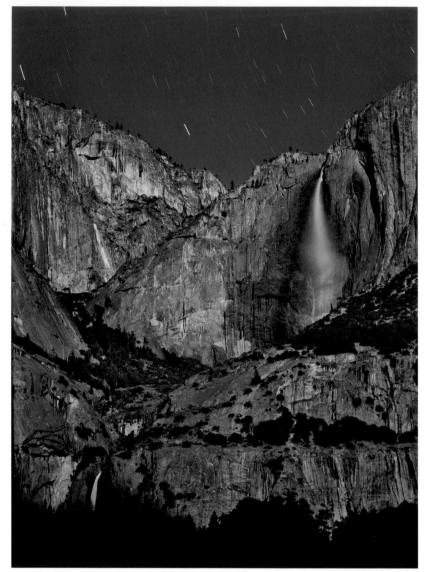

Image Stabilization

A relatively recent technology installed in some of the newer lenses to steady your image, *image stabilization* is often most helpful if you're using long lenses or handholding your camera. Usually built with an internal gyroscope—a spinning device that compensates for vibration—image stabilization enables you to shoot up to two stops slower than the handheld shutter rule. So if you were handholding a 200mm lens with image stabilization, instead of your shutter speed normally having to be no slower than 1/200 sec., you could shoot as slow as 1/50 sec. without any potential camera shake.

THE HANDHELD SHUTTER RULE

Keep in mind this general rule of thumb regarding shutter speed when you are taking images without a tripod—that is, handholding your camera. When the rule is applied, you have less of a chance of a blurred or soft image due to camera shake.

The rough guide most photographers use is *the slowest possible shutter speed used should not go below your lens focal length*. For example, if you're handholding your camera using a 50mm lens, you shouldn't use any shutter speeds lower than 1/50 sec. (or the closest equivalent speed). Use a 70–300mm lens, zoomed in at 300mm, and you can't go below 1/300 sec. (as shown in the photo below). However, with the advent of image stabilization (see page 22), you might be able break this rule, although not all lenses have this ability. When in doubt, use a tripod if at all possible.

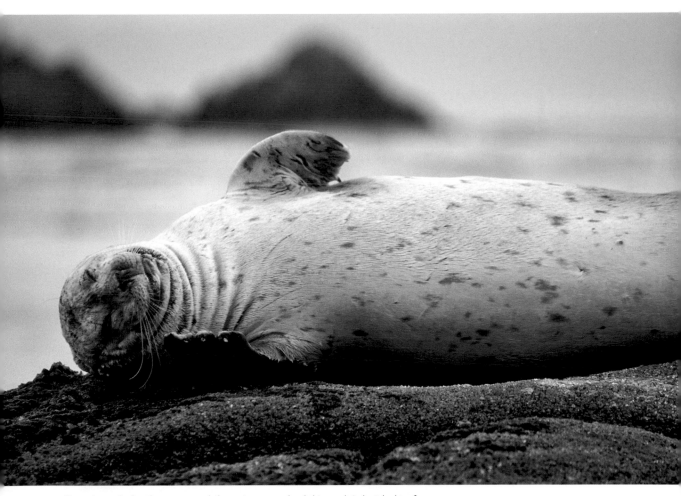

Since I needed to be more mobile as I approached this seal, I decided to forego my tripod. The shutter speed on my camera was fast enough to allow me to handhold it and avoid camera shake.

1/500 SEC. AT ƒ/4, ISO 100, 300MM F4 LENS

Aperture

Another main component of exposure, the *aperture* is an adjustable iris—circle, hole, or opening—inside your lens that changes depending on your setting, which is called the *f*-stop. See the photo at right.

Aperture controls two aspects of exposure:

❏ **The amount of light entering the camera and lens:** through the *f*-stop, a measurement used for the size of the lens opening. The larger the aperture, the more light; the smaller the aperture, the less light.

❏ **The depth of field in the scene:** This is the measurement, in inches, feet, and meters, at which subjects, located at various distances from the camera, are in focus.

Some photographers refer to a largest aperture available on your lens as *wide open* and the smallest as *closed down*. Throughout this book, I will refer to aperture as *larger* or *smaller* and depth of field as *maximum* and *minimum*.

Examples of small and large apertures (or *f*-stops) are listed in the table below and range from

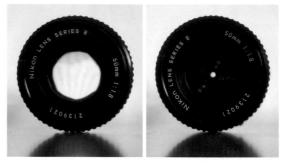

An actual aperture comparison on a 50mm lens, with the lens on the left at f/4 and the lens on the right at f/22.

f/1 (the largest opening, and very rare to find in lenses) to *f*/180 (the smallest opening, which most cameras or lenses do not possess but can possibly be found on something like a pinhole camera). Most lenses range between *f*/2.8 (the largest aperture allowing in the most light) to *f*/32 (the smallest aperture allowing in the least amount of light), but these differ from model to model.

Unfortunately, since each aperture number in the table seems arbitrary, this information is not easily deciphered or memorized.

Aperture / *f*-Stops

In 1/3-stop increments (also known as 1/3-step EV values), largest top left to smallest bottom right (one-stop increments in bold)

f/1	*f*/1.1	*f*/1.3	*f*/1.4	*f*/1.6	*f*/1.8	*f*/2	*f*/2.2	*f*/2.5	*f*/2.8	*f*/3.2
f/3.5	*f*/4	*f*/4.5	*f*/5	*f*/5.6	*f*/6.3	*f*/7.1	*f*/8	*f*/9	*f*/10	*f*/11
f/13	*f*/14	*f*/16	*f*/18	*f*/20	*f*/22	*f*/25	*f*/28	*f*/32	*f*/36	*f*/39
f/45	*f*/50	*f*/55	*f*/64	*f*/90	*f*/125	*f*/180				

Note that there can be aperture settings between those listed in this table (if you set your camera in half-stop increments). Also, note that some *f*-stops listed may not be available in your camera. Most lenses fall somewhere between *f*2.8 and *f*32.

What does the number stand for? It represents a scientific measurement of *the ratio between the diameter of the aperture and the focal length of the lens*. It's not as important for you to know how the numbers came to be as to understand what each setting does.

As with shutter speeds, f-stops are generally referred to in *stops of light* (f/22 to f/16 being one stop of light, f/22 to f/11 being two stops of light, and so on). Similar to our pupils contracting and dilating depending on the amount of light needed, so, too, are f-stops used to control specific quantities of light.

With zoom lenses, you may find the more expensive models to be *fixed* aperture lenses and the more affordable to be *variable* aperture lenses. A fixed-aperture lens refers to the largest aperture remaining constant as you zoom in and out. If you have an 80–200mm f2.8 lens, at 80mm your largest aperture available will be f/2.8, and at 200mm it will be f/2.8 as well. A variable aperture lens refers to the largest aperture available changing as you zoom in and out. If you own an 80–200mm f3.5–4.5 lens, at 80mm your largest aperture available will be f/3.5, and at 200mm it will be f/4.5. The benefit of a fixed lens is that it won't change your exposure as you zoom— simply because there will be no light loss resulting from a change to a smaller aperture.

DEPTH OF FIELD (DOF)

The second function of your aperture is depth of field, which is *the range from which subjects, at various distances, are in focus*. Depth of field changes as your aperture changes: As you increase the f-stop number, you increase the depth of field.

Assume the lens you're using is an f2.8 60mm lens, ranging in f-stops from f/2.8 to f/22. At f/2.8, you would have minimal depth of field— not much in focus outside of what your lens is focused on specifically, as in the photo below. But at f/22, you would have maximum depth of field—a wide coverage of focused subjects in front of and behind your specific focal point, as demonstrated in the photo at the top of the next page.

Something to be aware of regarding your lens and depth of field is that when you look through your camera at a scene, regardless of where your aperture is set (f/2.8, f/32, or anywhere in between), you will always see through your camera at the largest aperture setting (for instance, f/2.8 or whatever the widest aperture of your lens may be).

Manufacturers set it up this way for you to see through your camera with the most light possible, hence the largest aperture. To see what is truly in

> ### TIP COMMITTING f-STOPS TO MEMORY
>
> If possible, start out memorizing f-stops in one-stop increments (f/2.8, f/4, f/5.6, f/8, f/11, f/16, f/22, f/32), understanding that each stop of light exactly doubles (with a larger aperture) or halves (with a smaller aperture) the amount of light entering the camera, just as with each stop of a shutter speed. Also note, as with shutter speeds, that f-stops are listed in 1/3-stop, 1/2-stop, or 1-stop increments depending on your camera or menu setting (usually listed in a digital menu as an EV step).

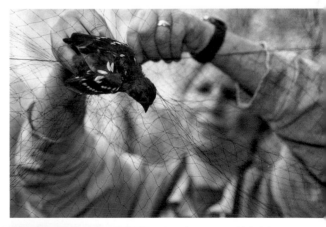

Wanting to draw the viewer's eye to the trapped bird, I decided to use a large aperture for minimal depth of field.
1/400 SEC. AT f/2.8, ISO 100, 60MM F2.8 LENS

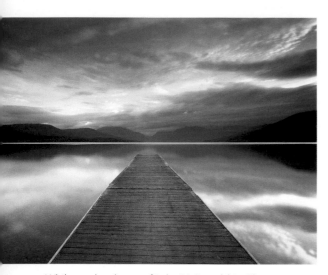

While on the shores of Lake McDonald in Glacier National Park, I chose an f-stop for maximum depth of field to pull everything into focus.

1/4 SEC. AT ƒ/45, ISO 100, MEDIUM-FORMAT 50MM F5.6 WIDE-ANGLE LENS

focus, say at ƒ/22, you must use the depth-of-field preview button on your camera (if it has one). When do you, the scene in the viewfinder gets darker; ignore this, since the button mainly allows you to see what your final image will look in regard to the depth of field at your particular ƒ-stop setting.

HYPERFOCAL DISTANCE

On almost all SLR lenses, the focusing ring shows you the distance at which your lens is focused. Once the number reaches the farthest distance, it shows an infinity symbol (∞), which refers to the farthest thing away—be it a mountain, the horizon, or the moon.

If you're shooting a scene, focused at infinity, and attempt to use the smallest aperture to have everything in focus—for instance, ƒ/22—you will not be making the most of your lens's depth-of-

TIP

CONTROLLING APERTURE

Although the aperture is physically inside your lens, most newer camera models control the function from a knob near your LCD screen on the top or back of your camera.

Hyperfocal Distance / Lens Comparison for 35mm Camera Systems

The scale below is in feet, the spot to focus that gives you one-half that distance to infinity (∞), in focus.

Lens (length)	ƒ/8	ƒ/11	ƒ/16	ƒ/22	ƒ/32
14mm	3.2	2.4	1.6	1.2	0.8
16mm	4.3	3.0	2.1	1.5	1.0
18mm	5.5	4.0	2.8	2.0	1.4
20mm	7.0	5.0	3.5	2.5	1.7
24mm	10	7.0	5.0	3.5	2.5
28mm	13	10	7.0	5.0	4.0
35mm	20	15	10	8.0	5.0

For example, if I am using a 24mm lens on a landscape and want as much as possible in focus, by setting my aperture to ƒ/22 and subsequently focusing at 3.5 feet, theoretically everything from 1.75 feet to infinity (∞) should be in focus.

field capability. The spot farthest away will be in focus, but the closest distance in focus might only be 5 feet away.

Set your focal point to 2 feet, possibly on a foreground flower, and at *f*/22 everything from just below 2 feet to 20 feet will be in focus, and thus you will lose sharpness on the mountain in the distance.

The purpose of hyperfocal distance is to take full advantage of your maximum depth of field.

To accomplish this, instead of focusing at the farthest or closest distance, set your lens to the hyperfocal distance, a certain focal point where the depth of field extends from half that distance to infinity.

Most applied by landscape photographers with wide-angle lenses, it's another way to guarantee focus throughout a scene.

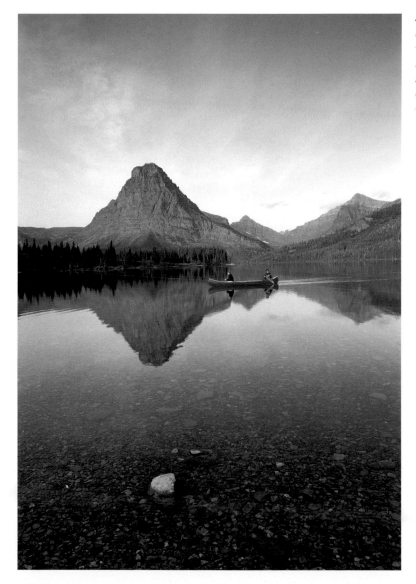

Applying hyperfocal distance helped me pull everything into focus, from the foreground rocks in Two Medicine Lake to the mountains along the Continental Divide, in Glacier National Park.
1/15 SEC. AT *f*/22, ISO 100, 24MM F2.8 LENS

LENS DEPTH-OF-FIELD COMPARISON

The parameters of depth of field also change among different focal lengths, wide-angle lenses having the ability to obtain great depth of field and telephoto lenses having limited amount of depth of field—when both are set at the same f-stop. Another example of this is f/22 on a 24mm lens: You may get everything from 2 feet to infinity in focus, whereas f/22 on a 200mm lens will only produce a depth of field from 25 feet to infinity.

An additional difference between lenses is the *perception* of depth of field. Using wide-angle lenses, you can get away with setting your f-stop to a lower number (a larger aperture) yet still have the appearance of decent depth of field. This is due to the shorter distance the focusing ring has to travel from its closest to its farthest focal point.

As seen in the photo of rock climbers on the facing page, most of my subject matter was more than 10 feet away, allowing me to use a larger aperture, thus letting in more light to use a faster shutter speed—yet everything still has the appearance of being in focus. However, because of this, if you wish to blur the background, having the appearance of less DOF, your subject has to be extremely close to your wide-angle lens.

In contrast, telephoto lenses tend to compact a scene by drawing the eye to a single spot, and since the distance between focal points is much greater than on shorter or wide-angle lenses, the opposite occurs with depth of field, as proven in the photo of the squirrel. You get a similar effect with macro lenses, since, as you get closer to your subject, your DOF becomes extremely limited (a topic discussed in chapter 5).

Numbers in Photography

When it comes to numbers and photography, figures have a tendency to read backward. Such is the case for shutter speeds and f-stops.

Shutter speed numbers like 8000 (for the shutter speed 1/8000 sec., seen as 8000 on most LCD camera screens) seem larger than 1000 (1/1000 sec.). Which it is, of course, but not when it's in fractions. So when photographers want to provide more light to an image, they tend to go up in shutter speed numbers when they should be going down. The result is the opposite of what they wanted, with an image becoming darker, or underexposed. Only when shutter speeds reach 1 second or more does the exposure lengthen using a larger number.

The same goes for f-stops. As numbers increase (f/8, f/11, f/16), the aperture diameter gets smaller, thus allowing in less light. Yet the first inclination of a photographer learning exposures is to increase the number for more light, since, after all, the term *increase* is usually associated with the word *more*. But, again, this makes your aperture smaller, causing a darker exposure. The other problem with apertures is that they're described as larger and smaller (going from more light to less light), yet when you talk about f-stop numbers, they go from smaller to larger (again, from more light to less light).

A good way to think about adjusting f-stops and shutter speeds is to imagine what actually occurs when you alter one or the other. For shutter speeds, remembering numbers are in fractions (until you reach 1 second) and are time related (as opposed to amount) can help you envision each change better. So think: *By setting my shutter speed to a higher fraction number, I'm shortening the amount of time the light can enter the camera and thus creating a darker exposure.*

As for f-stops, you can simply remember that as the f-stop number increases, less light enters your camera. So think: *If I change my f-stop from f/2.8 to f/16, the smaller aperture lets less light into the camera, creating a darker exposure.*

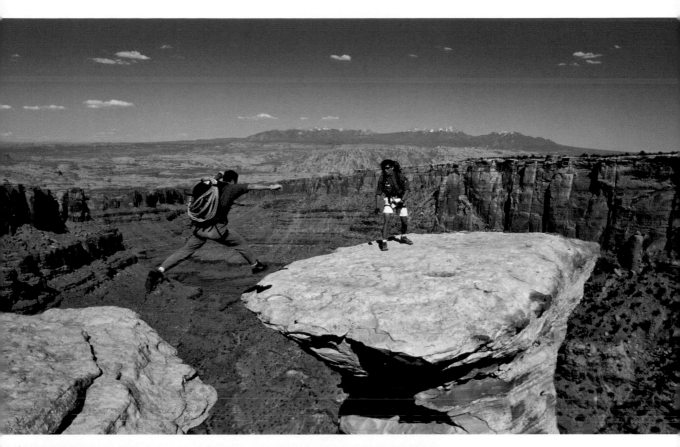

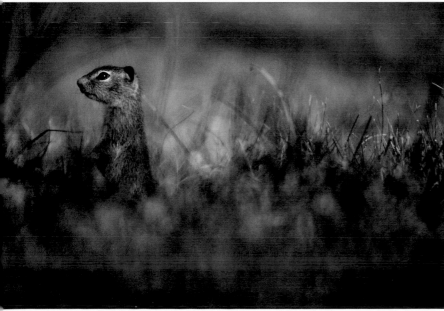

In the photo above, my hopes of capturing this rock climber in midflight forced me to use a fast shutter speed. But by using a wide-angle lens, I was still able to give the appearance of great depth of field. The telephoto lens used in the photo at left eliminated many distracting blades of grass only millimeters from this ground squirrel, creating a much cleaner image.

ABOVE: 1/30 SEC. AT ƒ/11, ISO 100, 80–200MM F2.8 LENS

LEFT: 1/500 SEC. AT ƒ/4, ISO 100, 300MM F4 LENS

Combining *f*-Stop and Shutter Speed

Now that you've learned how your shutter speed and aperture work independently, the coordinated mix of both is true exposure, used in combination to regulate how much light the camera records in order to produce a proper exposure. You cannot use aperture without shutter speed, and vice versa, as each has its effect on the other.

This a key point that confuses many people, the reason being that in photography numbers almost seem to be reversed, against logic and common sense. Even I reverse them from time to time when I'm lecturing.

What do I mean? Well, when we think of *under*exposing a scene with our shutter speed—that is, when we want to make a darker exposure—our logic-ruled minds assume that in this case the word *under* means "I must go lower, lower in the number," when in fact actually speeding up the shutter creates a shorter, hence "under," exposure. If I wish to *over*expose using my *f*-stop, we think *over* means "I must go over the number I have set right now," when actually lowering your *f*-stop number makes the aperture larger, allowing more light and overexposing the image.

Combining both shutter speeds and apertures at this point can really begin to throw the beginning exposure student off, but to understand exposure, you must know how they work together.

HOW ONE AFFECTS THE OTHER

If you're focusing on shutter speeds—that is, if it's your first priority for a shot—you still must consider aperture. Using a faster shutter speed (1/500 sec., 1/1000 sec., and so on) allows you to stop action nicely, but since it also permits less light, you may need to move to a larger aperture, or lower *f*-stop number, such as *f*/2.8, *f*/4, and so on, to adjust for this. By doing so, you sacrifice depth of field, which means you may blur the background, drawing the viewer's eye to your subject, but your focus needs to be dead on.

The same goes for slower shutter speeds. You may wish to record a scene using a slow speed (1/4 sec., 1 sec., and so on), but this allows additional light to enter the camera, subsequently forcing you to set your aperture smaller—that is, to a larger number *f*-stop, such as *f*/16 or *f*/22).

Photographing from a boat, I wanted to freeze the kayakers with little camera shake and a blurred background. The exposure combination of a fast shutter and large aperture did the job.
1/2000 SEC. AT *f*/4, ISO 100, 300MM F4 LENS

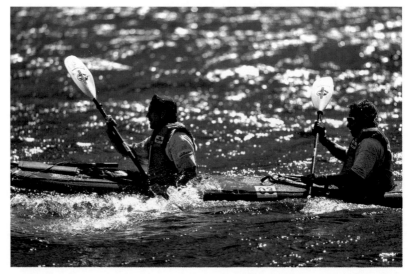

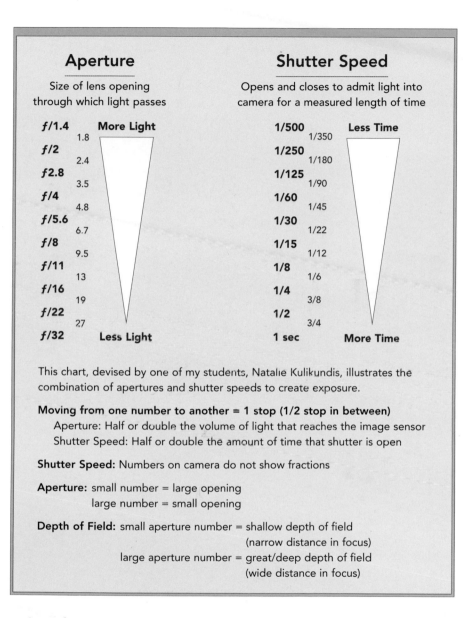

Aperture

Size of lens opening through which light passes

f/1.4	**More Light**
1.8	
f/2	
2.4	
f2.8	
3.5	
f/4	
4.8	
f/5.6	
6.7	
f/8	
9.5	
f/11	
13	
f/16	
19	
f/22	
27	
f/32	**Less Light**

Shutter Speed

Opens and closes to admit light into camera for a measured length of time

1/500	**Less Time**
1/350	
1/250	
1/180	
1/125	
1/90	
1/60	
1/45	
1/30	
1/22	
1/15	
1/12	
1/8	
1/6	
1/4	
3/8	
1/2	
3/4	
1 sec	**More Time**

This chart, devised by one of my students, Natalie Kulikundis, illustrates the combination of apertures and shutter speeds to create exposure.

Moving from one number to another = 1 stop (1/2 stop in between)
Aperture: Half or double the volume of light that reaches the image sensor
Shutter Speed: Half or double the amount of time that shutter is open

Shutter Speed: Numbers on camera do not show fractions

Aperture: small number = large opening
large number = small opening

Depth of Field: small aperture number = shallow depth of field
(narrow distance in focus)
large aperture number = great/deep depth of field
(wide distance in focus)

Sure, there are situations where the exposure combination you hope for is exactly the settings that apply for the specific scene, but this does not occur all the time.

As with shutter speeds, apertures come with tradeoffs, especially when depth of field is involved. Obtaining more depth of field requires a smaller aperture—that is, a higher f-stop number, such as f/16, f/22, and so on—but also limits the amount of light again. Consequently, a smaller aperture causes you to use a slower shutter speed, which is something to consider when shooting subjects that may move during your exposure or when you're not using a tripod (the handheld shutter rule).

The photo at the top of the next page demonstrates this: While photographing a landscape scene along the California coast, I used the smallest

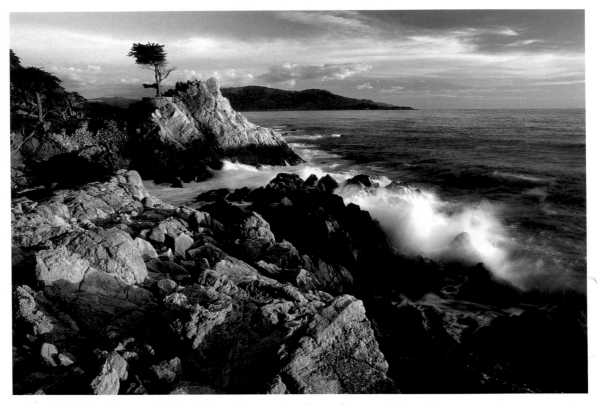

The golden light of sunset added to this coastal scene, but the smaller aperture and late afternoon light also created a longer exposure.

1/2 SEC. AT ƒ/22, ISO 100, 24MM F2.8 LENS

aperture that my lens had to offer, ƒ/22, to obtain maximum depth of field. By doing so, it forced me to slow my shutter speed down to 1/2 second. At this speed, I would not be able to freeze the crashing waves as they burst off the rocks, which might have looked nice, but to me the slower shot showing the waves in motion worked just as well—not to mention putting the entire scene in focus, from foreground rocks to distant coastline.

The opposite occurs when you're using a larger aperture (for instance, ƒ/2.8, ƒ/4, and so on) for minimal depth of field. More light filters through the lens, causing your shutter speed to increase. Sometimes it can be to your benefit, but on occasion you may not prefer a fast shutter speed—hence the tradeoff and decision you must make when creating your image.

THE CONCEPT OF EXPOSURE VALUE (EV)

Exposure value—not to be confused with exposure compensation (EC), which is explained later in this chapter—is a method that was created to simplify exposure combinations for certain measurements of light. The term is used throughout digital photography and can be a bit puzzling, since it's applied in a variety of ways: to measure light, for incremental settings in your aperture or shutter speed, for your meter using exposure compensation, and so on. If you get a little lost in this section, move forward and then refer back to it from time to time; as you learn more about exposure, EV may begin to make better sense.

Zero (0) is the base starting point for EV, measured as ISO 100, ƒ/1 at 1 second. As the diagram

below illustrates, there are many exposure combinations that fit into the EV 0 (such as *f*/4 at 15 seconds or *f*/11 at 2 minutes). There's a formal explanation for this measurement and how it was arrived at, but instead of burdening you with complex mathematical terms, I'll discuss EV "lite," as it were, using specific photographic situations that recreational photographers can understand.

The exposure value chart lists combinations recognized at equivalent exposures, a topic covered in chapter 4.

Exposure Values

EV	f-stop												
	1.0	1.4	2.0	2.8	4.0	5.6	8.0	11	16	22	32	45	64
-6	60	2m	4m	8m	16m	32m	64m	128m	256m	512m	1024m	2048m	4096m
-5	30	60	2m	4m	8m	16m	32m	64m	128m	256m	512m	1024m	2048m
-4	15	30	60	2m	4m	8m	16m	32m	64m	128m	256m	512m	1024m
-3	8	15	30	60	2m	4m	8m	16m	32m	64m	128m	256m	512m
-2	4	8	15	30	60	2m	4m	8m	16m	32m	64m	128m	256m
-1	2	4	8	15	30	60	2m	4m	8m	16m	32m	64m	128m
0	1	2	4	8	15	30	60	2m	4m	8m	16m	32m	64m
1	1/2	1	2	4	8	15	30	60	2m	4m	8m	16m	32m
2	1/4	1/2	1	2	4	8	15	30	60	2m	4m	8m	16m
3	1/8	1/4	1/2	1	2	4	8	15	30	60	2m	4m	8m
4	1/15	1/8	1/4	1/2	1	2	4	8	15	30	60	2m	4m
5	1/30	1/15	1/8	1/4	1/2	1	2	4	8	15	30	60	2m
6	1/60	1/30	1/15	1/8	1/4	1/2	1	2	4	8	15	30	60
7	1/125	1/60	1/30	1/15	1/8	1/4	1/2	1	2	4	8	15	30
8	1/250	1/125	1/60	1/30	1/15	1/8	1/4	1/2	1	2	4	8	15
9	1/500	1/250	1/125	1/60	1/30	1/15	1/8	1/4	1/2	1	2	4	8
10	1/1000	1/500	1/250	1/125	1/60	1/30	1/15	1/8	1/4	1/2	1	2	4
11	1/2000	1/1000	1/500	1/250	1/125	1/60	1/30	1/15	1/8	1/4	1/2	1	2
12	1/4000	1/2000	1/1000	1/500	1/250	1/125	1/60	1/30	1/15	1/8	1/4	1/2	1
13	1/8000	1/4000	1/2000	1/1000	1/500	1/250	1/125	1/60	1/30	1/15	1/8	1/4	1/2
14		1/8000	1/4000	1/2000	1/1000	1/500	1/250	1/125	1/60	1/30	1/15	1/8	1/4
15			1/8000	1/4000	1/2000	1/1000	1/500	1/250	1/125	1/60	1/30	1/15	1/8
16				1/8000	1/4000	1/2000	1/1000	1/500	1/250	1/125	1/60	1/30	1/15

This diagram illustrates exposure values (the left column) for various f-stops and shutter speed combinations, at ISO 100. Shutter speeds are listed in seconds, unless designated as minutes by the letter "m."

Caution!

In my research on exposure value (EV) and exposure compensation (EC), I found that numerous sources use the abbreviated term EV for both exposure value and exposure compensation, thus causing confusion. Even digital camera menus list it this way. This is because the way to compensate for your exposure (when in automatic modes) is through the exposure value. The best way to separate the two is to see EV as a measured value and EC as a compensation for your meter (defined later in this chapter) using that value.

From the exposure value chart on the previous page, a table was developed to address certain lighting types or conditions, as mentioned with time exposures earlier in this chapter. Most charts list a series of scenarios dealing with everything from sunsets to home interiors to night sports—they even go so far to list situations such as "light sand in slightly hazy sunlight."

I rarely refer to this exposure value list, partly because of my photographic experience but also because these scenarios can be easily measured by your meter and determined by you under varying conditions that are impossible to know beforehand. So I've eliminated those types of circumstances from my list in the table below, only addressing situations where my meter may not read the light accurately (the first quarter moon) or be able to read the light at all (a 4-hour time exposure of the stars). This is where knowing the exposure value can give you a good starting point.

Exposure Values for Various Lighting Types or Conditions

Lighting Type / Condition	EV (at ISO 100)
The Moon	
Full moon	15
Gibbous moon (between a full moon and half moon)	14
Quarter moon (first quarter or third quarter, also known as a half moon)	13
Crescent moon	12
Moonlight (photographing scenes using the moonlight)	
Full moon moonlight	−3 to −2
Gibbous moonlight	−4
Quarter moon moonlight (also known as a half moon)	−6
Aurora borealis and australis (the Northern Lights)	
Bright	−4 to −3
Medium	−6 to −5
Night scenes	
Distant view of a lit city skyline	1
Fireworks (as a time exposure to show movement in the trails)	3
Lightning	2
Christmas lights, lit candles, floodlit building or monuments	4 to 5
Stars	
Star trails (no moonlight)	−6 to −5
Star trails (with moonlight)	−5 to −3

Using Exposure Modes

When it comes exposure modes—as opposed to metering modes (see chapter 3)—the first question I would ask you is this: How well do you know your camera? You may have an idea of some of its features, such as *program* (or *automatic*), which is the mode your camera is possibly set to since it's the default setting of many models. But are you aware that your camera offers other exposure settings, giving you greater control of the way you shoot?

All exposure modes (with the exception of *manual*) capture images while automatically metering the scene for you to some extent. That is, you may control some of the settings (such as the *f*-stop you want to use), but the camera's meter will determine the final exposure. Each exposure mode is slightly different, letting you decide on one or two settings to control and thus giving you more artistic freedom to create with these functions

APERTURE PRIORITY (AV)

An exposure mode allowing you to set your aperture, *Aperture Priority* (often abbreviated *Av* or *A*) gives you the ability to control depth of field while the camera calculates the best shutter speed to expose the image correctly.

Av is a nice automatic feature when depth of field is most important for a particular scene yet you don't want to manually control the metering by setting the shutter speed yourself—whether by choice, due to a hurried schedule or event, or a because of a fast-moving subject that doesn't allow much time to meter (as in the photo below).

You may want to take a quick landscape scene with maximum depth of field, but a second later you may decide to limit your depth of field by selecting a large aperture. Either way, you're able to focus on your aperture alone and concentrate on the scene at hand.

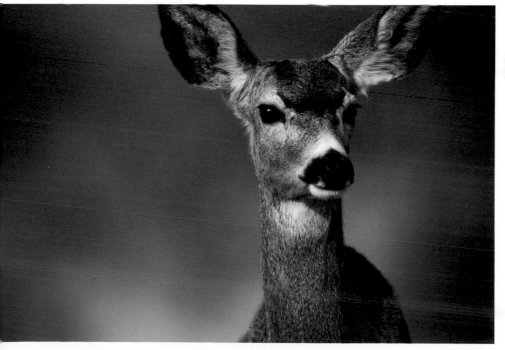

Photographing deer on the move in Lava Beds National Monument didn't allow for much metering time. This is where Aperture Priority mode could do the job. 1/500 SEC. AT *f*/4, ISO 100, 300MM F4 LENS

Using Aperture Priority let me set the depth of field needed for this landscape scene in Montana's Glacier National Park.
1/15 SEC. AT *f*/32, ISO 100, MEDIUM-FORMAT 125MM F3.2 LENS

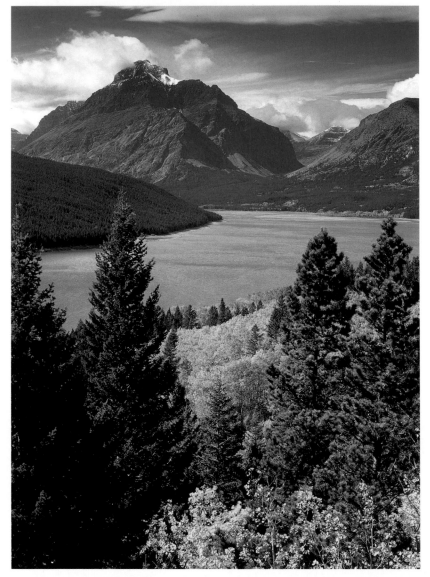

ASSIGNMENT **Use Only Aperture Priority**

Aperture Priority mode is great to practice with when learning more about how your *f*-stops work. You can familiarize yourself—and become comfortable with—what comes into focus using the various apertures and how they change a scene.

Go out one day or even one week and only use Aperture Priority. When you eliminate more variables and are able to concentrate on one aspect of your camera at a time, I believe you can learn about that feature much more easily. The same goes for Shutter Priority mode when you just want to learn about your shutter speeds.

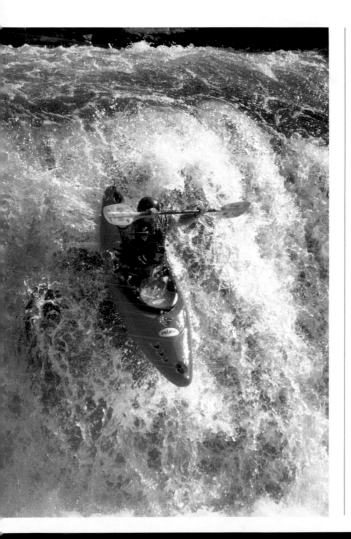

SHUTTER PRIORITY (TV)

In Shutter Priority (*Tv* or *S* for short), you can select the shutter speed over the available range and have the camera calculate the best aperture for a proper exposure.

Operating similarly to Aperture Priority, Tv is often used to create shots dealing with time, whether fast or slow, allowing you to focus on the speed of your shot while not having to meter or set the complete exposure—again, whether by choice, because of a hurried schedule or event, or due to a fast-moving subject that doesn't allow much time to meter.

Capturing a sporting event in which you want a fast shutter speed but know you'll be on the move too much to meter each scene? Want to shoot a panned slow exposure of some wildlife and prefer to concentrate on focus and composition instead? Tv is the way to go.

Shutter Priority mode gave me the control to set a fast shutter speed, capturing this kayaker as he headed over a waterfall.
1/1000 SEC. AT ƒ/4, ISO 100, 300MM F4 LENS

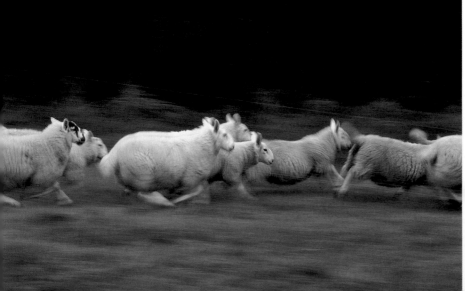

Photographing sheep in Scotland wasn't as easy as I thought it might be. Since they wouldn't permit me to get close to them, I decided to shoot in Tv for a slow pan and chase them down for a shot.
1/30 SEC. AT ƒ/16, ISO 100, 80–200MM F2.8 LENS, AT 135MM

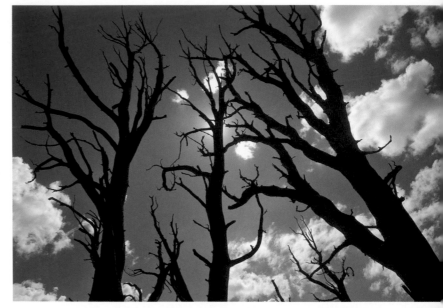

Shooting the photo at right high in Kings Canyon National Park, I under-exposed from my meter's recommendation, thus creating a dramatic image of the silhouetted pines. The photo below was taken at sunrise in Yosemite. Due to the lighting conditions in the park, any other mode besides Manual would have exposed the scene inaccurately.

RIGHT: 1/250 SEC. AT ƒ/16, ISO 100, 24MM F2.8 LENS

BELOW: 1/60 SEC. AT ƒ/11, ISO 160, 80–200MM F2.8 LENS, AT 100MM

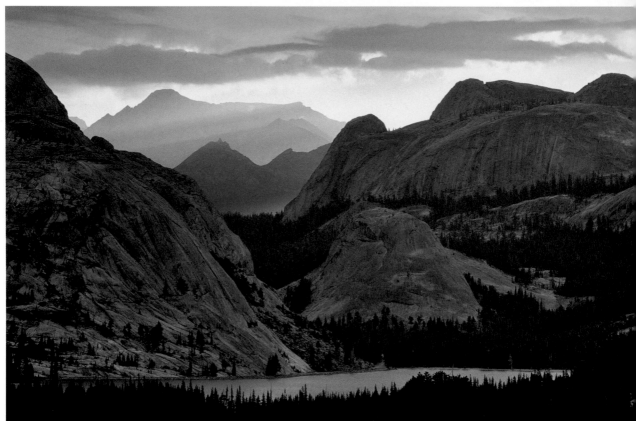

PROGRAM

Most current systems refer to this exposure mode as Program (or *P*), with older models using "Automatic." In this mode, the camera sets both the aperture and shutter speed based on the meter's recommended exposure for any specific scene. So all you have to do to compose a picture is focus and shoot. But exposure control isn't completely lost with this automatic mode, and many cameras offer a selection of Program modes.

One type of P mode lets you rotate your dial, changing the combinations of aperture and shutter speed; Nikon calls this *flexible Program,* and Canon refers to it as *Program shiftable.* Other program modes have preset combinations for specific shooting situations, such as Child, Landscape, Night, Portrait, and Sports.

The main problem with Program, as well with the Shutter and Aperture Priority modes, is that they rely on the camera's internal reflective meter to judge the lighting and set the exposure. Your camera's meter is very good, and a number of metering options can help you expose better, but the meter can often be wrong, which is a big reason why I rarely shoot in auto exposure modes (an issue expanded on in chapter 3).

Note that if your camera offers Automatic, then the abbreviation will be A (and possibly Av for Aperture Priority to distinguish one from the other). But since most cameras today use the term Program, P is usually used.

MANUAL

The only mode in your camera allowing you complete control of your exposure is Manual (or *M*) mode, my personal favorite and the default exposure mode on all my cameras. It allows you to set the aperture, shutter speed, ISO, and other functions of exposure without your camera making the decision for you—the key being you must determine the proper metering for the scene.

As you begin to learn more about metering, exposures, and the myriad lighting conditions you can come across while shooting, you'll begin to see that Manual exposure mode allows the greatest flexibility with your images. By putting the decision making in your hands instead of leaving it to the camera, you can make choices your meter never could.

M mode lets me take the meter's recommendation of a proper exposure and decide the setting I feel would create the best exposure—whether I wish to create moods by under- or overexposing, or fix potential metering issues or miscalculations.

Manual is by no means an easy option, however. A photographer can make an exposure mistake just as easily as the camera can. And under certain circumstances, I've needed to use another exposure mode—such as those involving an active subject moving in and out of various lighting conditions between shots too quickly to re-meter on my own—which is the kind of situation that makes auto exposure necessary, not to mention a blessing.

Exposure Compensation

The setting in your camera known as *exposure compensation* (EC) enables you to adjust your exposure measured by your light meter. Almost all cameras offer a form of exposure compensation, using the "+/–" symbol located either on top of your 35mm dSLR camera or in its menu (this is true even for older cameras, including one of my first SLRs, from the 1980s).

Exposure compensation can usually be adjusted from +2 to –2 EV (stops of light), in 1/3 steps, with some systems offering half-stop and one-stop EV steps. In most digital systems today, the numbers are listed in decimals where the fractions are rounded up (–1, –0.7, –0.3, 0, +0.3, +0.7, +1)—with –2/3 EV being –0.7, +1/3 EV being +0.3, and so on.

Confused yet? There can be some bewilderment when we begin to use EC and EV in the same sentence. To simplify it, merely recognize exposure value (EV) as the actual measurement of light and exposure compensation (EC) as the altering of this measurement.

Exposure Compensation in an Automatic Setting
(in 1/3-stop increments or step values)

ƒ5	ƒ/5.6	ƒ/6.3	ƒ/7.1	ƒ/8	ƒ/9	ƒ/10	ƒ/11
1/100	1/125	1/160	1/200	**1/250**	1/320	1/400	1/500

In this example, the camera's meter gave us a recommended exposure setting of 1/250 sec. (shutter speed) at the aperture setting of ƒ/8.

+1/3 EV (+0.3) Exposure Compensation in an Automatic Setting

ƒ5	ƒ/5.6	ƒ/6.3	ƒ/7.1	ƒ/8	ƒ/9	ƒ/10	ƒ/11
1/100	1/125	1/160	1/200	**1/250**	1/320	1/400	1/500

If I wanted to create a brighter exposure (overexposing from the meter), I could dial a compensation of +1/3 EV, in which case the meter decided to make the aperture larger by 1/3 ƒ-stop to ƒ/7.1, while leaving the shutter speed of 1/250 sec.

–2/3 EV (–0.7) Exposure Compensation in an Automatic Exposure Setting

ƒ5	ƒ/5.6	ƒ/6.3	ƒ/7.1	ƒ/8	ƒ/9	ƒ/10	ƒ/11
1/100	1/125	1/160	1/200	1/250	1/320	**1/400**	1/500

By dialing a compensation of –2/3 EV, the meter decided to make the shutter speed faster by 2/3 ƒ-stop to 1/400, while leaving the aperture at ƒ/8, creating a darker exposure (underexposing from the meter).

ADJUSTING EXPOSURE COMPENSATION

Exposure compensation is a feature mostly used in automatic exposure modes when you want to adjust your image. Why would you want to use it? Because, as I'll discuss in chapter 2, your camera's meter is often fooled by various conditions (snow, the sun, strong backlighting, and virtually any metered subjects that aren't middle gray in tonal value)—and exposure compensation is a way to correct these miscalculations when in an auto exposure mode such as Program, Aperture Priority, or Shutter Priority. (This doesn't apply as much in the manual exposure mode.)

Why wouldn't you use EC when in manual? Because although EC is available in this mode, there's little need for it since you can adjust your exposure just as easily on your own. Not to mention that if you set your EC and forget about it in Manual, you may throw off all of your future exposures.

In automatic, however, your meter can be fooled under various conditions, and changing your exposure compensation will tell your camera to allow more light to enter (a positive "+" EC) for a brighter exposure, or to allow less light (a negative "–" EC) for a darker exposure. EC may change the exposure settings through the adjustment of your aperture, through your shutter speed, or possibly through a combination of both.

For a light-toned scene like this ice plant flower detail, unless you shoot in manual you need to adjust your EC in any auto exposure mode to replicate the accurate tones of the petals. How much should you adjust the EC? It all depends on how far, in stops, the tonal values area from middle gray.

1/160 SEC. AT ƒ/4.5, EC +1.0, ISO 100, 60MM F2.8 MACRO LENS

My Last Word on EC

Camera manuals don't adequately explain exposure compensation, as is the case with so many topics. "Just adjust your EC to obtain the correct exposure," the directions say—but if it were that easy, we'd all capture perfect exposures every time.

Since I mainly shoot in Manual, I hardly ever use exposure compensation. True, Manual is a mode that takes time and patience to learn, but in my opinion, it's the best to use in the long run.

Working with ISO

I started my photographic career years before the digital age, and a film's ISO (derived from the International Organization for Standardization, formerly called ASA, from the American Standards Association) always referred to its sensitivity, in effect by classifying its speed—which affects the exposure, grain, detail, and color in your images.

Choosing the right film speed was an important aspect to the decision-making process in creating my photographs.

ISO still plays an integral part of every digital image, and although it is defined using terms such as *image sensor* and *noise*, not much has changed from the days of film as far as how ISO works.

Choosing a lower setting of ISO 100 for this Montana scene not only affected my final exposure setting but also assisted in obtaining the rich color and detail of the landscape.
1/2 SEC. AT ƒ/22, ISO 100, 24MM F2.8 LENS

As with digital cameras, the ISO number is measured on a scale equivalent to film, is also referred to as digital ISO, and indicates the image sensor's sensitivity to the amount of light present. Depending on its setting, ISO still affects my images when it comes to saturation of color, addition of grain (noise), detail (pixels), contrast, and exposure.

The benefit of digital, however, is that I can change my ISO sensitivity for every shot I take with a simple change of a dial depending on each individual photographic scenario—as opposed to the past, when ISO was set into the roll of film I was using. Now I can record a variety of images taken at different ISO speeds, yet all on the same memory card, a method some pros call the "digital push."

ALTERING EXPOSURES WITH ISO

When it comes to main camera settings controlling exposure, f-stops and shutter speeds are the first of these, with ISO being the third.

ISO numbers run similar to shutter speeds (as detailed in the table below), with options to adjust in 1/3-stop, 1/2-stop, or one-stop increments (called ISO step values), and varying in minimal and maximum number settings depending on the type of camera you own.

As with shutter speeds, every time the ISO number is doubled or halved, it is measured as one stop faster or slower, respectively, with 1/3 stops in between if desired. With every change of your ISO, your exposures will change as well,

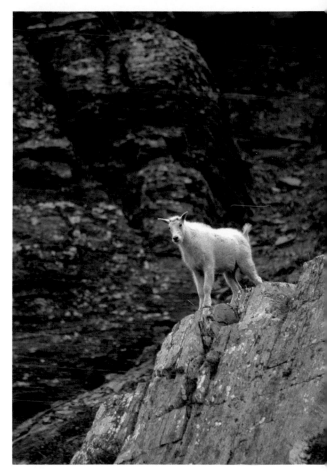

Photographing this mountain goat in low ambient light created a slow exposure using ISO 50 (1/30 sec. at f/2.8), potentially causing movement in the animal or camera shake, which would have resulted in a soft image. By raising my ISO setting to 200, my shutter speed increased, eliminating the concern.

1/125 SEC. AT f/2.8, ISO 200, 80–200MM LENS, AT 200MM

General ISO Settings
(in 1/3-stop increments, also called 1/3 step values)

100	125	160	200	250	320	400	500	640	800	1000	1250	1600

Less sensitive to light ————————————————▶ More sensitive to light

(Please note ½-stop step values are not shown above.)

either speeding up or slowing down depending on the number you choose.

This is because ISO alters your meter, changing the actual final exposure, whereas *f*-stops and shutter speeds are merely settings configured from your meter's recommended exposure. The faster or higher number ISO, the less exposure is required—that is, a shorter time is needed to expose the scene. The lower the number, the more exposure is required—that is, use a longer shutter speed or wider aperture to adjust for the low ISO setting. If you increase your ISO from 100 to 200, your exposure will increase by one stop as a result. Move from 100 to 400, and the exposure will be two stops faster.

AUTO VS. MANUAL

Most digital cameras allow the option of controlling your ISO either in an automatic or manual mode. These are similar to exposures modes: one allows the camera to control the setting, while the other offers full control set by you, the photographer.

The Auto ISO mode provides you with the flexibility of shooting on the go, your camera automatically determining the ISO depending on the amount of light within a scene, increasing or decreasing the sensitivity accordingly. For the most part, this mode chooses lower number settings the brighter the light entering the camera and higher number settings the darker the light is in frame. Often the default setting in your digital camera, Auto ISO can be a nice option when you just want to capture images fast without fiddling around with camera dials or functions. But as with auto exposure modes, you never know what you may get as an end result.

This is why I prefer Manual ISO. By turning off Auto ISO and setting it on my own, I have the reassurance that my ISO will stay at the number I have set it to, and I also have the option to change it whenever I deem necessary. I know this adds to my fiddle-factor time if I have to change the ISO settings now and again, and there's the chance that I might forget what I set it to previously and not check it before creating new images. Notwithstanding these oversights that can occur using Manual ISO, it's still my mode of choice because it gives me total control. As I delve into ISO and explain the advantages of disadvantages of the various sensitivity settings, this may make better sense.

COLOR CHANGES WITH ISO

One previous aspect affecting color in my images was the ISO sensitivity of the film I used. If I loaded a lower ISO, I knew the saturation of color would be strong and the scenes in general would be vibrant. If I chose a higher ISO to shoot faster—for example, capturing wildlife in low-light situations—the tradeoff would be the richness of color in my final images. With digital ISO, however, color is not noticeably affected when you go from a low to a high setting. Instead, if color is lost anywhere, it's through noise created by the digital ISO sensitivity.

ISO AND NOISE

Having the ability to switch ISO settings midstream during a shoot is a wonderful feature of digital photography, allowing you a wider coverage of exposures depending on the scenario. However, with one advantage comes a disadvantage: Just as increased grain in film can occur at higher ISO settings, digital noise can build as your ISO increases.

Noise is described as small statistical variations in color values on your image sensor as a result of one of the following:

❏ **Amplifying the electrical signal** when light is converted in the form of pixels

❏ **The same pixel being exposed several times** by the same amount of light

❏ **A weak signal** when the image sensor receives little or no light at all (often called "stuck pixels" or "hot pixels").

To put it in general terms, noise shows up in your images as color speckles, detectable in high ISO settings and most noticeable in clean areas such as clear skies, deep shadows, skin tones, or any expanse with minimal texture or patterns.

As digital technology continues to move so rapidly, so do improvements with image quality, and although most cameras manufacturers reduce noise in their firmware, you now can correct or remove noise with alternative software programs such as Neat Image or Noise Ninja. Another method to improve on noise is built into your image sensor (see chapter 2).

I chose an ISO of 200, creating less noise and accurate skin color in my daughter's face (far left). Increasing the ISO to 1600 in the image at near left, you begin to notice the effects of noise, resulting in the loss of saturation, contrast, and subtle shift in color. The image below is a close-up section combining both images to magnify the noise (the top image at ISO 200 and the bottom image using ISO 1600).

FAR LEFT: 1/80 SEC. AT *f*/2.8, ISO 200, 55MM F2.8 LENS

NEAR LEFT: 1/1000 SEC. AT *f*/2.8, ISO 1600, 55MM F2.8 LENS

WHAT ISO TO USE WHEN (THE "DIGITAL PUSH")

Knowing I can change my ISO for any exposure I wish is a great photographic option given the variables and limitations I'm often working with on a photo shoot. As noted in the ISO comparison Chart, as I raise my ISO, the increase in sensitivity allows me the possibility to take pictures in low-light situations where flash may not an option. But if I have the option of using a low ISO setting, my images will have less noise and an overall better quality.

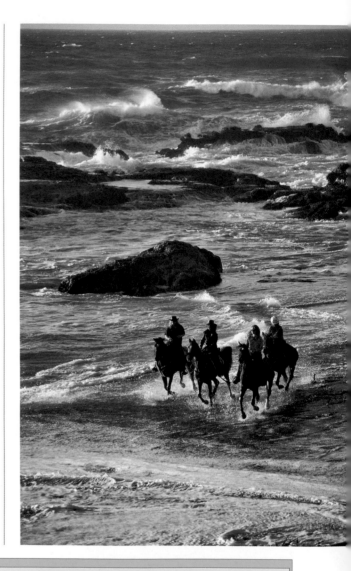

As the last light of day faded fast, I photographed these horseback riders along the California coast. I knew my goal was to freeze them in motion as they pounded through the surf, so I set my ISO to 200, increasing my shutter speed enough for the exposure.
1/250 SEC. AT ƒ/2.8, 200 ISO, 80–200MM F2.8 LENS, AT 135MM

ISO Comparison Chart

Lower ISO Settings ISO 50–200	Higher ISO Settings ISO 400–3200
Larger aperture and/or a longer shutter speed needed	Smaller aperture and/or faster shutter speed required
Little noise, better color	Increased noise, more color degradation
Better image detail	Less image detail
Flash may be required	Possibility of not having to use flash

Choosing an ISO

Some photographers may prefer grain or noise in their images depending on the kind of shot they're after, but since noise is easier to add than remove after the fact, I prefer to capture images with the least amount of noise. Therefore, when it comes to choosing an ISO setting I generally ask myself the following questions:

❏ **What do I want my exposure to be?** The exposure I choose could determine the ISO I will need to set. A tripod in some circumstances can increase my ISO options, since a slower exposure can be steadied by its negating the need for a higher ISO and faster shutter speed.

❏ **Does the light allow for this exposure?** If my subject is well lit, my exposure may still work using a low ISO, allowing me to capture the high-quality image with little or no noise. But if I'm working in conditions with minimal light and either choose not to use flash or am restricted to use only the ambient light available (such as in an ecclesiastical or spiritual setting), I may be forced to increase my ISO to get the shot I desire.

❏ **Is my shutter speed fast enough for the lens I'm using?** At the largest aperture, depending on the amount of light available, the shutter speed may not be fast enough to handhold my lens while capturing a sharp image with no camera shake. I may either have to increase my ISO or consider using a tripod.

❏ **Is the shutter speed fast enough for my subject?** In situations where a subject may require a semi-fast shutter speed (photographing children, indoor sports, wildlife in motion, working in shade), an increase in ISO sensitivity can help.

ASSIGNMENT Shoot an Image
Where Aperture Defines the Scene

Controlling aperture and depth of field not only lets you pull the viewer to a certain point in the scene but can also place the entire scene in focus. Utilize this lens function using Aperture Priority (Av) mode in your assignment, and create a photo characterized by your *f*-stop setting.

Whether you document a scene using minimal depth of field (for example, a raindrop on a flower petal), maximum depth of field (a grand landscape using hyperfocal distance), or somewhere in between (a cowboy's rough hands, with a hint of focus to his face and hat in the background), make sure your final image draws the viewer's eye straight to your subject.

While you work on this assignment, attempt to record as many specifications and details of your selected image that aren't included in your EXIF metadata (the information attached electronically to each image you shoot; for more on this, go to page 56). You can find most of your exposure settings through the metadata, but certain things, such as filter type and direction you were shooting in, you should keep track of yourself in case you want to share all of your information later.

In this photo, I wanted to eliminate as much of the surroundings as I could. S to minimize depth of field, I set my aperture to its largest setting.
1/250 SEC. AT *f*/2.8, 60MM F2.8 MACRO

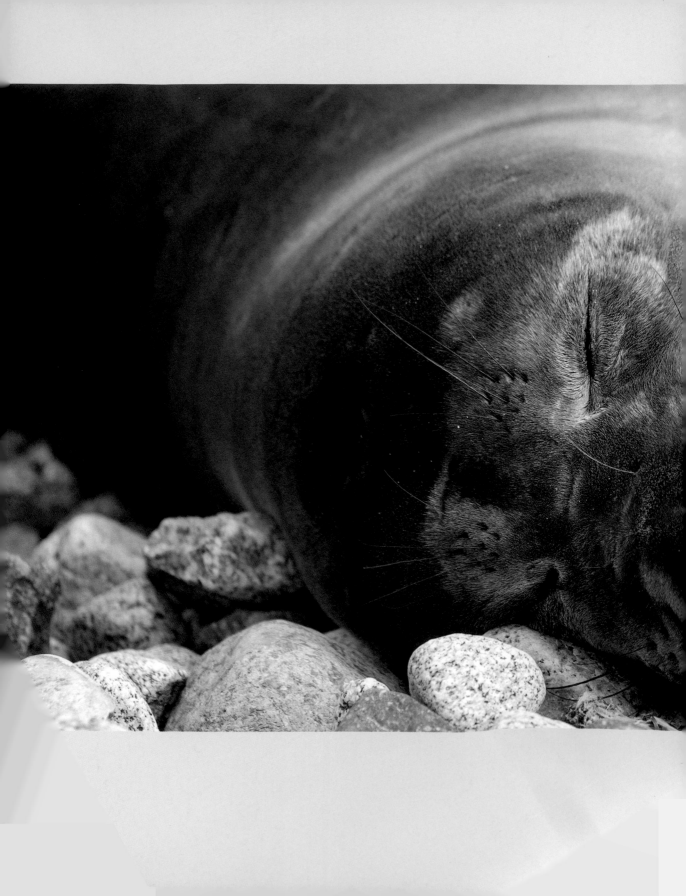

Digital Exposure

DIGITAL PHOTOGRAPHY EMERGED in the early 1990s, and although it had some catching up to do with film, many professional photographers could see early on the advantages it would bring to the industry.

I jumped into digital as early as 1995. While documenting the Eco-Challenge adventure race in the middle of the Utah desert, I transmitted my images over phone lines every evening, watching my film-less photos appear on the *Salt Lake Tribune*'s cover the next day. Now, not only has digital technology taken over the market in terms of consumer purchases, but improvements and options added in the majority of dSLR cameras have also helped bring digital to the forefront of professional photography.

Instead of loading film and finding a scene to shoot, today's photographer must consider which file format, color space, and White Balance (WB) to select before the capture. Sure, expanding your choices can be great as an artist, but the general laws of photography still apply—and having more choices doesn't necessarily make the process any easier.

In this chapter I introduce the various additional features new to photographers in the digital age. Although I've been able to capture great exposures with my non-digital cameras, I find that these new tools greatly enhance my creative and technical choices when I'm shooting in the field.

File Formats

When it comes to new camera features, most photographers tend to jump in headfirst and begin to use these tools without fully understanding their benefits or detriments. Such is the case when it comes to digital file formats.

Most photographers who use digital cameras have the capability to shoot in raw format—"RAW" is incorrect, since it's not an acronym like TIFF or JPEG—but ask a handful to describe what raw is and you may end up with a variety of answers, some correct and some not.

When I began using dSLRs over a decade ago I, too, was lost for a while when it came to understanding the differences in file types. With the introduction of raw over the past few years, it seems as if the formats finally have their feet firmly secured in the digital world—that is, until another innovation comes along to upset the apple cart.

While teaching a wildflower workshop, I documented this calla lily without even looking through my viewfinder to avoid crushing the plant (that's part of the beauty of an LCD screen to check compositions). Knowing the contrast would be high, I shot in the raw file format to obtain the maximum detail and amount of information possible.
1/80 SEC. AT ƒ/20, ISO 100, 12–24MM F4 LENS, AT 14MM

In this section I define each current format not merely for information purposes but so that you can understand how each affects your final image—and consequently your exposure.

HOW FILE FORMATS AFFECT EXPOSURES

Every time you capture a digital image, each file contains specific information and data depending on a variety of settings. One setting crucial to the quality of your digital photograph is the format you shoot in, since each alternative receives a different type of processing—and this alone can affect your final image.

Depending on which file format you choose, your exposure could look better or worse, take up more or less of your memory card's "budget," or display fine or mediocre detail. Learning about each option gives you a choice to make under the conditions and final use you may have for any specific image. Correcting or adjusting exposures after the capture, as well as saving your image files, are other expansive steps in the process of digital photography. All of these are addressed in chapter 8.

RAW

Defined as "unprocessed" data, this format is usually referred to generically as raw, but it may also be known as something else, depending on the camera manufacturer (Nikon calls it *NEF,* or *Nikon Electronic Format*, and Canon uses the term *CR2,* which stands for *Canon Raw Second Generation*).

Most photographers, myself included, recognize raw as the optimal format to shoot in, since no original information is lost. Hence, it's the format that obtains the most data and in the purest form. Because of this, raw captures the highest quality in areas such as color range, detail, and contrast ratio; it's also the widest of all formats at 12- or 14-bit, as compared to 8-bit in JPEG (a *bit,* or *binary digit,* being a basic unit of information storage).

Another reason for raw's superiority in capturing images comes from the unprocessed data: Stored by your sensor, the pure data allows you the most flexibility when preparing the final digital image in your computer. The information is not compressed or converted, giving the photographer a variety of post-processing exposure corrections, all with little or no visible *artifacts,* or defects—that is, less noticeable adjustments in your final digital file.

The only downsides of raw are its larger file size—occupying more card or disk space—and the extra computer time spent on manipulating the image by the photographer.

RAW + JPEG

Currently, I shoot exclusively in this dual format, which offers the best of both worlds, producing two image files for each capture, a raw file, with all of the original unprocessed data, and a JPEG file, creating a quick and easy-to-open smaller file that's possible for all to view and share.

By choosing this option, however, you are producing two files every time you press the shutter,

Beyond Raw

Recently, Canon added another option to the mix with *sRaw,* or small raw file format. Basically, this produces a file half the size of a raw file, while maintaining all the raw features. To an extent, it produces a file with fewer pixels per line, which results in a smaller file that allows some shooters more images per memory card.

Nikon went in a slightly different direction, creating a variable color bit depth to cut the image file size. These two innovations—and whatever surely will follow in their wake—won't sway me from my preference. As someone who prefers the largest file size with the most information, I'll still be shooting in the regular raw format for some time.

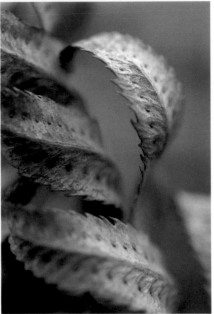

Shooting a burnt section of a fern in raw + JPEG allowed me to capture one large unprocessed raw file (left), giving the most detail and flexibility, as well as a small JPEG file (above), which isn't as accurate and detailed but can be opened and reviewed quickly—not to mention sent to others more easily.
1/40 SEC. AT ƒ/6.3, ISO 100, 60MM MACRO F4 LENS

so your memory card will tend to fill up faster with each frame, eating up those precious megabytes of storage space. However, as memory card capacities grow larger, seemingly every year, starting at 1 gigabyte (GB) and expanding all the way to a 16GB version—and I'm sure we'll see even larger versions soon—I still feel this is the top option for your digital workflow.

TIFF

Before raw took over the field, the file format known as TIFF (*Tagged Image File Format*, abbreviated to "tif" at the end of a file name) was the best option to capture digital images in their highest form. TIFF files can be compressed or uncompressed and are larger than JPEG files, but they still retain the full image quality. Compression is a nice aspect of a TIFF file because it can be done without losing any information (also known as *lossless* compression) and at the same time gives you more card or disk space.

However, with the expansion of raw, many camera manufacturers no longer offer the option to shoot in the TIFF format. To work with or save images in TIFF, you have to go through imaging software such as Adobe Elements.

JPEG

JPEG (*Joint Photographic Experts Group*, abbreviated to "jpg" at the end of a file name) is a file version compressed by your camera's built-in raw converter. It may be the smallest digital file your camera produces, but in fact JPEGs are actually the most popular format shot by all photogra-

phers. Basically, they're a universal format that's able to transfer and open fast for easy manipulation and adjustments.

Low JPEG versions are also used as the main image format on websites: They're small enough to transfer quickly online while still looking good onscreen, yet higher quality JPEGs also contain enough information to produce nice quality photographic prints.

The disadvantages of JPEGs are that they only produce an 8-bit file—limiting your image in terms of color and detail, as well as exhibiting higher contrast—and are compressed in a method known as *lossy* compression. Essentially, some visual quality vanishes in the process, and JPEGs even suffer generational loss—meaning, they degrade in quality every time you open and resave the image file.

I rarely shoot JPEG only, but when I head out with my family and only want to bring a small compact camera along, my point-and-shoot does the trick. The only disadvantage is that it only shoots JPEGs—that is, 8-bit small files with less detail.
1/125 SEC. AT ƒ/2.8, ISO 64, 38–114MM F2.8 LENS, AT 38MM

JPEG Settings

If you plan to shoot in JPEG format only, I highly recommend using the highest JPEG quality offered in your camera, often referred to as *JPEG fine* or *JPEG high*. With this setting, a file is usually compressed to a ratio of roughly 1:4, or a quarter of the size of the normal file. *JPEG normal,* the middle-quality JPEG setting, compresses the file to 1:8 and *JPEG low* to 1:16. Archiving JPEGs is covered in chapter 8.

Image Sensors

An image sensor is the medium for digital cameras, a device that converts what we see through our viewfinder into an electrical signal that subsequently becomes a digital file.

There are currently two types used in digital imaging: a CCD (charge-coupled device) and a CMOS (complementary metal oxide semiconductor). What's the difference? CCDs are the original technology, but CMOS uses a method of recording the signals that consumes less battery power.

How do they work? Each image sensor is a silicon chip containing millions of photosensitive diodes called *photosites,* usually corresponding to one of the discrete elements known as a *pixel* in your digital image. The photosites record the light they receive as numbers that specify the color and brightness of each individual pixel in the image, which together create the resulting picture you see.

IMAGE SENSOR SIZE

Sensor size is something to keep in mind when you're buying a camera, since it plays as important a role as ISO when it comes to *noise*, which is the digital equivalent of a print photo's graininess.

The larger your sensor size, the less noise you obtain at higher ISO settings, because, on a larger sensor, the pixels are bigger and able to receive more light, creating a greater signal-to-noise (S/N) ratio. And the better the signal, the less visual noise there will be. Photosites on a large sensor can also be farther away from each other, resulting in less contamination from neighboring electrical signals.

Many consumer-based digital cameras have smaller image sensors, around $1\frac{1}{8}$ inches wide (as on my current Sony 8MP point-and-shoot camera). Yet even though my Sony has the same 8 megapixels as the Canon 30D digital SLR, the 30D uses a half-frame image sensor, much larger than my point-and-shoot's $1\frac{1}{8}$-inch size. The SLR's images produce far less noise than those from my point-and-shoot, but the latter can fit in my pocket, so sometimes I'm willing to trade quality for convenience.

CCD or CMOS?

Which is the better image sensor? There's a debate as to which of the two produces a higher quality image, since CCD has narrowed the gap on CMOS and can offer a more consistent image in low light conditions. But the edge probably goes to CMOS, mainly due to the battery issue.

Image Sensor Sizes

Image sensor name	Size (approximate)	Type of cameras using this sensor
Full frame	36mm x 24mm (in relation to 35mm film, thus the name)	High-end pro digital SLRs (dSLR)
Half frame	24mm x 15mm	Semipro dSLRs
2/3 inch	8.8 x 6.6mm	Consumer-based dSLRs
1/1.8 inch	7.2 x 5.3mm	High-end 5–8MP point-and-shoots
1/2.7 inch	5.3 x 4.0mm	Low-end consumer-based cameras and high-end cell-phone cameras

Color Space

Another option in your camera's menu affecting your image is *color space*, which is also known as *standard color encodings*. The two main color spaces used in most digital SLRs today are sRGB and Adobe RGB (*RGB* stands for the primary colors red, blue, and green), and some high-end cameras offer more. Each color space establishes the gamut of colors available for viewing or reproduction in your image file and basically determines how much color each image will hold.

The least amount of color space is offered by sRGB, whereas Adobe RGB incorporates a slightly wider gamut. ProPhoto RGB, an option offered when opening a raw image file in software such as Photoshop, has the largest color space coverage.

One nice feature about shooting in raw is that the unprocessed image isn't locked into a specific color space, even though the setting in your camera may be, for example, Adobe RGB. But if your camera doesn't offer raw capture, or if you decide to shoot in JPEG format, your color space is determined by the setting in your camera—in which case, I'd set it to Adobe RGB.

Bit Depth

Color information in digital image files is also controlled through bit depth, usually 8-, 12-, 14-, and 16-bit, depending on the file format originally shot. As mentioned earlier, bit depth determines the number of tonal values to be recorded, with JPEG files recording at 8-bit and raw at 12- or 14-bit, with the ability to open at 16-bit. So as the bit depth increases, the amount of tonal values do so as well exponentially, as seen in this table. As with any area of digital photography, I recommend obtaining as much information as possible and, if necessary, removing it later. It's far better than recording less and then attempting to add information after the capture.

Bits	Tonal Values Available
8	256
12	4,096
14	16,384
16	65,536

Color Space and Exposure

Why is color space important to exposure? It's critical to obtain the most information in your original image in regard to highlights, shadows, lighting, and color. Quite simply, the more information contained in the file, the better the overall exposure will be.

Why would you want to figure out which color space to shoot in depending on the scene in front of you? My personal belief, and the way I shoot, is not to add this to my thought process when I'm photographing. Truthfully, I don't know if I could judge the color space from just any scene, especially when I'm dealing with so many other factors while trying to get a great shot. Instead, I set my camera to Adobe RGB, the widest gamut it offers, then shoot in raw, and, finally, open the file in ProPhoto RGB.

I don't believe you should potentially limit your images by choosing a small color space, such as sRGB, even with an image that has barely any color at all. In my experience, there's really no disadvantage to choosing the large color space, so why take the chance? If you have two sinks in front of you, one larger than the other, and you don't want to splash any water on the floor, you wouldn't choose the smaller sink, would you?

Just remember: ProPhoto RGB is best for printing, and Adobe RGB is best for viewing on monitors. In fact, sRGB was also created for monitor viewing, but Adobe RGB seems to be the standard these days.

EXIF Metadata

A wonderful feature of digital technology—as well as a great learning tool with exposures—is EXIF, or *Exchangeable Image File Format,* the most common type of metadata used in photography.

Metadata is a standard type of information embedded into each image file, listing the settings at which the photo was taken—in short, it's your own personal exposure assistant. Originally developed to standardize the exchange of data between imaging devices, EXIF metadata is now the universal format and as such is supported by almost all digital camera manufacturers.

EXIF metadata can be accessed through your camera menu, as well as via various imaging software, such as Adobe Elements or Photoshop, both of which allow you to see more specific information. Although this new technology virtually ends the day and age of photographers taking notes on their exposure settings, EXIF metadata does not record information such as filters used, direction you were facing, or any off-camera strobes (flash) that you may have decided to use.

EXAMPLES OF METADATA

The type of information recorded in each file varies by camera manufacturer and model and can include the following:

❏ **Date and time the photo was captured:** great for general referencing, and often noted down to the second.

❏ **Exposure:** Listing shutter speed, aperture, and ISO setting as well as exposure mode, metering mode, and exposure compensation.

❏ **Resolution and amount of compression:** Resolution is usually shown in pixels per inch, whether in raw, TIFF, or JPEG format.

❏ **Lens:** From prime or fixed focal length lenses, to specific millimeter setting in zoom lenses, the data records the lens used as well as the focusing mode (auto or manual).

❏ **Color information and White Balance settings.**

❏ **Orientation:** Recognizes if you took the picture in a horizontal *landscape* or a vertical *portrait* composition, and then opens the file accordingly.

❏ **Flash:** Tells you if your flash fired and whether a red-eye removal feature (which eliminates the red glare in a person's eyes) was utilized.

❏ **Camera information:** make and model, copyright or camera owner, and any additional data you can add, depending on your camera manufacturer's options.

Depending on the digital camera and imaging software you use, EXIF metadata information can be converted. For example, if you have a camera with an evaluative metering mode, the phrase *evaluative* can read as *matrix, pattern,* or *average* in your image software program. Your shutter speeds and *f*-stops can also be converted into numbers reading slightly differently.

Beware that you can also lose EXIF metadata if you open or save an image file in a software program that does not support the format.

> **TIP** FINDING YOUR METADATA IN ADOBE ELEMENTS
>
> In Adobe Elements, you can locate your metadata through File and File Info. Chapter 8 shares more information and tips on EXIF metadata and your digital workflow.

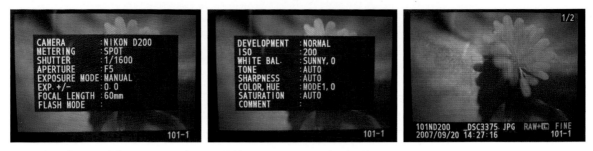

Examples of some of the EXIF metadata available in your camera's back LCD monitor.

When opening a file in Photoshop using the current version of EXIF metadata, go to the File menu and then into the File Info submenu to find your exposure information. This is usually located in two places, usually in "Camera Data 1" and "Advanced."

Your LCD Screen

The increase in popularity of digital cameras today is in large part due to the easy access you have, and instant gratification you get, reviewing images taken just seconds earlier. Unfortunately, digital doesn't offer you the skills and techniques for producing a better picture or even the intangible information for how you may have come to produce that image. Therefore, relying completely on your LCD (liquid crystal display) screen, also known as LCD monitor, for all of your exposures will not only give you a false sense of proper exposure but may also impede your progress toward improvement.

Most dSLR cameras have two LCD screens: the top LCD (also known as an EAE, or *electronic analog exposure,* display), usually in gray tone and displaying some exposure settings such as aperture, shutter speed, metering mode, exposure mode, and the space left in your memory card (how many shots are left before the card is full).

The back LCD monitor, usually larger and in color, gives you the option to review images taken, as well as some of the EXIF metadata, a detailed histogram (more on this soon), and other menu options and settings. Many photographers often make the mistake of relying on this back LCD screen to judge their exposure when in the field.

UNDERSTANDING ITS LIMITS

Most screens or monitors are referred to as TFT LCDs (*thin film transistor liquid crystal displays*). They currently range from 2 inches to 3.5 inches (measured diagonally) in most dSLR cameras, and hold roughly 230,000 pixels. Even though they're improving in quality and size every year, these miniscreens still lack the viewing power of a 19- or 20-inch computer monitor.

Comparing the image on my camera's LCD screen to that on my 20-inch computer monitor is like comparing the picture on a handheld 4-inch television to that on a high-definition 36-inch flat-screen TV. In other words, there is *no* comparison.

Highlights, shadow detail, subtle colors, and sharpness are just some of the elements that come to life when your image moves from your camera's LCD monitor to your computer monitor.

LCD Screens and Exposure

I'd guess that at least 90–95% of my students have trusted their LCD screens for exposure, and when I tell them they can't do this, most don't believe me until it's too late. ("Why *can't* I check my LCD screen?" they ask. "It's bright and colorful and the details seem pretty sharp.")

Even though, to your eyes, the LCD screen appears to show an accurate depiction of the scene you may have just captured, it's slightly misleading. The size of your image sensor is in fact much more important than the size or quality of your LCD screen—it's like buying a car based solely on the exterior, when of course the engine is what truly counts. Of course, that fact doesn't stop a lot of people from continuing to over-rely on the limited LCD screen (or buy flashy cars that end up being good-looking lemons).

LCD Screens: The Pros and Cons

The Pros: They're great to check framing, review moments, or scan facial expressions or reactions—like people blinking—and they even have the minor ability to check focus (but not tack sharp focus). **The Cons:** Don't depend on your LCD screen for exposures, especially when you're outdoors, where the external light and reflections make it tougher to see your image.

Judging the exposure of this subtly toned Blue Dawn flower wouldn't work on my camera's LCD screen, so I used the screen to check composition and trusted my experience to determine the exposure.

1/200 SEC. AT ƒ/3.5, ISO 100, 60MM MACRO F2.8 LENS, AT 90MM ON THE DIGITAL CAMERA BODY

TIP NEVER TOO LATE TO CALIBRATE

Make sure your computer monitor is calibrated to its best potential, or else you'll experience viewing problems and probably not understand why the image on the computer screen isn't much better than that on the LCD. It's something people don't often think of, but your monitor can, and should, like a scale, be properly calibrated, or else you won't be able to see the glorious transformation an image can make when its enlarged. This topic is covered in detail in chapter 8.

Making Sense of the Histogram

The histogram, a feature that's offered in many digital systems today, from point-and-shoot cameras to dSLR models, can be retrieved through your menu and viewed overlaying, or next to, your image as seen on the rear LCD screen. This graphic representation of an image's pixels can be a great supplemental tool for digital photographers and, when combined with your image on the LCD screen, can give you a decent amount of exposure information. But before you refer to your histogram for all of your exposures, you

An example of the histogram on the camera's back LCD monitor, overlaying the macro image of a flower.

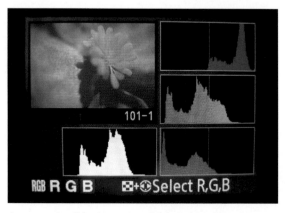

An example of the histogram displayed on the camera's back LCD monitor, separated by the layers that make up a color image: red, green, and blue.

should know that it's an advanced feature best used by experienced photographers. Although the histogram collects a wealth of information for each image taken, interpreting it is another story.

DYNAMIC RANGE

Created as a digital tool to illustrate the tonal range or brightness levels in your image—from bright highlights to even midtones to deep shadows—your histogram usually covers a five-stop dynamic range matching the tonal range of most image sensors in today's cameras.

Since the LCD screen doesn't give you the most accurate representation of your exposure, the histogram combined with the visual image onscreen, mixed in with your photographic knowledge, will help you determine if the highlights and shadows in the scene have fallen into the image sensor's range—that is, in accordance with the exposure setting you chose for that particular shot.

How does this work? Well, digital images are made up of numbers. The histogram is a graph made up of two axes of numbers representing exposure levels in a photograph. All histograms are the same: They range from 0 to 255—0 representing solid blacks or shadows, 128 corresponding to

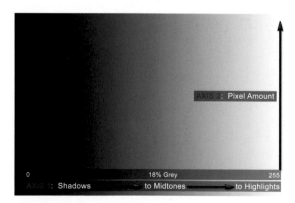

This chart illustrates the information recorded on a histogram along both axes.

middle tones or 18% gray, and 255 denoting solid white or the brightest highlights—as we travel left to right along the horizontal axis (Axis 1).

Axis 2, or the vertical axis, displays the amount of pixels (once again, in numbers), and the higher the level, the more saturation of pixels in that specific tonal area. Some cameras separate the histogram into three zones—shadows, midtones, and highlights—whereas other systems arrange these tonal ranges into five zones (to mimic the five-part range of stops in the image sensor). Depending on the color, contrast ratio, and tones within your scene, your histogram will display in a variety of ways. The histogram can also be accessed in post-capture editing programs such as Photoshop CS3 and Photoshop Elements. You can read more about this in chapter 8.

IMPROVING AND ADJUSTING EXPOSURE

It's not easy to know when to adjust or correct an exposure from simply reading your histogram. Years of experience generally come into play when a photographer chooses to use a histogram as his or her exposure marker, and even the most seasoned pros refer to this feature only occasionally. Most times, in attempting to expose a scene correctly, photographers determine tones using a meter, whether an incident meter or the camera's own reflective meter. (Metering is discussed in the next chapter.)

When I apply the histogram's graph to my photos, I *can* see how the results match the image on screen, but if I had to determine my exposure solely from the chart, I would only be able to do so because of the twenty-plus years of exposure knowledge I already have.

I often tell my beginning exposure students to ignore the LCD and histogram. Why? Because I can pull thousands of images from my files that clearly show "awful" histograms yet are well exposed. It is one of the reasons why some experienced pros say there is no such thing as a *bad* histogram.

Let's take the example of a *high-key* image, such as the sailing scene on the next page, which is called that because it's mostly made up of bright areas or white. While in the U.S. Virgin Islands, I photographed a sailing scene with models during a storm. Although I captured an appropriate exposure for what I wanted, the histogram butted up against the left side of the chart, making it look as if I overexposed the scene. Ignoring this fact, I went with my exposure experience, metered the fast-changing scene, and shot away. The storm light adjusted the exposure so fast I couldn't rely on looking down at a histogram to assist me— because by the time I did, the sailboat was in darker or brighter light anyway.

When you look at the histogram, you can see on the right side what appears to be a buildup of highlighting and *clipping,* a term referring to the loss of exposure information or detail as a result of being outside of the dynamic range of your image sensor. You may also see clipping as the small animations known as *blinkies* on your camera's histogram, telling you what is off the chart and overexposed. But once again, the overall exposure in the sailboat photo is correct in my book.

The flip side of the high-key image can be seen in the *low-key* photo example, a night reflection image of the town of Christiansted on St. Croix, with a similar result on the shadow side. Review the histogram of the photo, even with the red, green, and blue layers, and the image appears heavily underexposed. But it's a dark scene with a great deal of black in the frame—hence, the nature of the histogram's levels.

Which is why, in many explanations of histograms, you'll be told that it's up to the photographer to determine the amount of clipping, which is dependent on your subject and the scene. If this is the case, what's the use of a histogram if I shouldn't trust it for my exposures? You *can* trust it for exposures, but just not when you're starting out. I recommend learning about

other aspects of exposure first, such as the subtleties of light and understanding your meter better. Then, once you get a feel for exposure, using your histogram as a secondary "digital light meter" will work much better.

For me, I personally like histograms for any post work I may do. When I'm editing an image in Photoshop, histograms are excellent reference points to assist me on how close I come to clipping my highlights or shadow areas.

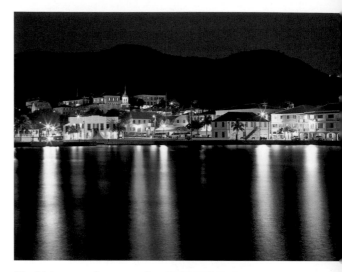

The histogram of a scene of Christiansted on St. Croix suggests the shot is underexposed, but the levels simply reflect the overall darkness.

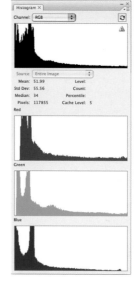

The light was changing every second, and as I rode in a zodiac boat alongside the sailboat, it was impossible to use a histogram check for the shot. Some may look at the white sail and feel it's overexposed (and the histogram indicated it was), but the skin tone of the models shows that it's not.
1/400 SEC. AT ƒ/5.6, ISO 100, 125MM MEDIUM-FORMAT F3.2 LENS

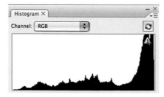

The histogram of the shot shows the abundance of highlights in the sailing scene.

Setting the Proper White Balance

A feature first introduced into digital cameras in recent years, White Balance (WB) is a welcome addition to photography, a function to fix various color shifts in photography depending on weather conditions, artificial light sources, or a combination of both.

The color shifts come from change in the balance of white light, which is controlled by three primary colors—red, green, and blue—the combination of which creates a neutral white. Whenever one hue is dominant over another, whether through atmospheric conditions or chemical compound results (such as sodium vapor lights, often used in urban areas), a shift occurs; sometimes it's aesthetically pleasing, such as a sunset, and sometimes it's not, such as tungsten lamps in homes.

Often controlled by filters in the past, or simply accepted as a limitation of film, color shifts can cause a variety of negative effects. Among other things, they can:

❏ mute skin tones when photographed in the blue light of shade or overcast

❏ turn office spaces green if illuminated by fluorescent lighting

❏ render home interiors orange from warm light sources such as candlelight or tungsten bulbs.

In photography, all light sources are known as having a certain color temperature, measured and placed into a Kelvin (K) temperature scale. Think of temperature not so much as *heat* but instead as a *color*. One problem that occurs with these shifts is how our eyes and minds tend to adapt and correct for them, making it more difficult to notice them. We tend to correct for shade and not notice the blue tones as much—or adjust for fluorescent bulbs, wondering why they aren't a pleasing source of light when some of the reason lies within its green tones.

The chart in effect gives a photographer an idea of how specific sources of light shift a certain direction. As you start to pay attention in these situations, you'll begin to notice changes through specific experiences, through tests, or just by visually comparing one against the other. As you do so, you'll learn how to implement White Balance in your arsenal of photographic choices to create better overall exposures.

Most cameras list a number of White Balance presets, depending on a variety of general conditions. If you know the situation you are photographing under fits into one of these presets, you can set the WB to it and watch the color corrections occur automatically from the non-WB to the WB shot.

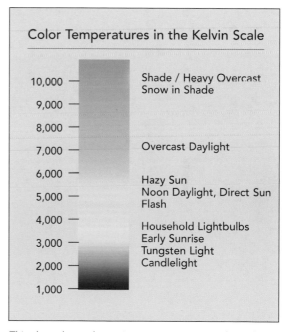

Color Temperatures in the Kelvin Scale

10,000	Shade / Heavy Overcast Snow in Shade
9,000	
8,000	
7,000	Overcast Daylight
6,000	
	Hazy Sun
5,000	Noon Daylight, Direct Sun Flash
4,000	
	Household Lightbulbs
3,000	Early Sunrise
	Tungsten Light
2,000	Candlelight
1,000	

This chart shows the various temperatures in the Kelvin scale, the colors they shift toward, and some of the lighting scenarios they fall under. White Balance produces opposite color shifts from these conditions to neutralize the original shift correcting the overall exposure.

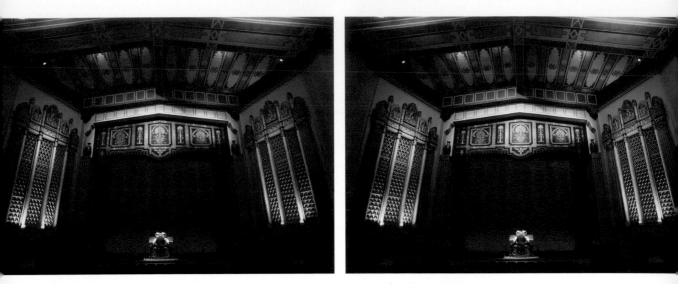

While photographing the interior of a theater, I shot the photo on the left with the White Balance set to Direct Sunlight, causing a strong yellow shift in the image. The WB of the photo on the right was set to Incandescent, correcting for the warm color temperature shift of light, most noticeable in the whites of the scene.

8 SEC. AT ƒ/5.6, ISO 100, 50MM MEDIUM-FORMAT WIDE-ANGLE LENS

Photographing on a heavily overcast day along the California coast caused a subtle blue shift in my image (left). By setting the WB to Cloudy (right), I was able to bring back the soft, warm rusty tones of the boat and surrounding grass.

1/13 SEC. AT ƒ/11, ISO 100, 20MM F2.8 LENS

General Menu Settings

General menu settings, which vary from camera to camera, include:

❏ **Auto:** Using a best-guess algorithm, Auto WB decides which color temperature to choose by measuring the light falling into the subject(s) in your scene.

❏ **Tungsten/Incandescent (3000K):** Used for warm shifts under incandescent light such as household lamps and candlelight.

❏ **Fluorescent (4000–4500K):** Set to correct for fluorescent lighting, but be aware that there are roughly six types of bulbs measured in different color temperatures (usually described on the bulbs).

❏ **Direct Sunlight (5000–5500K):** Most general conditions where direct sunlight is available, such as a blue-sky day. Best setting for shooting sunrises and sunsets to let the natural color change occur in your scene and not be corrected by WB.

❏ **Flash (5400K):** For use when you employ your flash for any scenes.

❏ **Cloudy (7500K):** For outdoor situations where the sun is blocked by clouds, such as overcast. Light overcast will be closer to 7500 degrees Kelvin, with heavy overcast leaning toward 9000 for the WB correction in overcast conditions).

❏ **Shade (10,000K):** Adjusting for the heavy blue shifts with subjects in ambient or indirect sunlight.

❏ **Choose Color Temperature:** A preset allowing you the choice of any specific color temperature, either to correct a shift or create a certain feel for an image, from 2500–10,000K.

❏ **White Balance Preset:** Allowing you to use a gray or white object as a reference from White Balance; probably the most accurate way of setting WB.

Q&A

Q: "Once I understand exposure, what happens to all my previous images that didn't have the correct White Balance?"
A: "As long as you shoot in raw, you're okay. In fact, I prefer shooting in Auto WB for one reason: Since I shoot in raw, and raw (unprocessed) files do not convert WB regardless of my settings—that's something only TIFF and JPEG formats do—for most lighting and color situations I can correct any potential color shift when I initially open the file in Photoshop. I can even batch process a number of images at once to correct the WB at the same time. But I only shoot in Auto WB if I'm referencing a gray card in the scene or if I have a natural and neutral gray reference from which to work.

When it comes to White Balance, the additional controls available in Photoshop are better than the choices in camera, so to me it's the one digital feature that's easy to correct post-capture (for more on this, see chapter 8).

HOW WHITE BALANCE AFFECTS EXPOSURE

In theory, White Balance is not supposed to affect exposure; it is merely meant to correct color shifts. But as colors change back to their respective hues with WB, it can appear to alter the exposure.

Why? Simply because exposures, brighter or darker, can change colors in your scenes (more on this later). A deep yellowish-orange, for example, can turn into a light yellow by lengthening the exposure or correcting the White Balance. When you adjust the White Balance, to the eye it may appear the exposure was longer (or brighter), but in effect only the color was corrected.

I haven't found a way—outside of checking the histogram—to monitor or control this when I expose a scene. If I wanted to, I could compare the WB corrected image on screen to the histogram, and that, along with experience, may help determine if the exposure is correct, but that's a bit much. In my opinion, trying to figure out how WB corrects a variety of situations and how these colors affect exposure ever so subtly is virtually impossible, and I'm someone with a solid understanding of color temperature, the histogram, and exposure.

A COMPARISON OF AUTO AND MANUAL WHITE BALANCE

Auto White Balance compared to manual White Balance is similar to shooting in an automatic exposure mode (such as Av, Tv, or Program) as compared to Manual mode: Sometimes Auto WB will correct the shift, but most of the time it will miss. So choosing to shoot in Manual is preferred, but don't try this until you get a handle on exposure. Throwing all this into the mix when there's already so much to think about with exposure can only make things tougher.

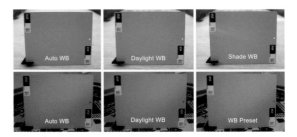

Comparing two scenes, left to right: The first scene was shot in shade using Auto WB, Daylight WB, and Shade WB. The second scene was shot indoors with tungsten lamps using Auto WB, Daylight WB, and WB preset using the gray card.

Early morning shade caused a heavy blue shift in this beach detail (near right) when my White Balance was set to Daylight (or Direct Sunlight). In the photo on the far right, I was able to correct for the color temperature shift by setting the White Balance to Shade, bringing back the neutral tones of the scene.

1/8 SEC. AT ƒ/16, ISO 100, 60MM MACRO LENS

TIP CORRECTING WB IN MANUAL

If your main reason for learning exposure is to cut down on your post-processing computer time, there's another accurate way—besides using the presets—to correct White Balance in Manual.

First, buy a WhiBal card from www.rawworkflow.com, which makes neutral gray cards in various sizes and tests each for accuracy. Using your WB preset, place the WhiBal card in front of your lens so that it fills most of your frame. Then press the shutter to set the White Balance: Your camera will measure the card using the available light and set this value for the WB preset. You can now shoot all your scenes using this WB preset, secure in the fact that you have an accurate correction—that is, until the light and/or color temperature changes in the scene!

Since digital cameras aren't necessarily precise at reading color temperature, there are separate meters you can buy, such as the Kenko KCM 3100, that perform this task more accurately. They can be used for color correction or light balancing in a variety of situations and give you less of a fudge factor when determining the color temperature for White Balance.

ASSIGNMENT Find and Shoot a Scene Using White Balance

White balance is a great tool to use in digital times: It can correct so many scenes affected by lighting, which can create color shifts in our images and change hues in negative ways. When you photograph on rainy, overcast, or cloudy days, your images lose warm tones from blue color temperature shift. By utilizing your WB settings while shooting under these conditions, you can quickly correct for this shift, bringing back the original hues of the scene.

If you wish to compare your WB settings, try shooting an image before (in Auto WB or Daylight) and after (set to Cloudy) if possible. Finally, understanding what type of information EXIF metadata records, including WB settings, make sure to note any important information not available in your image file (such as filter and time of day).

This spring scene would have lost all warm tones if it weren't for WB correction. The emerald green grass and muddy brown trail retained their original colors with my WB setting, while maintaining the cool tones in the stormy sky.
1/4 SEC. AT *f*/34, WIDE-ANGLE LENS WITH A THREE-STOP GRADUATED NEUTRAL DENSITY FILTER

Metering

RECOGNIZING AND UNDERSTANDING how your camera meter operates, how it wants to read various scenes, and how it can be fooled under a variety of circumstances are essential to good exposure. Once you come to understand metering, you can begin to control your exposures better.

While exploring the metering process, I'll discuss the range at which your image sensor (and film) can document highlights and shadows in a scene and begin to share ways on how to work within this range when in the field. Once you know how your camera meters a scene, the next function for you to grasp is metering modes, learning how the differences between each can drastically affect your exposures. These steps will not only help you understand the exposure parameters of your camera—as well as your image sensor's capability—but they'll also begin to offer you options and functions to choose under a variety of circumstances. This newfound knowledge will assist your judgment and decision making when metering for the optimal exposure.

Metering for the Best Exposure

In most cases, image sensors and film can't handle the wide range between highlights and shadows in one scene, so a photographer has to select the best exposure. This can be done by exposing for the subject, composing creatively to eliminate certain distracting areas, using tools such as filters (see chapter 4), or working with a flash or other artificial light (see chapter 7). Figuring out which method works best under what conditions takes time.

I'm sure it comes as no surprise to you that there's no perfect formula for exposing every shot. And, again, that's the beauty and challenge of photography: attempting to record what our minds envision, what our eyes may see, or what we want the viewer to focus on.

Our eyes have a range of seeing roughly twelve to fifteen stops of light in any given scene, while image sensors (or film) stay in the range of five to six stops of light (from highlight to shadow detail). With the advent of digital, many photographers are beginning to see a subtle stretch in the range of image sensors, but this still falls short of what the visible eye can see when in the field. It's one of the big reasons why, when you get your images processed or transferred to your computer, they just can't compare to what you saw when you were out there shooting. Before addressing the subject of how to meter a scene, I first must explain the differences between some meters as well as how your camera's meter measures a scene.

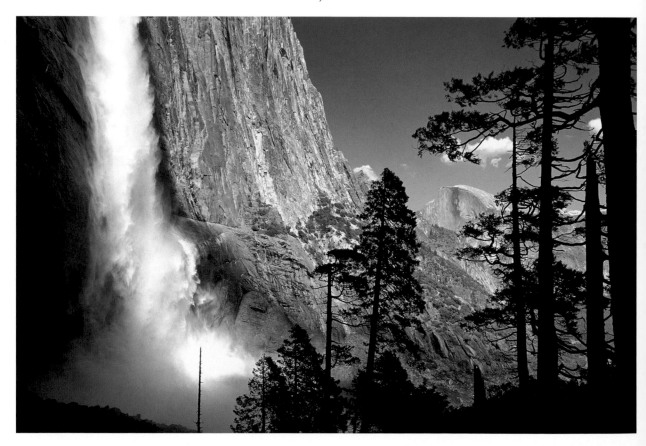

My eyes could see detail in the shadows while I was photographing this contrasty Las Vegas poolside scene, but knowing my image sensor couldn't cover the range between highlight and shadow, I decided to expose for the sunlight areas only. This gave me the chance to create a graphic scene using the light and drawing the viewer's eyes to my subjects.
1/500 SEC. AT ƒ/8, ISO 64, 115MM F2.8 LENS

◀ Documenting a dramatic scene such as this one taken in Yosemite National Park can be difficult. By understanding how my meter reads the highlights, shadows, and mid-range tones, I was able to navigate my way to a solid exposure within an image sensor's dynamic range.
1/15 SEC. AT ƒ/22, ISO 100, 24MM F2.8 LENS

The Differences between Incident and Reflective Metering

Light meters are devices that read luminance, or luminosity, converting the measurement into an exposure recommendation. I use the word *recommendation* because you don't necessarily have to shoot at the exposure setting determined by your light meter. In fact, to put it bluntly, your meter is often wrong, but you can still use it as a reference point from which to determine your exposure.

There are two types of light meters: reflective meters, like the ones in all 35mm camera systems (digital and film), and incident meters, which are often separate handheld meters. The difference between them is critical, as both read light very differently. But despite the fact that incident and reflective meters *read* light differently, remember that both attempt to produce the exact same tone when they *measure* light, a tone often referred to as middle gray (see page 75).

DEFINING EACH METHOD OF METERING

Reflective meters (like the one inside your camera) read the light that reflects or bounces off of your subject—for instance, a gray card, a face, a landscape, a building, or the moon. I mention these examples since with this type of meter you don't have to be next to your subject, allowing you to meter objects far away (as seen in the diagram below).

Incident meters (handheld types) read the light that falls onto your subject. What you do is hold the meter next to your subject facing the light, or in the same light your subject is in, to read and measure the light falling onto it. Incident meters are great in many ways, but a disadvantage with them is that they must be held in the same light as the subject, which isn't always possible when shooting pictures. Some incident meters can also measure flash or strobe lighting, which is why most studio photographers own them.

To reiterate the differences between the two types of meters, one detects the light after it falls on your subject (reflecting), while the other reads it before it strikes the subject (incident). So if you were photographing a window on a building that was reflecting sunlight, a reflective meter would

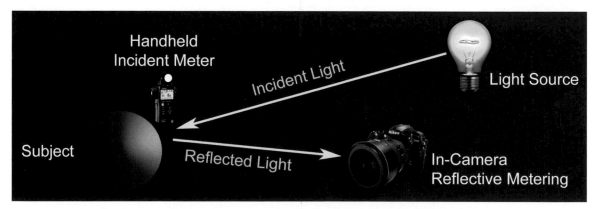

This diagram illustrates both types of meters and how they read light. The incident meter reads light directly falling onto the subject, while a reflective meter reads the light reflecting off of the subject and into the camera.

read the actual sun reflecting off of the windows (as shown in the photo below), whereas an incident meter would read the light falling onto the window and building (if you could get close to the building, or at least in the same light). Which is the better method to use all depends on how you shoot.

CHOOSING THE BEST METHOD FOR YOU

I do own a handheld flash/incident light meter, an older Sekonic L-508 with reflective spot, flash, and incident-metering capability. I use it for specific situations such as when I shoot with my medium-format camera—since it doesn't have an

My incident meter is an older Sekonic L-508, and here it's measuring the light and displaying it on the LCD screen, which shows 1/250 second, at ƒ/4.07 (basically, ƒ/5), using ISO 100. This model also has reflective spot and flash metering capability.

Using my reflective meter, I was able to meter this San Diego building detail correctly, even though the sunlight reflecting off of the windows could have fooled my meter. This scene also replicates the range of light your image sensor covers, from white without detail to black without detail and every tone in between.
1/800 SEC. AT ƒ/8, ISO 100, 300MM F2.8 LENS

internal meter—as well as for advertising and corporate photo shoots, where I create lighting setups using multiple strobes and need to meter the power of each strobe.

Some photographers prefer to carry separate meters, believing that incident meters are more accurate because they read the actual light as opposed to the reflected light on their subject. Certainly they can be more precise for shots, including those requiring flash (strobes) or capturing dark- and light-toned subjects that can normally fool a reflective meter. But incident meters have to be in the same light as your subject and can give inaccurate readings themselves depending on the mood you're going for or the direction you're pointing them when taking the reading. They also add an extra step—and an unnecessary one if you learn how to operate your reflective meter correctly.

I still prefer my built-in reflective meter for most circumstances I come across while taking pictures, so unless you're advanced in your understanding of exposures and photography in general, there's no need to work with a separate light meter when starting off. Keep it simple for now, especially when there are so many other variables to deal with regarding exposure.

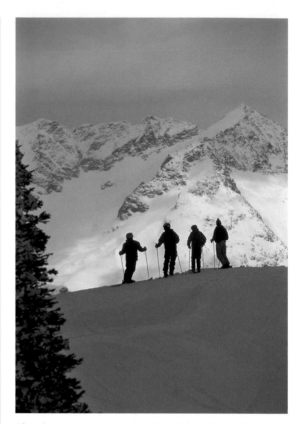

This skiing scene in British Columbia could only be metered using reflective metering, since it gave me the ability to read the sunlight on the distant mountain. An incident meter, on the other hand, would have only been able to read the light I was standing in, which was shade. 1/250 SEC. AT ƒ/8, ISO 100, 80–200MM F2.8 LENS, AT 200MM

The Final Word on Internal vs. Incident Meters

If you already own a camera with an internal reflective meter, start off learning this type of metering first. If, over time, you find that an incident meter is something you want to include in your stockpile of equipment, then you can move forward and get one. Outside of some sections in chapter 7 that cover flash, I mainly refer to reflective metering throughout this book.

TIP METERING AND SHOOTING IN 35MM

In the case of shooting in 35mm, I've used my internal reflective meter for 99% of my shots—and that includes when I'm shooting with my current digital 35mm SLR. To me, it's an easier method of metering and means there's one less piece of equipment to carry around. Not to mention that it covers most lighting scenarios I encounter anywhere in the world.

How Your Camera's Meter Works

In my workshops I teach various levels of photographers, from beginning to self-professed advanced. But all of them, even those who've been shooting as far back as the 1950s, almost unanimously admit they rarely utilize their camera meters or understand how to expose a scene.

But that's okay, and understandable. So many recreational photographers just haven't been shown the ways and options available to control various aspects of a scene. If they do get a shot with a good exposure, it's either through *bracketing* (photographing a few different exposures on one scene), guessing, or using an automatic setting on their camera and simply getting lucky.

If you choose an automatic exposure setting (such as Aperture Priority or Program) and compose a shot, you may never find out all the ways you could change and alter the image through metering. And as I stated at the start of this chapter, this is the reason why I feel this section is one of the most important in this book, since it's so important to know how your camera meter operates and to understand the concept of middle gray.

UNDERSTANDING MIDDLE GRAY

Obtaining middle gray tones is the main goal of all meters, whether your camera's internal reflective meter or a handheld incident meter. They're all programmed to recommend an exposure setting resulting in a middle gray tone for every subject (with reflective meters) or for all strengths of light (with incident meters) they read.

Middle gray is defined as a tone halfway between white and black. Ansel Adams referred to this as Zone V, but it's also called middle toned or 18% gray, the latter an ink-density tone originally used to standardize the printing industry. Find a scene or subject that's 18% or middle gray—whether it's the actual color gray or another color with a middle-value tone, such as sky blue or tan brown—and your camera's meter wouldn't have much of a problem exposing it correctly.

The difference between how each type of meter reads middle gray is this:

❏ **Reflective meters** try to make every subject they point at middle gray in tone, from bright snow to middle skin tones to dark green pine trees. Capture all of these subjects using a reflective meter, trusting the setting it comes up with, and if the subject isn't middle gray in tone your exposure will be wrong: White snow will look middle gray, and shaded pine trees will appear brighter than they should be.

❏ **Incident meters** will read all light and average the measurement to middle gray, allowing you to expose all tonal ranges of subjects without influence from them—but, again, remember that you must be in the same light as your subject. And if you are, this doesn't mean incident-meter readings will always be correct. One concern is determining your exposure depending on what your incident meter was measuring.

WHERE METERS FAIL

Problem areas where meters fail usually have to do with light tones and whites as well as dark tones, shadows, and blacks—basically, anything

This diagram illustrates an example of middle gray (listed as 18% gray) and where it sits between shadow and highlight detail.

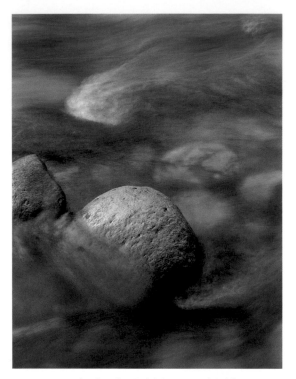

A granite riverbed in the Gold Country of California produced a scene with a great deal of middle tones, not a difficult exposure for your reflective meter to handle.
1/4 SEC., AT ƒ/32, ISO 100, MEDIUM-FORMAT 125MM F3.2 LENS

brighter or darker than 18% gray. Because all reflective meters measure light and average it to this middle gray, they tend to overexpose dark-toned subjects, because they want to expose them longer and make them brighter, thus changing their true darker tone to middle gray. They do the same with lighter-toned subjects: underexposing them by shortening the exposure, adjusting their true light tone to middle gray.

> **TIP AN ASIDE ON GRAY CARDS**
>
> Some photographers like to carry gray cards to use as references when working with reflective meters. Holding the card next to your subject to measure the reflected light allows the meter to read the available light without being fooled by the tone of the subject. But you must be able to hold the card next to your subject or in the same light, which isn't necessarily always available to you. Gray cards are also cumbersome items to carry around, and in the past I've rarely used one in the field. But today, if I happen to be using a WhiBal card to check White Balance, the same gray card can measure the light as well.

Photographing snow with your reflective meter always causes problems. In the photo near right, I show the example of trusting your meter, which wants to make every area it reads middle gray. In the photo far right, I've corrected for this by brightening the exposure 1⅓ stops.
LEFT: 1/2000 SEC. AT ƒ/2.8, ISO 100,
80–200MM F2.8 LENS, AT 200MM
RIGHT: 1/800 AT ƒ/2.8, ISO 100,
80–200MM F2.8 LENS, AT 200MM

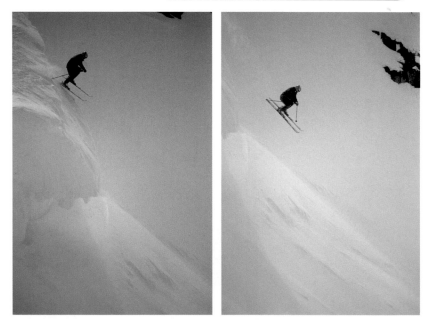

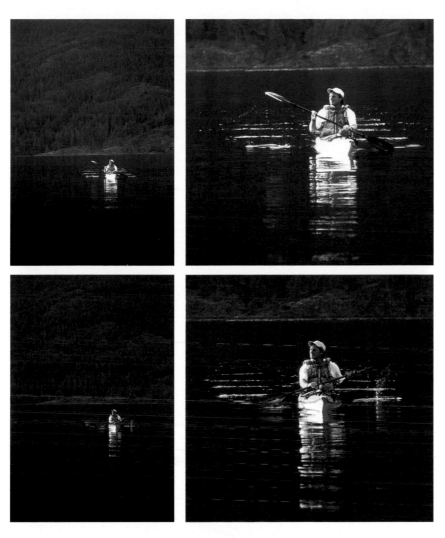

If we use an incident meter and measure the light on the shaded part of our kayaker, we will have overexposed the sunlit side as well as the entire scene.

1/200 SEC. AT ƒ/4, ISO 100, 80–200MM F2.8 LENS, AT 100MM

If we meter the sunlit side of our subject and expose for this setting as shown here, however, our subject is now correctly exposed, as are the surrounding areas for this particular scene.

1/500 SEC. AT ƒ/4, ISO 100, 80–200MM F2.8 LENS, AT 100MM

Middle Gray: Tonal Value, NOT Color

It's important to understand that when I'm talking about middle gray in tone, I'm referring to tonal value and not color. When discussing meters, middle gray can come in the form of a gray door, medium-colored brown bark, a pair of slightly faded blue jeans, an orange leaf, or a Caucasian person's tan face. To the meter the color isn't the issue, only the density (or tonal value) of the subject. When you compose a photo consisting primarily of middle-toned values (such as the riverbed on the previous page), the meter will not be fooled as much (hence you'll get a decent exposure), since middle tones are what the meter is trying to obtain. However, most tones don't fall into this middle gray setting.

Capturing rock climbing at sunrise in the Buttermilks of California provided me with a fairly easy image to meter. Although these boulders weren't gray in color, their tone was close to middle gray, so I trusted my meter's recommendation for the scene—and it worked.
1/400 SEC. AT ƒ/5.6, ISO 100, MEDIUM-FORMAT 125MM F3.2 LENS

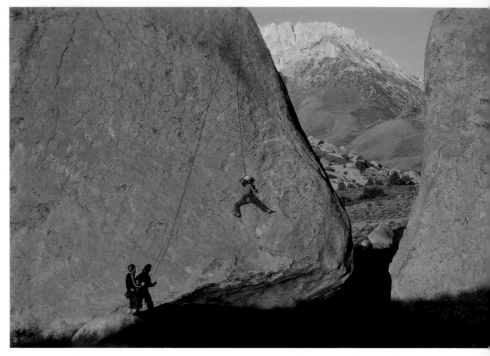

ADJUSTING EXPOSURE COMPENSATION (EC)

Exposure compensation (EC), covered in detail in chapter 1, is a way to correct the recommended exposure when the framed scene fools the meter. EC is mostly used in auto exposure modes (Av, Tv, Program), which don't allow you to adjust your exposure from the meter's recommendation (you *can* adjust the setting, but the exposure will always follow the meter and go for middle gray).

If you meter a scene with snow in Av, and the meter sets an exposure for ƒ/4 at 1/500 sec., it doesn't matter if you adjust this to ƒ/5.6 at 1/250—the exposure will still be underexposed since the meter was initially fooled by the bright subject. By understanding this, you can then set the EC to overexpose this snowy scene from the meter reading—how much is up to you—the result giving you a better exposure.

This isn't a bad way to start off, since it lets you learn about your meter as well as exposure without having to think about too many things at once. As you progress, you can then move to Manual to control more aspects of the exposure. Once you're shooting in Manual exposure mode, there really isn't any reason to use EC since you can make exposure adjustments on your own.

Here my exposure compensation button has been adjusted to –1, to underexpose the metered scene by one stop.

All barks aren't created (or metered) equally. Since subjects like tree bark range in tone, adjusting your middle-gray-minded meter is critical to solid exposures. Their exposure settings (ISO, f-stop, shutter speed) aren't as important as recognizing every tree's tonal value when compared to middle gray. I photographed four different tree barks at four separate national parks, each containing a different tonal value. If I had trusted my meter, most photos would have been incorrectly exposed. Instead, I took the meter's recommended exposure setting and determined if the bark I was photographing was brighter than middle gray (top left), middle gray exactly (top right), or slightly darker (bottom left) or much darker (bottom right) than middle gray. By overexposing (top left) or underexposing (bottom left and right) from the meter's recommendation, I was able to come up with a realistic tone for each bark.

The Range of Exposure

A subject mentioned in chapter 2 (in the histogram section) as well as earlier in this chapter when I compared our eyes to our image sensors or film, the *range of exposure* is determined by a few factors. The first is the dynamic range—that is, how wide a range of light, in stops, from highlights to shadow areas, your image sensor or film can cover. Once you know this, you can understand the parameters that you can work within for all scenes. You can also read this as tonal values from light to dark or white without detail to black without detail.

The second is the type of lighting you're working in and the contrast ratio of this lighting, an area that I expand on in chapter 5. The third deals with the information contained in your image file or film and extracting this information through post-capture methods such as darkroom dodging and burning or the new digital darkroom methods in Photoshop. All these factors help determine how much detail and information you can document within any given scene.

WORKING WITH STOPS OF LIGHT

As I explained in chapter 1, a stop is a unit of exposure defined as the relative change in the brightness of light. A one-stop change in light either cuts the amount entering the camera in half or doubles it. This can occur through the change in your settings (for example, 1/500 to 1/250 doubles the amount of light) or through a change in light (the sun disappearing behind a cloud, cutting the light in half or dropping the exposure by one stop).

When dealing with stops in relation to exposure settings, you first want to find out what your camera is set to in regard to EV steps (most systems work in 1/3-stop, 1/2-stop, or 1-stop increments). By identifying the EV step you are in, you can quickly determine how many stops you are moving for each click of your *f*-stop or shutter dial. For instance, if my camera is set to 1/3 EV stops, then three clicks of my shutter or aperture dial moves one stop.

By learning *f*-stop and shutter speed numbers, you can begin to do the math in your head, knowing how many stops you've changed your initial setting. If I've changed my aperture from *f*/4 to *f*/16, I know I've moved four stops; jump from 1/1000 sec. to 1/30 sec., and I've moved five stops.

Another important feature in your camera is the exposure display or exposure level, often found in your viewfinder or in the top LCD display. This is seen as a series of notches with a "+," "0," and "–" going from left to right, although some cameras place these symbols with the "–" on the left and "+" on the right. When set to 0, this is the meter's recommended exposure for the scene it's reading. All auto exposure modes shoot at 0.

When you dial the notches toward the "+" symbol, you are overexposing from your meter's recommendation. When you dial the notches toward the "–" symbol, you are underexposing from your meter's recommendation. Whenever I buy a camera, I prefer to have two stops on either side of 0, or middle gray, giving me a wider tonal range to meter and reference in a scene.

> **TIP** **A NOTE ON LENSES**
>
> Another aspect to consider when purchasing equipment and referencing stops is lenses. The price of a lens often depends on its speed. Lenses are sometimes referred to as "fast" or "slow," corresponding to their maximum aperture. The wider the aperture, the lower the *f*-stop number, and the faster—and more expensive—the lens. An F2.8 maximum aperture telephoto lens will not only allow you to see better through it, and capture less depth of field, but in comparison to an F5.6 lens, its additional two stops can give you a much faster exposure.

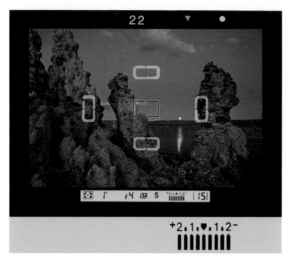

This image shows exposure displays in half stops in your viewfinder, enlarged at the bottom. Notice there are two notches between each stop—hence, half-stop increments.

Here we see exposure display in stops on my top LCD display. Notice the round notches between the rectangular notches indicating 1/3 stops—the longer notches below are six per stop to either work for 1/2-stop or 1/3-stop EV steps.

THE LATITUDE FROM HIGHLIGHT TO SHADOW

The next step in working with stops of light is becoming familiar with the dynamic range from highlight to shadow. The only way to determine the difference in brightness from highlight to shadow (or white with detail to black with detail) is by measuring the light, and in photography this is often accomplished by using stops. In the past when film was used, the brightest highlights to the deepest shadows usually gave photographers a range of five to six stops, depending on the type of film they were working with (whether transparency slide, negative, black and white, and so on).

With the introduction and improvements in image sensors, this range has stretched a bit, providing roughly 5½ to 7 stops of light—but this is still limited when compared to our vision. In chapter 8, I'll show you how we can stretch this in post-capture, but for now, understand that any information outside of this 5½- to 7-stop range will be lost, whether becoming black or white without detail. For the most part, black with detail is usually two stops underexposed from middle gray, while white with detail is typically two stops over middle gray. Take a half stop further on either side of limited information and you have your five-stop range between highlight and shadow.

A misapprehension many of my exposure students have is that they should be able to capture all information from the brightest highlights to the deepest shadows, but for most scenes this is just not possible. Given the limitations of an image sensor, a photographer has to decide what the best exposure would be under the specific circumstances.

So the next time you meter the sunset and it reads f/16 at 1/1000, and then you meter the ground in front of you getting a reading of f/16 at 1/8, you'll know why this seven-stop difference either produces a nice sunset with a black, detail-less foreground or a well-exposed foreground with an overexposed, washed-out sunset. This is similar to the photo of the rock climbers on page 78,

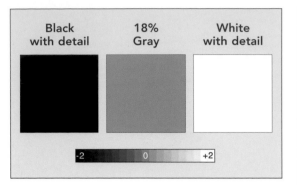

This diagram includes a bar illustrating the range of your image sensor (from black or white with detail to middle gray to white with detail). The bar gives you an idea, in value or tone, of the difference in "stops of light" from middle gray to white with detail (two stops overexposing from middle gray) to black with detail (two stops underexposing from middle gray).

where I lost information in the shade in the lower part of the frame, since the range of light went outside of my image sensor's dynamic range. Or in the landscape on page 70, where I lost detail in the silhouetted trees, and the poolside scene on page 71, where most shadow information was lost as well. Regardless, all of these scenes work because my main subject held the correct tonal value.

FINDING TONAL VALUES IN THE REAL WORLD

When you're learning how to expose and using a reflective meter, how you determine tone becomes crucial. Since we weren't raised to look at the world in tonal values, manually metering a scene can be a tough task at the start of anyone's exposure education. Deciding what matches a middle gray tone in various subjects with varying colors is not easy. And if you can't find a middle gray tone in your scene, searching out a tone darker or lighter than middle gray that you can accurately meter is just as difficult. It can often take years to hone your skills and become aware of how to meter certain subjects and ascertain into which tonal range they truly fall.

As I photographed more and more, I began to notice a consistency when finding certain tonal values. Shooting specific subjects over and over, such as the sky, and analyzing my exposure mistakes or successes, I was able to recognize where to look for specific tones. Capturing people more and more, I noticed similar skin tones and became acutely aware when one was lighter or darker than middle gray, which gave me a good start to exposing the person correctly. I began to see how capturing the front-lit grass gave me one tone, backlit gave me another, and the same grass in overcast conditions produced three tones (see the photo opposite). Exposing the tones of deep forest pines in sunlight differed from exposing the same forest in stormy light. Our eyes and minds tend to correct so much for light that you must force yourself to think in tones.

PERFECT VS. CORRECT EXPOSURES

Given the multitude of photographic conditions, it's impossible to squeeze all scenarios into a predetermined set of parameters using mathematical measurements or standardized lists—such as exposure values—and then, from these measurements, allow your camera to set the exposure it deems correct. Light can fluctuate every second, exposures can change at every direction, and your meter can't even determine correct tones in the first place.

> **TIP** THE SQUINT TEST
>
> Another way of distinguishing tones is through the squint test. Take two opposing colors, such as red and blue. At first they may seem to have similar tones, but when you squint, they might look exactly the same. The squint test also works for contrast, which, when determining tonal value from highlights to shadows, is just as important since it helps you see them better. I expand on various tonal values throughout the real world in chapter 6.

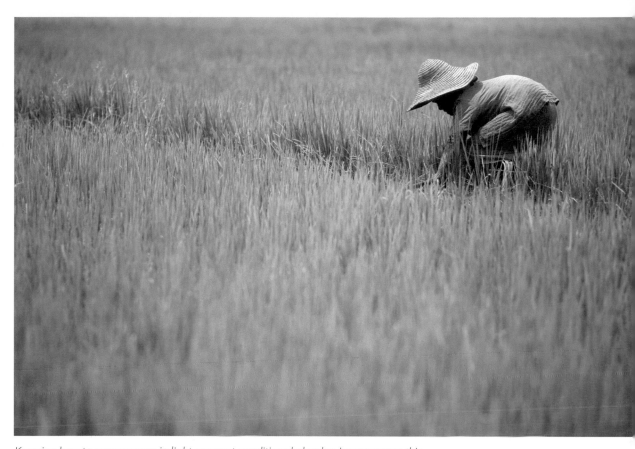

Knowing how to expose grass in light overcast conditions helped as I came across this scene traveling through the highlands of Borneo. I was able to use the rice fields as a marker, slightly darker than middle gray, to determine the exposure I desired.
1/500 SEC. AT ƒ/4, ISO 100, 300MM F4 LENS

Even if we used this method of static measurements and parameters, and could produce a technically correct exposure, creating a scene with a great histogram and keeping all of the highlight and shadow detail intact, would it even be what we desired? Maybe the exposure is dead on and might represent the original scene, but is the image compelling? My point is that although exposure involves many technical elements, its main goal is to allow you to be more creative with your imagery. As an art form, photography has never been about the correct exposures but rather about capturing perfect exposures for the context

of the scene and in accordance with the intent of the photographer. The difference is that, conceptually speaking, there really isn't any correct exposure—it's truly, and simply, what the artist or photographer wants to create.

That being said, you definitely need to have the knowledge of and experience in controlling exposure. But once you do, the great thing about understanding it is being able to manipulate a scene to capture it the way you wish. A perfect exposure may or may not produce tones realistic to the original scene, yet neither is wrong or right. What matters is what works best to convey your message.

An Example of My Perfect Exposure

This rock-climbing shot is an example of my creating an image that best gets my message across. Anyone could say that if they took a meter reading of the light, the correct exposure might be brighter, or possibly the early morning, bright eastern sky was not this tone of blue or that detail could be seen in the climber and surrounding rocks to the naked eye. But I wanted to underexpose the climber, deepen the sky, and create something dramatic. To me, this was the perfect exposure, although a brighter exposure might have been technically correct.

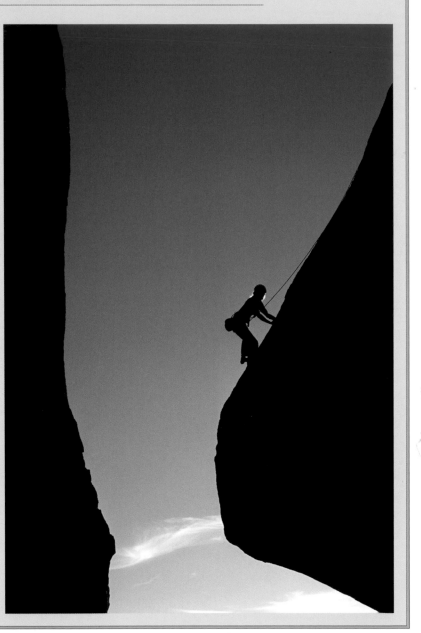

I knew what I wanted to expose for this shot before I even walked into the shade of the rock. Going for shape and form instead of a technically correct exposure helped me produce this dramatic climbing scene.
1/125 SEC. AT ƒ/16, ISO 100, 35MM F2.8 LENS

Choosing Metering Modes

The last part in understanding how your reflective meter works is knowing what areas your meter is reading within the frame. As described in chapter 1, exposure modes set exposures based on what the metering mode reads and recommends for any particular scene. All metering modes are not the same, and identifying how each reacts, depending on the scenario, will help you move closer to grasping the subtleties of exposure.

Your camera may or may not have every mode listed. Many have variations of these modes, and some models only offer certain ones (such as spot metering) in higher-end systems. But what follow are the main metering modes used by the majority of camera manufacturers. In the past all we had was one metering mode, center-weighted. Today, these different modes are designed to be able to sense the light in a scene in different ways. Which mode is used depends on the type of subject you're shooting and how the light is striking it.

PARTIAL

Reading 8 to10% of the viewfinder, partial metering assigns the greatest weight to the center of the frame to determine an exposure setting. Some choose this metering mode for backlit subjects, since background light has less influence on the small center area. Another circumstance where partial metering can work is if you have a middle-toned subject that takes up this general center area of the frame .

CENTER-WEIGHTED

Similar to partial metering, center-weighted (CW) metering covers a slightly larger middle area of the scene. The main type of metering mode used in cameras for years, CW reads the light from the entire composition but gives extra weight, priority, or importance to the center (roughly 13 to 15%, varying with some camera manufacturers).

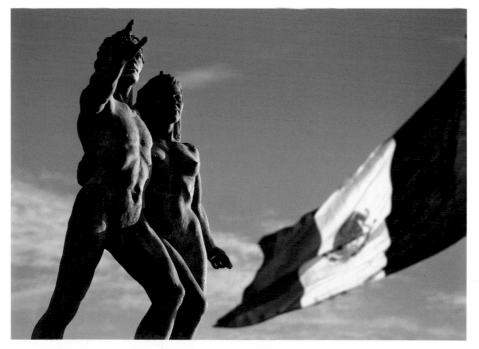

Using partial or center-weighted metering produced a solid exposure of this Mexican scene since the center area was close to a middle gray tonal value.
1/400 SEC. AT *f*/5.6, MEDIUM-FORMAT 125MM F3.2 LENS

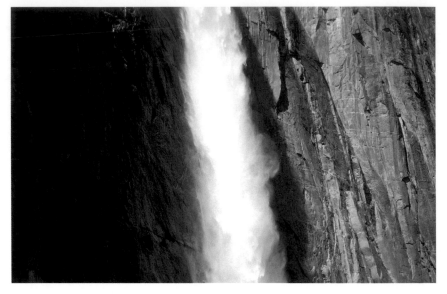

Although this detail of Yosemite Falls was contrasty, my center-weighted meter still gave me an accurate exposure, balancing the highlights, shadows, and middle tones without being overly dominated by any one of the three.

1/500 SEC. AT ƒ/6.3, 300MM F4 TELEPHOTO LENS

This mode is good for a variety of uses where the subject is relatively large in the frame, such as portraits, or where there aren't major sways in tones one way or another. On occasion CW mode can take a contrasty scene, and if the differences in light and dark tones are somewhat balanced, it can average them out enough to give you a decent exposure. However, center-weighted metering assumes that your subject is in the center—and when we consider composition in our images, this isn't necessarily the ideal situation to create an interesting image.

I once considered CW, the oldest of modes, the most inaccurate of the bunch, but as I've conducted exposure workshops over the years, and tested each mode against the other, I've come to the conclusion that there truly isn't an accurate or inaccurate mode; it all depends on the scene being metered.

SPOT

Spot metering is my favorite mode of metering for almost any scene, and it's usually the default mode on my camera. But it's not easy to use when you're starting out, and you have to make a few informed decisions, based on the information provided by the mode, to meter a scene correctly.

Analogous to center-weighed and partial modes but much more exact, the spot metering mode reads the light from only a small section in the center of the frame, usually 1 to 5% in most cameras (Canon, for example, spot metering 3.5% of the frame, Nikon using 2%). This precise metering gives you the chance to read small sections of a scene. If the area at dead center in your frame is middle gray in tone, then using spot can give you a good starting point for an exposure— but, having said that, I don't use it this way. Instead, I utilize spot metering not to read the small section of the center of my shot but to meter numerous spots around the scene and various tones, and then I decide what to set my exposure to in Manual exposure mode.

Spot metering is great for contrasty scenes, for shooting into the sun, and, if used the way I've recommended, for other extreme scenarios. But it's not for neophytes, since it takes extra thought for each image and on occasion difficult calculations to determine some exposures. And it can require additional knowledge of lighting and tones in the real world, something familiar to advanced, not beginning, shooters.

Spot metering many areas of this scene allowed me to pick the best exposure for the shot. I took readings from the ocean, the sunset sky, the clouds, and the cliffs. Once I determined what was most important for the scene regarding tone and detail—which in this case was the separation of the bridge against the cliffs without losing color in the sky and water—I set my exposure. By selecting specific areas within the scene, I was able to get accurate readings without interference from another area or tone.
1/250 SEC. AT ƒ/8, ISO 200, 80–200MM F2.8 LENS, AT 150MM

EVALUATIVE, MATRIX, AVERAGE, PATTERN, AND MULTI

Developed by Nikon (which uses the term *matrix*) and Canon (which employs *evaluative*) and given different names by others (including EXIF metadata), this metering mode uses the light intensity in several points around the frame, favoring no major portion of your composition and averaging these measurements for the final suggested exposure setting. More expensive cameras generally measure more points, and how each measurement is combined varies from camera to camera.

Matrix metering is considered the most accurate method of determining exposure for most scenarios. This is because it involves several readings within a scene and, unlike other metering modes, is not as heavily influenced by bright or dark sections.

In general, this mode gives you solid results under a broad range of conditions, can result in more properly exposed scenes than most other metering modes, and allows you to let the camera determine the exposure more so than you. But even this approach can't provide perfect results

While photographing a bicycling event—from a moving car, no less—where the participants were coming out of dark forested areas into bright sunlight every few seconds, and where backgrounds would change in an instant, evaluative or matrix metering was the best choice of modes. The quick movement combined with the change in light just didn't allow me to meter every scene, so instead I trusted my metering mode to average each the best it could. I didn't get perfect exposures every time, but the results were close enough, and in a case where I wouldn't have been able to change my exposure any faster, it worked.
1/60 SEC. AT ƒ/18, ISO 100, 24MM F2.8 LENS

every time. The contrast in a scene may be too strong to achieve the ideal exposure in all parts of a photo if left for the meter to determine. In some instances you may *want* to under- or overexpose a scene from the meter's recommendation. This might be the case with snow or an image consisting of all dark tones. There have even been the odd times when matrix metering produced the worst exposure of the modes, but this is pretty rare. I prefer to use evaluative metering in places where I can't change my exposure fast enough, either due to a fast-moving subject or the need to

move my camera across several lighting situations in a short period.

> **TIP EVALUATIVE MODE TIPS**
>
> When using manual focus, most evaluative metering modes base the exposure reference on the center focus point. If you are using auto focus (AF), the evaluative mode can start from any number of focus points chosen by the photographer, which is anywhere from three to eleven points, depending on the camera model.

USING AUTO EXPOSURE LOCK

Great for automatic exposure modes (Av, P, Tv), auto exposure lock (AE lock) allows you to pick a place in your scene for your meter to read and then enables you to lock in the setting while you reframe or recompose your shot. This gives you the flexibility of working fast while not having to meter each scene, and it also gives you the best result—that is, the composition you desire.

Some love it, some never use it—but it's a nice option. You can make it simple by attempting to find a middle gray tone in each frame you shoot, meter that tone, lock it in, and fire away. Of course, this only works if you're able to find an 18% gray tone.

You also have the option of getting more complicated by using your exposure compensation (EC) in line with your AE lock. For example, if you're shooting in snow with white all around you and don't have the luxury of finding a middle gray tone, you can set your EC to overexpose by 1½ to 2 stops, meter the white snow, and shoot away. Now you know your EC will correct the underexposed snow, initially fooled by the meter's propensity for creating middle gray tones.

I do use AE lock in my little point-and-shoot camera when I'm taking fun family shots and not paying too much attention to exposure. But I rarely use it in my dSLR, preferring instead to meter each scene for the best possible exposure.

ASSIGNMENT **Capture the Same Scene Using All of Your Available Metering Modes**

Find one scene to document—ideally, one with some contrast or change in tonal values—and shoot three frames in an automatic exposure mode (Av, Tv, or Program), changing the metering mode with each shot (matrix to center-weighted to spot, or the modes you have). Then attempt to capture the same scene in Manual exposure mode using your favorite metering mode, choosing the exposure you feel is best. For your Manual shot, try not to look at your LCD screen between shots and consider adjusting your exposure from the meter's recommendation. Then compare the results in the computer.

When you shoot this assignment, keep track of what shot was taken with which metering mode, since EXIF metadata can change the names of the metering modes in post-capture editing software. As with any digital images, you can find most, but not all, of your exposure settings through the metadata (which doesn't include filter, direction, and location).

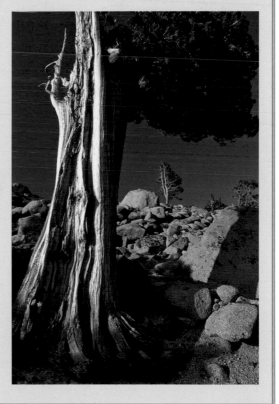

The side lighting and contrast in the landscape would have produced drastically different exposures from spot metering to partial to evaluative. I set my camera on a tripod and chose to spot meter the scene.
1/15 SEC. AT ƒ/22, ISO 100, 24MM F28 WIDE-ANGLE LENS AND POLARIZER FILTER

Creative Techniques

YOU SHOULD NOW HAVE a general understanding of metering modes, exposure modes, f-stops, and shutter speeds. But learning the decision-making process of exposure takes practice, play, and more practice—and then you have to analyze your inevitable mistakes. On occasion, you'll find technically correct exposures that aren't necessarily the best at creating the mood or feel you were hoping to achieve. Another potential pitfall is obtaining a solid exposure—only to discover afterward that your settings still didn't give the visual effect you wanted.

This is where the *art* of exposure comes into play. In this chapter, I offer a few more tools to help convey moods through exposure by tapping into the spectrum of *equivalent exposures.* I also explain how filters can assist you in the field.

But you should know that these additional tools don't guarantee solid exposures, and if they're used in an improper way they could result in the exact opposite—that is, a worse exposure than you may have started with. But, as with any art, it takes time and experience to find the best uses for each instrument, so be patient and forge ahead. If you do, you will slowly but surely move toward creating the type of quality work you crave.

Creating the Exposure You Want

When someone is analyzing one of my images, I often get the question, "Did it look like that when you were standing there taking the photo?" My style of work is often geared toward realistic-looking scenes, and for the most part the images I capture are through hard work, determination, preparation, experience, and luck, so my general answer to the viewer is, "Yes."

Another factor playing a part in the way I create my work is the clients to whom I license my images. Most publishers prefer natural-looking images from the real world that give an honest representation of a specific location or subject. Which means I put more effort into documenting

the most amazing scene possible in camera, with little or no post-capture work à la Photoshop.

But there have been countless times throughout my travels, and depending on numerous factors and goals, when have I attempted to create a look or a feel with my images employing techniques accepted by the general public as an accurate representation of a moment. I usually did this by manipulating the scene using the tools of my trade. Is the photograph a representation of reality? Some may feel it is, while others may not.

In my opinion, photography has always been a manipulation of reality, dating all the way back to its beginnings in the mid-nineteenth century. We

While searching for an interesting rock formation in the Alabama Hills in California, I came across this boulder, and by effectively using my polarizer I was able to enhance the scene.
1/30 SEC. AT ƒ/16, ISO 100, NIKKOR 24MM F2.8 LENS WITH CIRCULAR POLARIZER

In this photo taken in Florida's Big Cypress National Preserve, I controlled exposure through a wide-open aperture and brighter light in the field of focus. The choices I made direct your eyes go to the alligator's nose and teeth, giving the feel of "danger" or "predator"—which is what I hoped to communicate in the image.

1/500 SEC. AT ƒ/2.8, ISO 100, NIKKOR 80–200MM F2.9 LENS

don't see in black and white. Our eyes don't have the ability to zoom in or out, or to look at the world the way a wide-angle lens can. So photography is to some extent part reality and part fantasy. Yet through your vision and how you choose to expose a particular scene, you can give the viewer your perception of this reality, as well as your artistic impression of the world. Both are unique and different; both are essential to photography as well as to art in general.

My initial goal in the photo above was to illustrate the predatory characteristics of my alligator subject. I did so not only through my focus point in the scene, capturing the animal's teeth and hopefully evoking some visceral response from the viewer, but also through my exposure setting, which included minimal depth of field coupled with my patience waiting for the right light.

This is another clear-cut reason why controlling more aspects of your camera can allow you so many more creative exposure possibilities. But how will you know which decisions to make when faced with a similar situation? One way is to learn about the many options you have with every one of your images through the concept of equivalent exposures.

Equivalent Exposures

When I conduct in-the-field workshops, the topic of equivalent exposures is one of my favorite sections to tap into and share with my students. It's usually a subject that causes a few eyes to widen and mouths to fall open as some realize what they've been missing—even though they may have been using it on a regular basis.

The idea goes like this: Once you choose an appropriate exposure for a scene, you can choose many corresponding f-stop and shutter speed combinations on your camera, combinations that allow the same exact amount of light as your initial exposure. This is called choosing an *equivalent exposure*.

OPENING THE CREATIVE DOOR TO EXPOSURES

Equivalent exposures allow you a wide range of creativity within a scene, since you can choose from a variety of correct combinations, whether in Manual or automatic exposure mode. Each shutter speed or aperture mix produces the identical exposure to the others—that is, the same measurement of light hitting your image sensor—yet each creates different results due to the various settings, as shown in the table below.

However, you are limited in some cases due to the following:

❏ **The speed of a shot:** Handholding a long lens and not being able to shoot at a slow shutter can result in camera shake.

❏ **Your lens's aperture range:** Some, for example, only have the largest aperture at *f*/5.6 or the smallest at *f*/16—the wider the range on your lens, the more choices you have.

❏ **The amount of light available at the time you're shooting:** Low light doesn't allow you to use a faster shutter speed than desired.

Many photographers aren't even aware of the various combinations they can use for almost every shot they take. If you're shooting in Manual, your choices are completely up to you, given that you select your initial exposure. When you shoot in auto exposure modes such as Aperture Priority (Av) or Shutter Priority (Tv), your combinations depend on your initial choice of aperture (in Av) or shutter (in Tv).

THE EXPOSURE SLIDE RULER

If you're still a bit confused about how equivalent exposure works, here's an example using the table below. Let's say that your proper original exposure for a specific scene was *f*/5.6 at 1/60 sec. Locate this exposure combination in the table, and then notice all the other combinations to find other equivalent exposures for this scene, which means the same amount of light landing on your sensor for every shot. But be aware of the fact that the final images would differ due to the varying depth of field and shutter speeds at which each scene was captured.

Equivalent Exposure Example
(in one-stop increments)

Apertures	*f*/1.4	*f*/2	*f*/2.8	*f*/4	*f*/5.6	*f*/8	*f*/11	*f*/16	*f*/22	*f*/32
Shutter Speeds	1/1000 sec.	1/500 sec.	1/250 sec.	1/125 sec.	1/60 sec.	1/30 sec.	1/15 sec.	1/8 sec.	1/4 sec.	1/2 sec.

The aperture–shutter speed combinations of these two mountain scenes are far apart, producing vastly different results—yet equivalent exposures.

FAR LEFT: 1/60 SEC. AT ƒ/4, ISO 100, 24MM F2.8 LENS

NEAR LEFT: 1/2 SEC. AT ƒ/22, ISO 100, 24MM F2.8 LENS

The key is the corresponding one-stop change in each setting that gives you the equivalent exposure (of course, equivalent exposures can be in 1/3-and 1/2-stop increments as well). For example, when you take ƒ/5.6 at 1/60 sec., our original example for the correct exposure, if you increase your depth of field one stop to ƒ/8, you are decreasing the amount of light entering the camera by one stop. Because of this, you must decrease your shutter speed one stop to 1/30 second, compensating for the initial change and allowing one stop of light back in.

You can also go the opposite way. Open your aperture from ƒ/5.6 to ƒ/4 (one stop brighter), then compensate by increasing your shutter speed one stop from 1/60 to 1/125 second, again to decrease the amount of light falling on your sensor, thus achieving an equivalent exposure.

As the information in the Equivalent Exposures tables prove, there are many combinations providing you with proper exposure for this specified scene. Nevertheless, if you capture this scene in the combination of ƒ/2 at 1/500 sec., the exposure produced will look much different than the ƒ/32 at 1/2 sec. combination (its equivalent exposure on the far right side of the table). Yet both will be *exposed* exactly the same. As you can see in the photos above, as with virtually any starting exposure, there is always a selection of combinations you can choose from.

Equivalent exposures can also be created through a range of ISO settings. This adds the third element to the equation, which, because of the extra math, can be slightly more confusing, especially to the beginner. Still, it's an option to consider once you grasp the basic concept.

As shown in the table at the top of the next page, I take the example of altering the ISO in one-stop increments, thus affecting the shutter speed (although you have the choice of changing the aperture or even both the shutter speed and aperture). And since you can make equivalent exposures in 1/3-, 1/2-, and one-stop increments using aperture, shutter speed, and ISO combinations, your choices are abundant; but instead of creating a gigantic chart based on one correct exposure for a situation,

Equivalent Exposures

(in one-stop increments using ISO)

ISO	100	200	400	800	1600	3200
Apertures	ƒ/4	ƒ/4	ƒ/4	ƒ/4	ƒ/4	ƒ/4
Shutter Speeds	1/15 sec.	1/30 sec.	1/60 sec.	1/125 sec.	1/250 sec.	1/500 sec.

we'll just look at one scenario. The more important aspect here is to understand the concept.

Back to the table. If we assume our initial correct exposure in a low-light situation is ƒ/4 at 1/15 sec. using ISO 100, we then must determine if this setting will give us the result we want. If we're not allowed to or can't use flash—such as in delicate photographic situations like being inside a temple or with an animal spooked by sudden light, or simply because we want to choose natural light over artificial light—maybe our shutter speed at 1/15 sec. just isn't fast enough. However, increase our ISO to 200 (one stop extra of light due to the increase in sensitivity) and this allows us to increase our shutter speed as well to 1/30 sec. If you examine the table again, you'll see, under these specific settings, that we can work all the way up to shutter speed of 1/250 sec. or even 1/500 sec. simply by increasing our ISO—hence creating an equivalent exposure.

Of course, the tradeoff is the additional noise and loss of color and detail in the higher ISOs, but such is the nature of photography. You often trade one advantage for a disadvantage or vice versa, and determining which you choose, under the myriad situations facing a photographer, results in the images you may or may not get. Yet if my choice is a wonderful moment blurred and lost due to a slow shutter versus a wonderful moment captured with some additional noise, I'll opt for the latter.

TIP FOR CAMERAS WITH 1/2- OR 1/3-STOP INCREMENTS

Equivalent exposures work in one-stop increments as noted, but if your camera has 1/2-stop or 1/3-stop increments for ƒ-stops and shutter speeds, so, too, can this concept apply using these parameters. Be aware of which increments your camera offers, or is currently set in, and then adjust accordingly. At the start, however, one-stop increments may be easier to understand and use when practicing this concept.

Case in Point

Let's take a specific case using the same table and a telephoto lens. You're photographing a mountain-biking event and determine the correct exposure is ƒ/11 at 1/15 sec. You may expose the shot correctly, but will the shutter speed be too slow to stop the bikers in motion? Will 1/15 sec. cause camera shake with that telephoto lens? The exposure may create a problem for both.

Now take an equivalent exposure of ƒ/2.8 at 1/250 sec., and both of these problems are solved. Sure, your depth of field is now minimal, providing you little room for focus error when capturing fast-moving subjects, but at least you have a fighting chance for a nice shot. If this doesn't sit well with you, and you still need that extra depth of field, there is a third equivalent exposure option to consider: ISO.

HOW EXPOSURE DECISIONS HELP CONVEY MESSAGES

Comprehending the idea of equivalent exposures gives you choices. The next step is to recognize how it can help you communicate through your photographs. Here are two main reasons:

❏ **Equivalent exposures provide you with a choice of varying exposures for any scene.** This gives you the chance to select what you feel works best for your final image. Giving you another example, if you are photographing a landscape scene along a riverbank, you can either choose a combination of large aperture with a faster shutter speed to freeze the water in motion (yet render minimal depth of field in the scene) or a smaller aperture with a slower shutter speed to get more parts of the frame in focus, as well as blur the water, thus giving it that glassy-motion feel, as seen in the photos at right.

❏ **Equivalent exposures are creativity critical because they provide you with a number of choices for exposure combinations.** Your choice greatly affects not only the way your final scene appears but also the way the viewer sees the image. How so? Look at the phots below. Both are images of the same cactus, photographed at virtually the same time of day, using the same camera and lens. In the photo on the left, the minimal depth of field draws

While photographing the Trinity River in California, I took two equivalent exposures showing the water in motion. The top photo slows the water enough but still illustrates texture to the river bottom, while the bottom photo gives a softer feel to the water, rendering it smooth and silky and conveying a gentler mood as it moves downriver.
1/2 SEC. AT ƒ/11, ISO 100

Capturing a simple detail like this cactus in Baja California can be documented a few different ways, and you have the choice to do so with equivalent exposures, as these two photographs show.
FAR LEFT: 1/250 SEC. AT ƒ/4, ISO 100, 125MM F3.2 LENS
NEAR LEFT: 1/4 SEC. AT ƒ/32, ISO 100, 125MM F3.2 LENS

your eye to a few of the endpoints of the cactus needles and by doing so conveys the message of thorny, prickly, spiky, and maybe even pain or avoidance. Subsequently, as shown in the photo on the right, the depth of field has pulled the entire scene into focus, and by doing so the image has become more of a pattern or detail of the cactus. Sure, the difference may be subtle or strong, but there will most likely be a difference on how the image is interpreted.

Should the gold miner's hands be in focus with his gold pan blurred in the background to draw attention to the gold flakes in his hand, or can you use a smaller aperture to have his hands and gold pan in focus without too slow of a shutter speed that may blur the scene by accident?
1/500 SEC. AT ƒ/5.6, ISO 100, 60MM MACRO LENS

By using selective focus you can draw the viewer toward these cabins along a riverbank, or would you prefer the entire scene to be sharp, appearing more like a landscape image of mountain scene?
TOP: 1/4 SEC. AT ƒ/5.6, ISO 100, MEDIUM-FORMAT 125MM F3.2 LENS
BOTTOM: 8 SECONDS AT ƒ/32, ISO 100, MEDIUM-FORMAT 125MM F3.2 LENS

Using Filters to Alter or Improve Exposures

Today's photographer can choose three types of filter applications: *on-camera* (the tried-and-true method of attaching filters to your lens while you shoot), *in-camera* (utilizing White Balance, or WB), or *post-capture* (the ones you apply after the fact using your computer—that is, the Photoshop method of a filter system). But be aware of the fact that while imaging programs like Photoshop offer some filter methods, they cannot replicate certain types such as polarizers, and although they can replicate neutral density filters with great control, there's a steep learning curve involved in mastering the process.

A benefit of using on-camera filters while you shoot is the minimal amount of post-processing work you have to do later. Attempting to record as much in your original image is always better than having to add it later. Imagine shooting two hundred images only to wish you had added a warming filter, then having to go back and correct it in each shot, which, even in a Photoshop batch method, takes time.

In other cases, if you don't capture certain highlights or shadow detail within a scene because you didn't use a filter, extracting the information later using Photoshop or other software methods may be tough or even may result in an unrealistic, lower quality photo.

Whenever you add an on-camera filter to your lens, it will affect your exposure by slowing it down anywhere from 1/3 stop to 3 or 4 stops, depending on the filter's color and density. Your meter usually adjusts the exposure, or exposure *recommendation,* accordingly, with some rare exceptions (such as using spot metering with a graduated neutral density filter), but it's good to recognize the general loss of light, since it could have a profound effect on your final shot. For example, adding a polarizer filter can slow your exposure, which may not help if you're shooting fast action with a telephoto lens and attempting to freeze your subject using a fast shutter speed.

FILTER CHOICES

There are literally hundreds, if not thousands, of camera filters you can purchase to use in the field. In terms of how they relate to exposures, I personally stick to just a few to assist me when in need:

❏ Graduated or split neutral density

❏ Polarizer

❏ Neutral density

❏ Warming.

Choosing the right filter for the job depends on many factors, including your familiarity with the different types available. Each is described below, but I recommend practicing and playing with every one to get to know their benefits as well as their potential disadvantages.

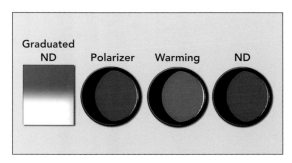

From left to right are examples of each type of filter: a two-stop graduated neutral density, a circular polarizer, a neutral density, and a warming filter.

GRADUATED OR SPLIT NEUTRAL DENSITY FILTERS

Ranging from one to three stops, graduated (often shortened to *grad*) or split neutral density (abbreviated as *ND*) filters are my personal favorite when it comes to on-camera filters that can correct or assist exposures. Clear on the bottom and darker on top, they come in varying degrees of neutral density (one, two, three, or four stop; these are also identified in different ways, as seen in the table at the bottom of the page. You can buy versions with colored neutral density upper halves, but I prefer the straight neutral density since it retains real hues.

The best grad or split NDs are also square, giving you the option of sliding them up and down depending on the horizon line in your photo. I also prefer graduated over split since grad ND filters provide a softer edge transition from clear to neutral density (as opposed to a hard transition in split NDs), showing less if any noticeable use of a filter in most of my shots. With their hard edge (also called "hard step") transitions, split ND filters can work better for certain high-contrast situations, as well as with longer lenses. Both, however, are better to use with wide-angle lenses. Such lenses offer a larger degree field of view, thus allowing you to see more of the filter from top to bottom.

TIP FILTERS DON'T ALWAYS FILTER EVERYTHING OUT

With any glass element on the front of your lens, the smaller your aperture (or higher your f-stop), the more chance you'll notice dust, water, or dirt on the glass. The same goes for grad or split ND filters. With more depth of field in smaller apertures comes the higher probability of seeing the soft or hard edge of the filter.

Graduated or Split ND Filter Chart
(defined in various ways by manufacturers)

Exposure (cut in stops in the neutral density area)	Log Density	Filter Factor
One stop	0.3	2X
Two stop	0.6	4X
Three stop	0.9	8X
Four stop	1.2	16X

How do graduated or split ND filters correspond to exposure? Graduated ND filters can help bring an otherwise too contrasty scene together by darkening its brighter parts (using the neutral density half of the filter), while leaving the darker or shadow areas alone (with the clear half).

When using a grad or split ND filter for the first time to expose a scene, many students ask me what the best method for metering that scene is. There's no hard and fast way to meter when using a grad ND, but I usually spot meter my shadow areas using the clear part of the filter, then check my highlights (usually the sky) using the dark part over the lens, and, armed with that information, determine how much I may overexpose the highlights and underexpose the shadows.

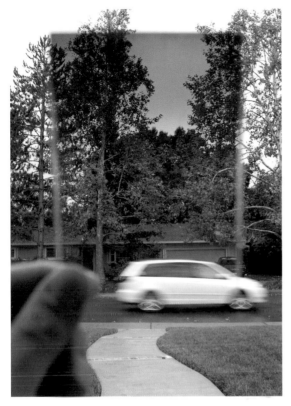

Placing a three-stop graduated neutral density filter in front of my lens, I can see the effects on the image in the filter and outside of the filter.

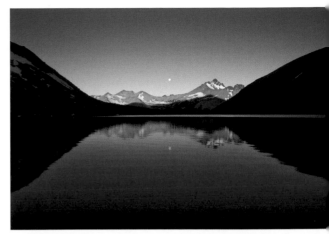

Using the Filter in Alternative Ways

Graduated and split ND filters are usually described as dark on top and clear on the bottom, and although most photographers use them in this configuration, there's nothing stopping you from rotating the filter if need be. Whether you flip it completely upside down or even sideways, it can still assist your exposures depending on the bright versus dark part of your scene. Just remember that the purpose of this filter is to use it without most viewers noticing that you did so—subtlety, not obviousness, is your goal.

A common use of grad or split NDs is in landscape photography, where balancing a darker foreground against a brighter sky is often necessary. In most cases, the light from the sky produces a shorter exposure than the reflected light off of the land in your image, which requires a longer exposure. Capturing the contrast ratio between the brighter sky (or highlights) and darker ground (or shadows) in one exposure is often too extreme for the dynamic range of your image sensor. This is especially the case during sunsets and sunrises, or in dramatic lighting scenarios, which are often what outdoor photographers seek out when creating amazing landscape images. As this scene formed high in the Andes mountain range in Patagonia, Argentina, I knew the only way to capture what I saw with my eyes was to use a grad ND filter.

TOP: 1/4 SEC. AT ƒ/22, ISO 100, 24MM F2.8 LENS, WITH NO FILTER

BOTTOM: 1/4 SEC. AT ƒ/22, ISO 100, 24MM F2.8 LENS, WITH A TWO-STOP GRADUATED NEUTRAL DENSITY FILTER

Taking this photo of the Tuolumne River, I used a two-stop grad ND on the top third of the scene. If the granite riverbank metered at f/22 at 1/2 sec. (using the clear part of the filter) for a middle-gray tone, and the sunlit mountainside (using the darker ND top of the filter) read f/22 at 1/10 sec., most likely I decided on an exposure of f/22 at 1/2 sec. That setting would underexpose (from middle gray) my riverbank by one stop and over-expose the hillside by 1⅓ stops (from middle gray). To my eyes, these tones seemed to match the real tones of this landscape, so I knew my exposure would be solid.
1/2 SEC. AT f/22, ISO 100, 24MM F2.8 LENS

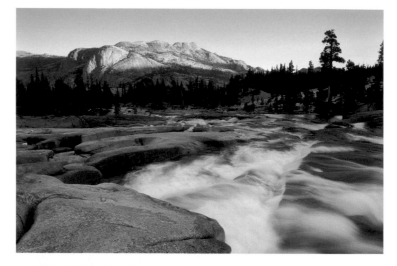

This shot of sunset along the California coast at Point Reyes National Seashore demonstrates the same treatment as above, using the filter in the top third of the frame to expose the sunset sky while keeping detail along the coastal hills.
1/4 SEC. AT f/22, ISO 100, 24MM F2.8 LENS

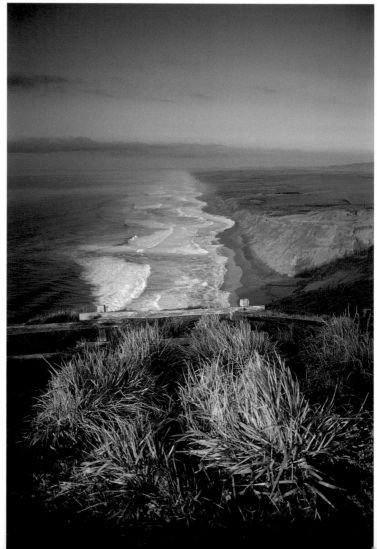

Photographing an indoor summer music festival created exposure challenges for me in the form of contrast. The photo far left was taken with no filter, and the photo near left was shot with a two-stop grad ND. By rotating my grad ND filter upside down, I was able to add detail to the audience and building through a longer exposure but without overexposing the orchestra.

FAR LEFT: 1 SEC. AT $f/5.6$, ISO 100, 24MM F2.8 LENS

NEAR LEFT: SEC. AT $f/4$, ISO 100, 24MM F2.8 LENS

POLARIZERS, OR POLARIZING FILTERS

Polarizing filters also have a special use, as well as an effect on exposure. They are available in two types: *circular* and *linear*. Circular polarizers are the most common, and they work best with current cameras and lenses that utilize autofocus and through-the-lens metering systems. Similar to grad or split NDs, polarizers come in various color casts as well. Once again, however, I prefer a neutral polarizer that doesn't shift toward a specific hue.

These specialized filters generally work to reduce atmospheric haze, adding saturation to skies and cutting reflections on a variety of surfaces such as water, glass, metal, leaves, and asphalt—basically, any shiny or reflective plane. Once you attach the filter to your lens, you then rotate or dial the filter for the amount of polarization you desire (from the least strength to the most polarization, which requires a 90° rotation).

For reflective surfaces, polarizers work best at an incident angle of 30–40°. The filter will still function at slightly different angles outside of the 30–40° range, but with less effectiveness.

When I photograph with a polarizer, I don't necessarily try to determine the angle when I'm shooting. I may estimate the angle at which I'm situated, then simply rotate my polarizer to see if it's cutting the reflection. If removing a reflection is of utmost importance for an image, then finding the 30–40° angle becomes critical.

By eliminating reflections, such as sunlight shining off of leaves, and cutting haze to deepen skies, polarizers can strengthen various colors throughout your images. With the reduction of glare on grass, leaves, or trees through polarization, greens come through stronger and are more evident in your images.

Find the right angle to cut reflections in a shiny red truck, a purple wildflower, or a river, and once again their colors intensify as reflections are reduced using a polarizer. Another advantage of cutting reflections is that it removes bright hot spots falling out of the image sensor's dynamic range, or off the right side of your histogram. And since you have the ability to rotate the polarizer for different strengths, you can choose to cut the reflection down some but not eliminate it completely.

The main drawback of polarizing filters is the loss of light entering your camera, thus leading to a longer exposure. Be cognizant of the fact that polarizers typically cut an exposure by one or two stops depending on the strength of polarization, so you may have to slow your shutter speed or widen your aperture, or both, to compensate for the use of the polarizer.

So if you're shooting action in low light or indoor situations and require a fast shutter speed for stop-action photography, the loss of light could create exposure problems. These filters can also cause a cooling effect, manifested in a subtle blue shift in your images. Fortunately, this alteration is easily correctable in post-processing. As for weather and light, polarizers always work better for landscapes and reflections in direct sunlight, bright sunny conditions, or with blue skies, as opposed to shade or overcast conditions, where all they do is cut reflections. And in some cases of heavy overcast, they have little or even no effect.

Polarizers can also add contrast to your scenes, and on occasion they're a welcome addition to an image. At other times, however, they can cause exposure problems due to the increased contrast. This also becomes an issue when you use the filter with a wide-angle lens in landscapes including skies. The extreme coverage of the lens—a 24mm lens covering a 90° area, for example—can incorporate so much sky, combined with the fact that the filter works best on northern or southern parts of a sky as compared to the eastern or western sections, that the contrast buildup can be obvious across the frame.

TIP POLARIZERS AND RAINBOWS

Polarizers can also help rainbows stand out a little better. Not only do they darken the sky, but, even more so, they intensify the refractions of light in the water droplets that create the rainbow's hues. Because of this, you can also lose some color in a rainbow if you dial the polarizer in a way that cuts the refractions of light, so beware of this.

TIP BEWARE OF VIGNETTING

Another hazard of the polarizing filter—and all filters—is the potential *vignetting* they can cause on wide-angle lenses: that is, the filter sticking out just far enough to be seen by the wide coverage of the lens, therefore causing the corners of the image to go black. Polarizers are more apt to cause vignetting since they are usually fatter than most filters, thus projecting farther out from the front lens element.

Best Directions for Polarizers

Equally effective for landscapes or skies, polarizers are most effective when pointing north and south and least noticeable when shooting east or west. Why? Simply put (and bypassing the lengthy technical explanation), as the filter increases the saturation in the deep blue sky, clouds—which aren't as affected by the filter as other subjects—stand out more intensely, with the filter helping to separate them even more from the sky's tonal value.

When you use a polarizer on a landscape, the darkening effect on the sky can also improve the feel of the exposure, giving a more pleasing aesthetic look to the final scene; this is because the sky, which is usually brighter than the ground without the use of a filter, gives a more washed-out appearance. The assumption is that the filter has cut the contrast, but in truth it has actually increased between the highlights and shadows. The deepening of the sky just *gave* the appearance of cutting the contrast ratio, thus "pulling" the exposure together.

I shot the same Grand Teton landscape scene with and without a polarizer filter. The photo far left was taken without a filter, while the one near left utilized a polarizer—which resulted in the sky having a richer hue, the trees appearing greener, and the contrast building up across the image.

FAR LEFT: 1/500 SEC. AT ƒ/5.6, ISO 100, 80–200MM F2.8 LENS

NEAR LEFT: 1/200 SEC. AT ƒ/5.6, ISO 100, 80–200MM F2.8 LENS

Adding a polarizer to this north-facing Montana highway scene helped the cumulus clouds project off of the sky, giving the appearance of added dimension in the final shot.

1/30 SEC. AT ƒ/16, ISO 100, 24MM F2.8 LENS

Using a polarizer along the Na Pali coast of Kauai allowed me to cut the reflections of sunlight off of the Pacific Ocean, thus revealing its true color.

1/250 SEC. AT ƒ/2.8, ISO 100, 80–200MM F2.8 LENS, AT 200MM

Photographing Nevada Fall in Yosemite gave me a nice rainbow to capture as mist rose up hundreds of feet. Using a polarizer deepened the green forest while at the same time strengthening the rainbow colors.
1/60 SEC. AT ƒ/16, ISO 100, 24MM F2.8 LENS

The effects of the polarizer while I documented this Victorian home added so much contrast that it almost created an exposure issue, affecting everything from the white highlights in the building to the dark green oak trees against the deep blue sky.
1/30 SEC. AT ƒ/11, ISO 100, NIKKOR 24MM F2.8 LENS

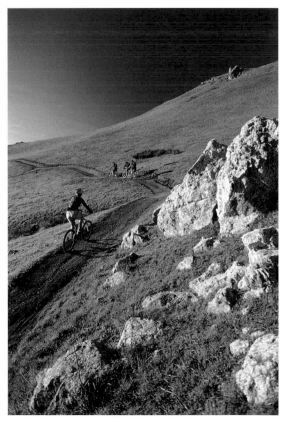

While I was documenting mountain bikers using a polarizer, my 24mm lens covered such a wide area from north to west that the polarization result created noticeable contrast in the sky.
1/30 SEC. AT ƒ/8, ISO 100, 24MM F2.8 LENS

NEUTRAL DENSITY FILTERS

Neutral density (ND) filters are, simply, gray filters. They vary in strength (from one-stop to eight-stop versions) and are made expressly to cut your exposure through loss of light entering your lens.

I don't use NDs often, but when I have a specific shot in mind, they're nice to employ. When would that be? If you wanted to shoot a long exposure to capture motion (water, tree branches, clouds), but, due to the amount of light present, your shutter speed was only reduced to 1 second—even while using the smallest aperture on your lens and lowest ISO. Adding an ND filter—say, a five-stop version—would reduce your shutter speed down to a 30-second exposure.

Another potential use of NDs is through your aperture setting. I've had times shooting in full sunlight when I preferred to use fill-flash, yet I didn't want much depth of field. With an ND filter, I could slow my shutter enough to use fill-flash while keeping the minimal depth of field I desired.

Adding an ND filter for this southern Baja scene cut my exposure down so much that I was able to use a slow enough shutter speed to create a glassiness in the ocean while showing some motion in the palm leaves.

30 SECONDS AT ƒ/45, ISO 100, MEDIUM-FORMAT 50MM WIDE-ANGLE LENS, USING A FOUR-STOP ND FILTER

WARMING FILTERS

Available in a series of varying degrees of strength, from a subtle amber color to a strong yellowish-orange hue, warming filters do exactly what their name says: They warm. Originally created to correct color temperature shifts in photographs per the type of lighting conditions, warming filters help with shade, overcast, or snow—all situations in which your image sensor (or film) would read the light as cool, giving your shots a bluish tone.

In the early morning ambient light, my image of the Santa Barbara Mission tended to go cool, losing some warmth in the earth tones. By adding an 81B filter, those subtle hues I could see with my eye came back to my image.

ABOVE: 1/30 SEC. AT ƒ/16, ISO 100, 24MM F2.8 LENS

RIGHT: 1/25 SEC. AT ƒ/16, ISO 100, 24MM F2.8 LENS

Usually listed as the 81 series (81A, 81B, 81C; the further down the alphabet, the stronger the warmth), this opposing yellow-orange hue would tend to balance or neutralize the blue shift.

A warming filter's effect on exposure is very minimal as far as numbers go: from 1/3 to 2/3 stop depending on the strength. And, once again, your camera's meter adjusts for it (something incident meters won't do unless you hold the filter over the meter). But if we're talking about the effect on exposure in the form of accurate color, then the subtle effects become key toward improving the overall look to your photo.

Skin tones in shade lose their innate faint warm appearance, and warming filters help add the correct hues back in. Landscapes in overcast light lose color and look cold and uninviting—once again, warming filters neutralize the cool color shift, in effect fixing the original tones seen by our eyes.

You can also use warming filters in sunny conditions when you want to add general warmth to a shot. If a client asked me to photograph a specific location at sunset, and the place where I was before heading to the arranged sunset spot had nice scenes to capture, I might use a warming filter to emulate what the light *would* have looked like an hour later (since I obviously couldn't be in two places at the same time). To me, if I were able to stay, the light at 7:00 P.M. would look very similar to the light at 6:00 P.M. with an 81A filter, so it wouldn't be a huge concern to me in terms of producing a realistic scene.

The Demise of Warming Filters?

Since digital has added the capability of controlling and converting your image files in camera, warming filters may have a new enemy. Although essential in the past, they may slowly be phased out with the advent of White Balance (WB)—see chapter 2, page 63, for my discussion of WB and the various image corrections and adjustments it makes regarding lighting.

Another threat to warming filters are post-processing filters available in programs such as Photoshop Elements and CS3 (mentioned in chapter 8). I go back and forth between using warming filters and not, since they offer a quick result with which I'm familiar. Sometimes setting my White Balance fills the need, and other times messing around with the WB may take longer, adding time in the form of the menu fiddle factor, so I quickly throw on the filter instead. But, to be honest, I can see the day coming when I may decide to carry one less piece of equipment as well as add one less piece of glass to the front of my high-quality lens!

ASSIGNMENT **Convey a Message Using a Filter**

Understanding equivalent exposures gives you the creative freedom to capture one scene in a variety of alternative ways. Use this knowledge combined with the filter information provided to produce an image that makes a point. Whether you capture the flow of a local river using a slow shutter while adding a warming filter to compensate for the shade, or decide to use a larger aperture in combination with a polarizer to emphasize a yellow sunflower against the blue sky, your main goal here is to choose the best equivalent exposure for the shot as well as to utilize a filter to improve your exposure. As always, attempt to record as many specifications and details of your selected image not included in your EXIF metadata (such as the filter you used and the direction you were shooting), should you need to refer to it later.

My goal here was to find and capture a magnificent landscape in which the contrast ratio between the top and bottom of the frame was extreme and in which a graduated ND filter would improve my overall exposure. At Jenny Lake in the Grand Tetons, using a small aperture of f/45 and a shutter speed of 2 seconds, combined with a two-stop graduated ND filter, I was able to document this stunning end-of-day scene.
2 SECONDS AT f/45, ISO 100

Lighting

OVER THE FIRST HALF of the book we've dealt with general exposure terminology, most of which has to do with technical aspects of a camera. Great—we're done, right? Hardly. Photography is not simply an equation you can plug in. It's part tools, part skill, part luck, and part art, and as such, it is informed by the artist's unique expression. Exposure is as much about the creative choices the photographer makes in regard to surroundings, composition, and lighting as it is about technical details of the camera. I once read in a National Geographic photography field guide that "An image doesn't start with a camera, it ends there." If you want to produce astonishing imagery, you need to consider many aspects of a scene, including the message you want to convey, *before* you click the shutter.

How Lighting Affects Exposure

Controlling the quality of light is one of the most critical artistic and technical aspects of photography. It allows you to set mood and draw focus and attention to your subject and can help elicit that intangible, jaw-dropping "wow" response. Great images and great lighting often go hand in hand. If you don't know how to find and expose light, you're lacking a key component of a photographer's arsenal. Yet many recreational photographers shoot during some of the worst times of day, place their subjects in poor lighting conditions, or fail to take advantage of extraordinary light when it occurs.

So, how do you go about identifying light that benefits a scene, as opposed to light that doesn't? The first two aspects of lighting to consider when analyzing a scene are these:

❑ **Subject contrast and lighting ratio:** The difference in tones, bright or dark, between the subject and the surroundings

❑ **Highlight-to-shadow contrast and detail:** The dynamic range of the entire image, from the brightest to the darkest part, and how this affects the overall feel of the shot.

SUBJECT CONTRAST AND LIGHTING RATIO

When I scout potential scenes, I often consider the contrast in the subject, as well as the lighting ratio between the subject and the surroundings. What type of light is illuminating my subject? What direction is the light coming from? How is it helping to separate my subject from the background?

> **TIP** COMPREHENDING LIGHT
>
> Train your eye to notice nuances of light. By doing so, you'll be able to plan your shots, consider your options, and previsualize your exposures.

Knowing the wonderful morning light would help create a beautiful exposure forced me out of bed early to capture this scene near Mendocino, California. I set my camera to spot metering mode and found a middle gray tone in the layer of trees. To confirm I had the exposure I wanted—with layers of tones throughout the landscape—I checked that my shadow areas were around two stops under-exposed from my setting and the highlight areas were anywhere from a half stop to three stops over.

1/30 SEC. AT ƒ/4, ISO 100, 80–200MM F2.8 LENS

Studies analyzing where people look when they view an image show that most look first either at the brightest or darkest part of a scene or at the area of focus within the image. Thus, one way to make something stand out in an exposure is to use light to separate it from its surroundings. You can have your subject brighter than the background, or darker.

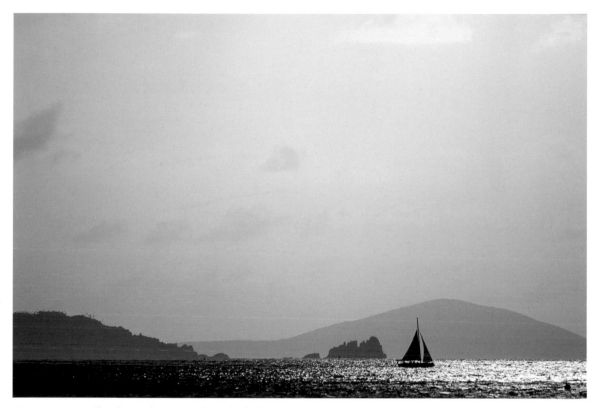

Positioning myself to frame the scene where the light would separate my subject from the background was key to the success of this image. I previsualized where I wanted the sailboat along St. John's coast and, checking various areas of the scene with my spot metering mode, exposed the shot to illustrate both the layers of distance between each section and the hues in the sky. The viewer can quickly locate the subject as well as recognize the time of day and the spatial relationship between subject and background. 1/1000 SEC. AT ƒ/4, ISO 100, 300MM F4 LENS

Previsualizing Light

One aspect of previsualizing a photograph is deciding the best way to utilize light. If you've thought a shot through, you may already know the lens you will choose, the best times of day to capture a particular scene, and the exposure you'll hope to use. The last step will be to use your camera.

You can look for this separation of light even before you lift the camera to your eye in one of two ways:

❏ Squinting (see chapter 3 for a discussion of the "squint test").

❏ Closing your eyes and then opening them to notice where you are first drawn. With this method, it is important to distinguish exactly what it is you first look at: Is it your subject, or is it the brightest or darkest part of the scene? Naturally, if your subject *is* the brightest or darkest element in the scene, you may be off to a good start.

Hot Spots and Black Holes

A potential hazard of lighting often occurs when contrast causes a distraction. An area within the frame can be too bright (a hot spot) or too dark (a black hole), taking focus away from the subject. You can sometimes fix this without changing one setting in your camera. Try moving just a foot to the left or right to subtly change the background. Or, wait for the distracting object to move out of frame or for the light to change. Sometimes simply adding another element to block the overpowering area can contribute to a better image.

Fall leaves in Yosemite Valley pop off the page, largely due to their contrast with the dark-shaded background. Moving close to the leaves allowed me to meter their tone without influence from the background. To make sure I was on target, I double-checked that my setting was underexposing the background by two stops or more.
1/1000 SEC. AT ƒ/4, ISO 100, 85MM F2.8 LENS

To capture the crowd watching a dolphin show in Ixtapa, Mexico, I exposed for the
background by walking out into the sun and metering the blue sky for a middle tone.
This silhouetted my shaded subjects, separating them from the colorful architecture.
1/1000 SEC. AT ƒ/5.6, ISO 100, 24MM WIDE-ANGLE LENS

HIGHLIGHT-TO-SHADOW CONTRAST AND DETAIL

Determining the contrast ratio between highlights and shadows can help you predict how much detail will show in your final image. A meter cannot correct for poor lighting or an extremely high contrast ratio. If your exposure setting is three or more stops from any item in frame, whether over or under your middle gray choice, there are bound to be blown-out highlights or shadows without detail. You can't do much about this in camera, so you need to search for angles and ways to capture a scene within the parameters of your image sensor or film. Watch the light to see how it changes the contrast within the scene. When it does, take advantage of it.

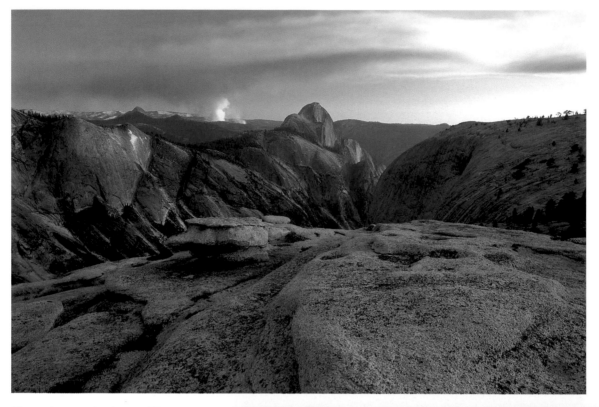

These photographs show Half Dome in Yosemite National Park at sunset from two different angles. I shot the image above in the high country during a forest fire. As the smoke from the fire blocked the sun dispersing the light, the strong highlight-to-shadow contrast diminished, allowing me to expose the scene while both sunny areas and shade fit into the five-to-six stop range of my sensor. The image at right, taken from Yosemite Valley on a clear day, had a high contrast from the direct sun, but I knew this could work for me if I waited for the right moment. As the rest of the valley fell into shade, the contrast eliminated most valley detail so that the graphic image contained only a few elements that fit into the dynamic range. This is yet another example of using a negative in photography to benefit your final image.

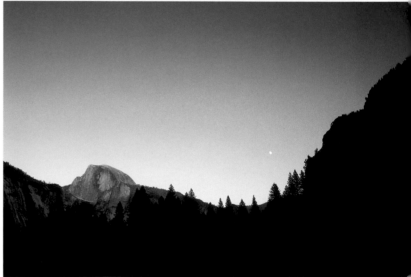

ABOVE: 1/8 SEC. AT ƒ/22, ISO 100, 24MM F2.8 LENS

RIGHT: 1/30 SEC. AT ƒ/16, ISO 100, 50MM LENS

When to Expose For . . .

There is no one simple method for exposure. When a student asks me what to expose for, my first inclination is to say "expose for your subject." But occasionally, your *photographic* subject isn't your *exposure* subject. How's that for confusing? Let me explain.

In this chapter's opening spread, my photographic subject may be the woman on the rock, but it's the morning sunrise on the Teton Range that I exposed for. Similarly, in the photo on page 117, I exposed for the colorful architecture and sky, not the dolphins, though they are clearly the main subject.

In the photo below, I wanted my *photographic* subject—the hikers on Sentinel Dome—in silhouette, and this meant that my *exposure* subject needed to be the color of the sky. Why? Because a silhouette is black without detail, thus the next most important part of the exposure is the hue you want to reproduce—here the bright sky behind the hikers. This is an example of exposing for the highlights.

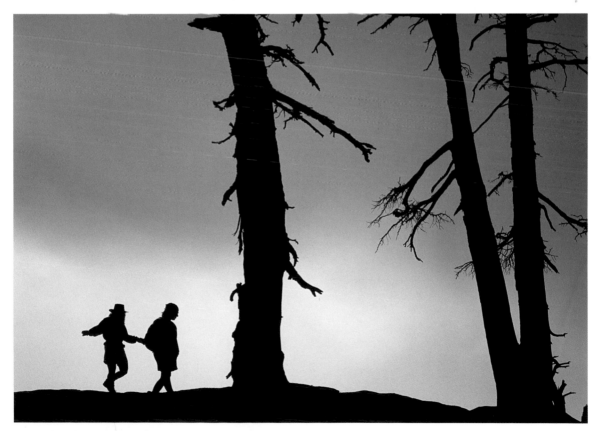

My goal in photographing these hikers walking off Sentinel Dome in Yosemite was to capture a graphic scene by exposing the gray hues of the stormy sky.
1/250 SEC. AT ƒ2.8, ISO 100, 80–200MM F2.8 LENS

HIGHLIGHTS

If highlights are of utmost importance to a scene—and this can occur in a number of situations—I make sure I correctly expose the scene to maintain the highlights' detail. For example, the photo below came to life when I exposed for the highlight of the sky, with less consideration for the pines below. In the photo on the right, the sunlit rock climber became the main focus and exposing for his skin tone was essential; holding detail in the rock wall behind him was important, but less so.

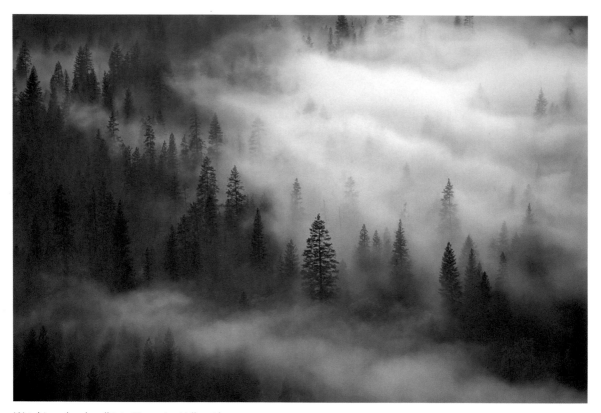

Watching clouds roll into Yosemite Valley, I knew my exposure would be based on capturing detail in them. I metered off of the brightest highlight and overexposed from the recommendation by roughly two stops.
1/500 SEC. AT *f*/8, 300MM F4 LENS

How to Choose Your Exposure

A general rule digital photographers follow is to place emphasis on capturing highlight detail in exposures. This may be technically correct, but there is more than one way to expose a scene. In many cases, exposing for highlights does not produce as good a photo as exposing for shadows, subject, or even middle gray.

Exposing for the highlight areas was key in this photograph. To avoid distraction in the background, I waited until the light on the rock wall fell completely into shade. Then, I determined the correct exposure for the climber's skin by using the similar tone of the sandstone rock in sunlight as a metering reference. I checked the background to make sure it was underexposed by almost two stops and fired away.
1/1000 SEC. AT ƒ/4, ISO 100, 300MM F4 LENS

The gothic and graphic shape of this monument in Edinburgh, Scotland, was part of the message I wanted to convey; holding enough shadow detail to see some of its structural design was another. The contrast in the scene wouldn't allow me to capture both highlight and shadow detail, so I chose the latter and filled the frame with as much monument as possible. Since the monument was backlit, exposing it close to black with detail represented the scene correctly.

1/30 SEC. AT ƒ/16, ISO 100, 24MM LENS

SHADOWS

Shadows can play a dramatic role in photography. Peering into the dark details of a scene, even when shadow is only a small part of the photo, can create a wealth of atmosphere. There are two ways to expose for shadows:

- ❏ **Make sure there is just enough detail in the shadow areas.** This works well when the darker feel of shade is critical to the photo.

- ❏ **Overexpose the shadows**—that is, open them up some for more detail. This is best when your subject is entirely in the shadow region of a scene, whether backlit or sitting in shade.

▶ *As I headed out to photograph Yosemite Falls at dawn, my hope was that sunrise light would illuminate the waterfall before hitting any other part of the north valley wall. But when the first rays of light touched the west wall, I knew that if I let the light continue down the face, the contrast would distract from the overall shot. The scene was strong enough for a good capture, so I shot right away. Because my subject was virtually entirely in shade, I brightened the shadow areas, exposing the shade approximately one stop under from a middle gray meter reading for most of the valley wall. You still get the feeling of shade, but with additional detail and clarity.*

1/8 SEC. AT ƒ/11, ISO 100, 80–200MM F2.8 LENS, SET TO 125MM

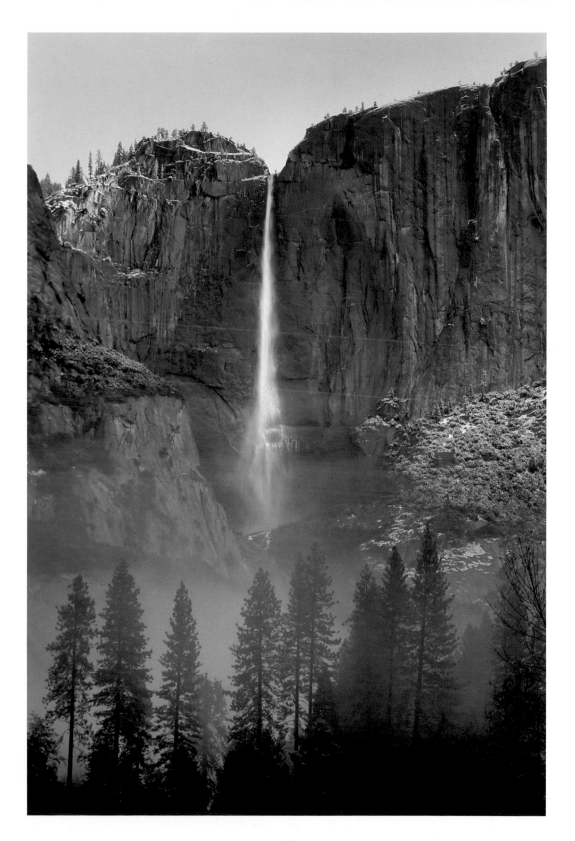

MIDDLE GRAY

Exposing for middle gray can be the right decision when your subject has a similar skin tone to middle gray (as in the photo below). You will need to consider, though, how the rest of the scene may come out. If your subject fills most of the frame, you are probably okay to shoot away.

A second situation comes into play when you are attempting to capture a larger scene, maybe a side-lit landscape, where highlights and shadows create a wide contrast ratio. When the range of light in a scene exceeds five stops, it is too far apart to be documented with detail in one shot. In these cases, if you expose for middle gray, most of your highlights will hold a bright tonal value (as well they should, since they are highlights) and your shadow areas will display tones closer to black than middle gray. Both areas may lose small detail in the extreme sections.

Capturing a close-up of this Argentinean gaucho didn't require much metering, only enough to determine his skin tone, which was close to middle gray.
1/1000 SEC. AT ƒ/4, ISO 100, 80–200MM F2.8 LENS, SET TO 200MM

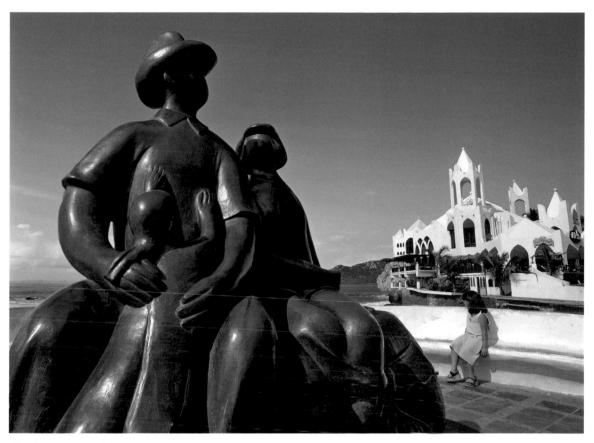

The darker tones of the statue and the white tones of the building in the distance created a tonal range that couldn't fit into my image sensor's dynamic range without some clipping in the highlights and shadows. I chose to meter a middle gray tone, which would expose most of the scene well. I used an area of the little girl's skin and a spot of the sky just above the horizon to determine my meter setting, then checked all other areas to see how much over- or underexposed they would be. The monument was under my setting and the building was over close to two stops, so I knew the tones in my photograph would match the tones I saw.

1/8 SEC. AT f/22, ISO 100, 50MM WIDE-ANGLE MEDIUM-FORMAT LENS AND A POLARIZER

How to Expose for Middle Gray in a Large Scene

First, attempt to find an element in the scene with middle gray tones. This should give you the starting point in your range of exposure. If there isn't a middle gray area to meter, meter the main subject, and, if the subject is lighter or darker than middle gray, adjust the meter's recommendation to match that real tone.

YOUR SUBJECT

Often, all that matters in a photograph is your subject. See, for example, the photos on this page. You may well ask, "What about the other tones in the scene?" If your subject is truly the most important element, I say expose for it. Attempt to capture the tone or color of your subject as accurately as possible and let the rest fall where it may.

While photographing ravens off the California coast in Channel Islands National Park, my main concern was capturing their black, shiny plumage. Capturing the moment came second. Underexposing by two stops from the meter's recommendation was key to the success of this image.

1/2000 SEC. AT ƒ/2.8, ISO 100, 400MM F2.8 LENS

This mountain goat was all I was concerned about as far as my exposure. Metering the fur on its chest and overexposing from the recommended middle gray setting by one stop gave me the realistic tone I desired.

1/500 SEC. AT ƒ/4, ISO 100, 300MM F4 LENS

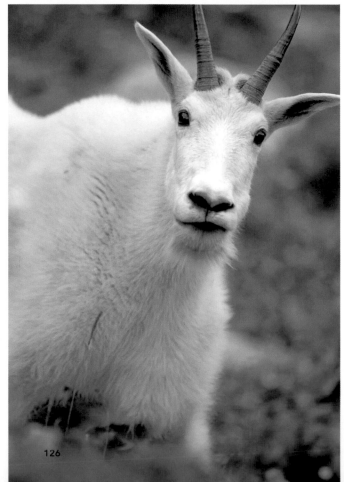

Directions of Light

The direction of light can accentuate, define, separate, or soften an image. Contrast creates dimension in a flat photograph, and to show shape and form, the right type of light is just as important as any other facet of the shot. However, many recreational photographers focus too much on a scene itself and often lose touch with how the light is influencing the image.

You may think catching the right light means waiting for it, but this is not always true. In many cases you can move a few feet, turn your camera in a different direction, and alter the contrast ratio drastically to create a completely different photograph.

There are three directions of light—side light, front light, and backlight. These and nondirectional ambient light (page 134) can mix into a myriad of combinations.

SIDE LIGHTING

When you take a three-dimensional world and convert it to a two-dimensional medium such as a photograph, you are bound to lose something, usually in the form of depth and dimension. In photography, one way to compensate for this is through side lighting. In side lighting, your subject is lit by a light source roughly 90° off-axis from your camera, illuminating one side while placing the other half in shade.

Side lighting can create a wide contrast ratio, and such shots can be tricky to meter. Which do you expose for: the highlight side, the shadow side, or a middle gray tone somewhere in between? This is critical and depends on the result you are trying to attain and the scene you are attempting to capture.

The middle gray tone is often a safe choice. I opted to expose for middle gray in the photos

> **TIP** USE THE SUN AS YOUR GUIDE
>
> Photograph to the north or south at sunrise or sunset, and given that the sun rises in the east and sets in the west, the scene you capture will most likely be side lit.

While photographing Mission San Antonio in Jolon, California, I chose an angle that gave my photograph depth and dimension—dimension depth in the statue of Father Junípero Serra and dimension in the relationship between the statue and the mission.
1/8 SEC. AT f/22, ISO 100, 24MM F2.8 LENS

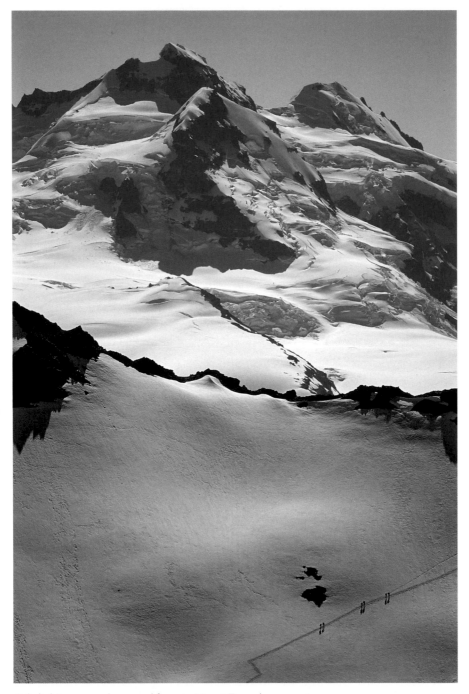

Side lighting gave shape and form to Mount Tronador, an ominous mountain in northern Patagonia. Every nuance is noticeable, from the cracks in the glacier to the shadows of the climbers below.
1/1000 SEC. AT ƒ/4, ISO 100, 300MM F4 LENS

here, even though this meant possibly losing detail in the brightest highlights and deepest shadows.

There are times when metering for just the highlight or shadow side is more appropriate, as in the photo below. Here, the otter's face is the key element, and exposing for it was my first pri-ority. How did I meter the scene? I may have metered the sunny side of the back of my hand, comparing it to the tone of the otter's nose; or possibly I spot metered the otter's body, under-exposing from the recommended middle gray reading.

As this otter rotated toward the morning sun, the side light isolated its face, separating it from the rest of the scene. The angle of the light also gave shape and form to its fur.
1/320 SEC. AT ƒ/4, ISO 100, 300MM F4 LENS

Adding Dimension Through Side Lighting

Side lighting adds depth and dimension into our 3D-chal-lenged images through highlights and shadows created by the plane and angle of light. Because of this, our eyes can view side-lit photographs with a better feeling for the shape and texture of the objects within a scene.

FRONT LIGHTING

In front lighting, the photographer is situated between the subject and the light source. Many beginners mistakenly believe this type of lighting provides the most, hence the best, light. Front lighting, however, creates flat, uninteresting images that have little dimension. Shadows are usually hidden behind items the camera can't see, and depth or separation can only occur through color, aperture settings, or the recognition of familiar subjects.

I tend to avoid front lighting. Mostly I use it when I have little other choice, due to my subject matter, the time of day, or both.

Since flat lighting tends to illuminate the entire scene in the same light, it is somewhat easier to expose due to the minimal contrast, and metering for it comes through deciding tonal values from each element's color. Because front lighting creates a flat light with minimal contrast, it is easy to expose by metering off of the tonal values from each element's color.

Front Lighting for Portraits

When photographing people, one benefit of front lighting is that it can be flattering, removing any imperfections in the skin. Due to the direction of the light, however, the subject is forced to look toward the light source in order to look at the camera. This makes most people squint heavily, which is never pleasing to the eye.

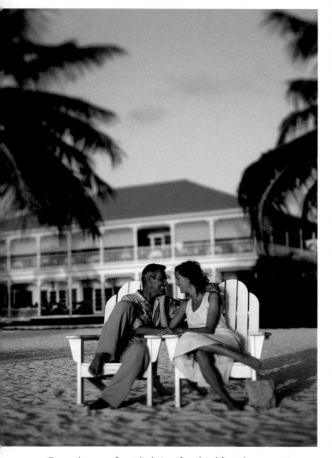

Forced to use front lighting for this lifestyle scene, I consciously chose a wide aperture of minimal depth of field and turned the models toward each other to keep them from squinting. I metered off of the models' skin for a proper exposure.

1/250 SEC. AT ƒ/3.2, 125MM F3.2 MEDIUM-FORMAT LENS

▶ To document an ultramarathon near Death Valley, I found a section of the highway that did a wonderful job illustrating the distance the runners were traveling, but the morning light behind me created front lighting on the scene. I chose to shoot it anyway, hoping the road, my wide aperture, and the cloud darkening the mountain above would create enough depth. Since I couldn't meter off of the runner, I found a middle gray tone just off of the side of the road.

1/500 SEC. AT ƒ/4, ISO 100, 300MM F4 LENS

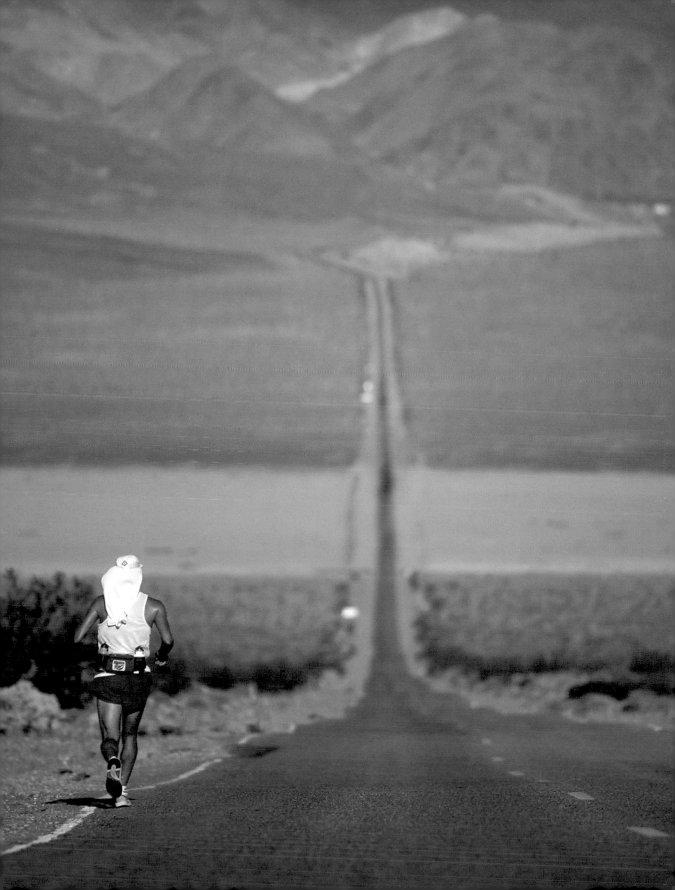

BACKLIGHTING

This is probably my favorite type of lighting and one I search out frequently. Good backlighting adds drama, helps to separate the subject from the background, allows the viewer to *see* the light, and accentuates shapes and forms. If used improperly, however, backlighting can create extreme contrast, harsh light, and concerns such as flare.

With backlight, you are usually shooting toward your light source, such as the sun, with your subject between you and the light. The extreme contrast between highlights and shadows makes it tough to nail such an exposure; however, the rim light can make your subject glow and your final image more commanding.

What to Expose for When Backlighting

In backlighting, as in side lighting, deciding what you will expose for and what you are willing to lose in detail becomes vital. Practice your exposures and you will slowly find regular settings that work for you. For example, underexposing a shaded subject by approximately one stop under middle gray often gives a proper appearance to the subject while maintaining enough highlight detail. A reading I often take is to meter the brighter areas and overexpose them from middle gray by about 1⅓ to 1⅔ stops. I've learned this gives my highlights the appearance of being almost too bright, similar to what I see when I look toward the sun.

While in Jack London Square in Oakland, California, I noticed the wonderful quality of backlight appearing through the trees. I set up my shot to include a slice of the sun and overexposed the lit walkway to capture shadow detail. All I had to do then was wait for a couple of people to walk into view.

1/250 SEC. AT ƒ/2.8, ISO 100, 80–200MM F2.8 ZOOM LENS

In this graphic shot, I stood in the shade of the palm tree to backlight Florida's Less Island coast. Wanting to silhouette my subjects to play up their shapes, I metered for the sky.
1/125 SEC. AT f/16, 50MM WIDE-ANGLE MEDIUM-FORMAT LENS

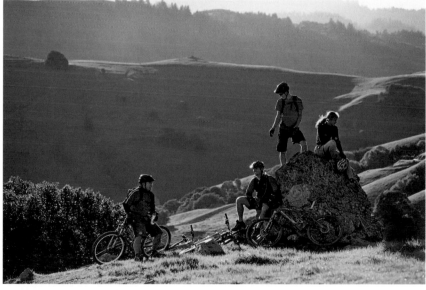

In this photograph for Sunset magazine, I chose to backlight my mountain-biking models while they rested in the late afternoon sun. The rim light separated them from the rolling hills and helped create a dramatic image. I took two meter readings: one of their skin tone, underexposing to give the appearance that they were in shade, and another, to confirm this setting, overexposing the grass by a half stop to make it appear bright green.
1/400 SEC. AT f/2.8, ISO 100, 80–200MM F2.8 ZOOM LENS

TIP THE PITFALLS OF BACKLIGHTING

To avoid low contrast or flare, make sure your subject is backlit, as opposed to just being in shade, so that its shape is emphasized. Use your hand or a lens hood to block the light from entering your lens. This takes away the harshness of the light and helps your backlit images maintain rich color and sharp details.

Ambient Light

Ambient light is actually nondirectional lighting. Defined as *all indirect light not attributable to direct sunlight, light rays, or a specific light source*, it's basically shade or similar in form to shade. Think of ambient light as light reflected off of surfaces in the environment and illuminating shadow areas. Without ambient light, objects in shade would be entirely black. This type of lighting is reliable and consistent and offers many benefits for your exposures.

Photographers often use ambient lighting when they want more controlled light outdoors for an extended period. Why? Because the brightness of ambient light changes on a slower timescale. Ambient light differs from direct light in the size of the source—while direct lighting might come from the sun or your flash or other manmade source, ambient lighting comes from sources such as the entire sky.

Because ambient light is a larger, more diffused light source, contrast is lower, and this gives a softer quality to the light. Thus, proper metering is usually derived from tones in the subject (not differences in brightness). You often see less defined shadows in ambient light. Its expansive properties provide even illumination, removing any potential splotchy highlights or shadows and helping to create cleaner, less distracting backgrounds.

Ambient light is flattering when photographing people, removing heavy shadows on the face, smoothing out the skin, and diminishing wrinkles.

As the sun moved in and out of the clouds above the Argentinean Pampas, my light source changed from directional (above), in which the sun overhead lit the guanaco skull, to ambient (right), with the entire sky becoming a source of soft, diffused light. The change in contrast is evident.

ABOVE: 1/3200 SEC. AT ƒ/2.8, ISO 100, 24MM F2.8 LENS.

RIGHT: 1/800 SEC. AT ƒ/2.8, ISO 100, 24MM F2.8 LENS

I chose to use ambient light to expose this scene of sunglasses, ironically illustrating the sunny qualities of this Southern California beach town with a diffused "non-sunny" light source.

1/4 SEC. AT ƒ/32, ISO 100, 125MM F3.2 MEDIUM-FORMAT LENS

Color Temperature

Ambient light frequently causes a shift in color temperature (a measurement, in degrees Kelvin, indicating the hue of a type of light source, such as fluorescent lighting or the sun). If the source of reflected light comes from a clear sunny sky, your image will have a strong blue shift. If it comes from an orange sky with warm-toned clouds lit by the sunset, you may have some warmth in your ambient light.

TIP AMBIENT LIGHT FOR PHOTOGRAPHING CARS

Ambient lighting is great for shooting shiny, reflective surfaces. Most car photographers shoot vehicles at dawn or dusk. They use the sky as a large lightbox, bouncing ambient light into the entire scene. This creates an aesthetically pleasing, smooth, long highlight across the vehicle's shiny metal surface.

WINDOW LIGHT

A unique type of ambient light, and one that is a staple in portrait photography, is window light. Window light is found almost anywhere a building or structure exists. It provides control without the need for additional light sources.

Why is window light unique? Once nondirectional ambient light enters a window, it becomes, in a sense, directional. The larger source is squeezed into a smaller area, therefore providing dimension. Yet the light still retains its soft ambient quality that is so flattering on faces, and it adds "catch lights" in the eyes (bright spots of light reflecting a nice twinkle).

If there is only one window where light can enter, you have more control over your exposure. Think of a person in a dark room with light filtering through a window. Move the person close to the window. The broadness and luminance of the light increases, speeding up the exposure on your subject while exposure on the rest of the room remains the same. This gives more contrast between the person and the background, and because the person is closer to the window, the light is softer on the face.

Move your subject back from the window and, with the light source farther away, the edge from highlight to shadow becomes slightly harder. The luminance on your subject also decreases, requiring you to lengthen the exposure. Thus, the difference in exposure between your subject and the room decreases, cutting the contrast.

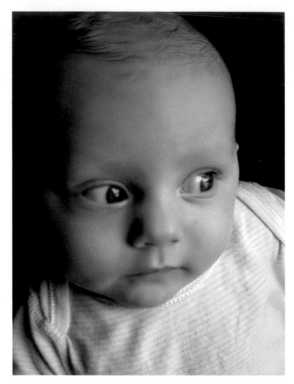

When I laid my baby daughter on her changing table, I noticed the window light on her face and quickly grabbed my camera. Metering the bright side of her face, I opened up a full stop to match her light tone.
1/50 SEC. AT ƒ/45, ISO 400

> **TIP** **USING STROBES TO CREATE THE LOOK OF WINDOW LIGHT**
>
> Photographers who don't have access to a large window or who prefer to control the light in very specific ways often emulate window light with off-camera strobes and large softboxes.

Using Window Light in Portraits

In regard to exposure, it is important to recognize the fall-off of light on your main subject, lit side to shaded side, as well as the background and surroundings. Most photographers will meter for the bright side of the face, which causes the rest of the room to go black since it's so much darker and requires more exposure. This can create a dramatic effect and make your subject stand out with little distraction from the rest of the scene.

Macro Imagery

Macro photography is not all that different from regular photography—you just have to pay close attention to your camera settings, the light, the contrast ratio, and the message you want to convey to the viewer. However, because macro photography entails working in smaller spaces, your ability to see light becomes all the more important. In small spaces, light moves fast and can change quickly, altering your exposures. Everything is larger on your final image, and paying attention to small details is imperative.

THE EXPOSURE ADJUSTMENT

As you get closer and closer to your subject, the lens elements dispersing the light stretch, resulting in a loss of light. This necessitates a change in exposure, either through the aperture, the shutter speed, or both. With through-the-lens metering (see chapter 3), your camera's reflective meter will most likely recognize the darker scene entering the lens and automatically adapt for the change. If your aperture is set to its maximum opening, the correction will first occur there.

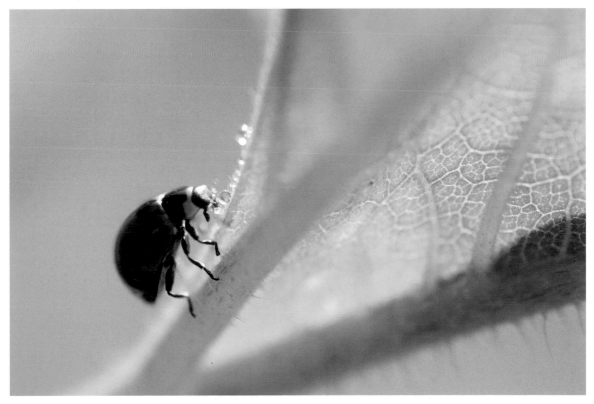

This image of a ladybug drinking may look simple, but only by utilizing the late afternoon sunlight, backlighting my subject, and exposing the translucent plant (for just a tad brighter than middle gray) did it all come together. Getting the ladybug in focus with such minimal depth of field (maybe a millimeter) also added to the challenge.
1/250 SEC. AT ƒ/5.6, ISO 100, 60MM F2.8 MACRO LENS

As I watched the last rays of light hit the western slopes of California's Mount Diablo, I knew that if I could find a lit blade of rattlesnake grass with shade behind it I could accentuate the warm quality of the light.

1/160 SEC. AT ƒ/2.8, ISO 100, 60MM MACRO LENS

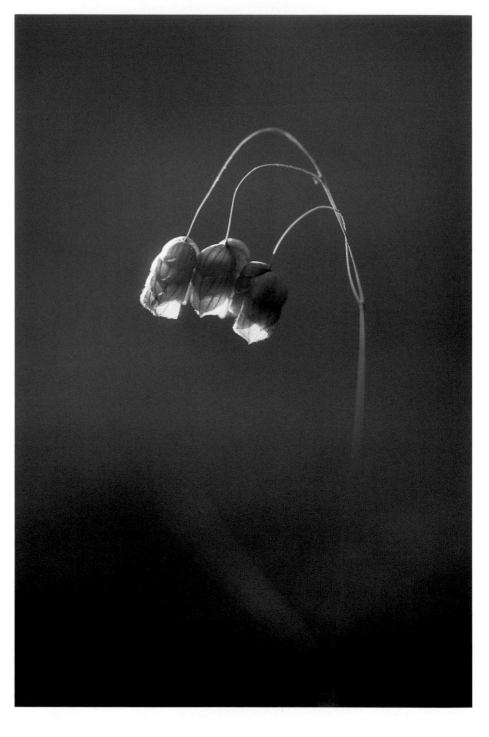

WORKING IN CONFINED SPACES

One of the key exposure challenges in macro photography is caused by the close proximity of your subjects. It becomes all the more important to be aware of what the light is doing, to watch things like your shadow or the lens' shadow on a plant inches away. What seems like little movement from wind on a landscape can look like a torrent on a delicate flower, making it necessary to be more acutely aware of shutter speeds.

As a lens focuses in tighter on subject matter, depth of field is minimized. At times this is beneficial; at other times it creates problems.

> **TIP** CAMERA SHAKE
>
> If the macro setting drops your shutter speed too low when you are handholding your camera, you will have camera shake, resulting in an image that is blurred. Macro lenses featuring internal focusing don't have this issue, since the elements remain close, producing no light loss. Make sure to check your macro lens to see which one you have.

Seeing the Light

As you move in close to small subjects, every element is intensified, and the direction of light as well as location of tiny highlights and shadows become exposure concerns. It may be easy to overlook or ignore a small highlight in a landscape, but take that bright area and magnify it a hundred times, as happens in macro photography, and it becomes a major distraction. You can eliminate apparent hot spots (too bright) or black holes (too dark) around your main subject by moving left, right, up, or down. You might have to move only inches or millimeters to reframe a less distracting background.

My first images of this horned lizard, taken in the harsh midday light, were pretty bad. But I continued to document the reptile, coming closer and closer, and finally got lucky when it started going back to its den. Since its tone matched the desert landscape almost perfectly, I was only able to separate it from the background by using use the shadow of its home.
1/1000 SEC. AT f/4, ISO 100, 60MM MACRO LENS

The Ever-Changing Light

Light is like a living, breathing animal. Light transforms and moves. It fluctuates as the earth moves, increases and decreases as clouds roll across the sky, and offers different qualities from season to season. It changes quickly, sometimes in milliseconds, other times over minutes. But, because our eyes and minds adapt for the variations in brightness, we may not even notice the changing light.

Understanding light involves studying the atmosphere. Observe where the sun moves and how its qualities change over time. Know when the moon rises and sets during the month and when the tides are high or low. Think about how the weather affects your shots. Use your observations to think about what might happen. This is one way to previsualize a scene or an exposure.

Shooting along Princes Street in Edinburgh, Scotland, I captured two images of the Balmoral Hotel about an hour apart. It is easy to see the change in light and hue of the sun reflecting off the building, the warm light turning deep orange right before sunset.

I awoke at dawn in Swan Valley, Montana, to a heavy, overcast sky but decided to shoot sun-up nevertheless. I drove my car up a hill, hoping the low clouds were simply morning fog and that I could not only drive into clear skies but get above the fog at sunrise to create some extraordinary images. On this occasion, I was lucky. Metering to capture detail in the fog was my main exposure objective.

1/400 SEC. AT ƒ/4, ISO 100, 300MM F4 LENS

The EXIF Metadata

Before the days of digital, in the midst of shooting roll after roll, shot after shot, in the ever-changing light, it was almost impossible to keep detailed information of each exposure. One of the beauties of the digital age is having your personal exposure recording assistant in the form of the EXIF metadata. This can be a great learning tool. The myriad of exposure combinations during a day caused by the changing light is vast. By comparing your exposures, or re-metering the same areas, you can see the subtle variations the light causes.

The Best Times of Day

Our eyes are amazing, having the ability to cover wide expanses of color and light. But because our minds tend to correct for these changes we often don't notice the small differences in light over the course of a day.

When people review my photographs, they often ask how I obtained the colors I did for the image— if I used colored filters or "Photoshopped" the image. Most are surprised to learn that I don't use filters, instead capturing color by choosing to shoot during optimal times of day with the finest quality of light.

SUNRISE AND SUNSET

A general rule of thumb in photography is that the light is often best closest to sunrise and sunset— that is, at dawn and dusk. An hour or two past sunrise, the light begins to get harsh, losing color and creating more neutral tones in subjects and landscapes. Midday is the worst time to shoot.

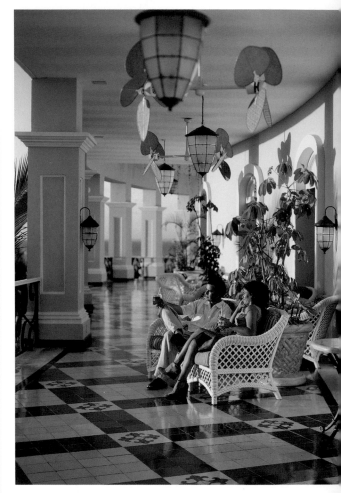

Scouting a resort in Mazatlán, I came across this location. I knew the afternoon sun in the west would light the walkway if I shot close to sunset with my camera pointing northward. When I returned with my models later in the day, the light was acting exactly as I thought it would, and I created this warm lifestyle scene.

How Time of Day Affects Exposures

A graph mapping the amount of light over the course of a day will show a hill effect: light is minimal at the start of a day, increases to its maximum around early afternoon, and falls off toward sunset. Because these early morning and late afternoon hours provide the least amount of light and require longer exposures, most people assume that shooting during the middle, brightest part of the day is best. This is a mistake, for a bright, sunny day often produces contrasty, colorless scenes.

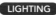
Sunrises and sunsets are the staple of nature, outdoor, and landscape photography, for they bring a quality of light like no other. Yellow and orange hues establish warmth, and the low angle of light creates many aesthetically pleasing exposure possibilities. Long shadows can highlight specific areas, warm colors contrast against cooler skies, and side light can add depth and dimension.

In this photo, previsualization and timing came together. I had traveled to the Port of Oakland in California to capture some bay scenes, choosing a time close to sunset when the light would be most favorable. Once I found the right angle to include both Bay Area bridges in one shot, all I had to do was attach my lens and choose the right setting. Exposing for the sky, a half stop brighter than middle gray, helped me maintain the rich golden tones while silhouetting the structures.
1/500 SEC. AT ƒ/4, 300MM F4 LENS

> **TIP MUCH DEPENDS ON THE WEATHER**
>
> A cloudless sky can help create strong contrast and nice hues in a landscape, but its clean, empty atmosphere may detract from the dramatic quality of the image. A stormy sky may block out and ruin the light, but with some luck it can add to the light and produce an amazing and rare quality.

I crawled out of my warm tent and hiked toward the northern end of Anacapa Island, in Channel Islands National Park, to capture this sunrise scene. The first rays of light added wonderful warmth to the islands while the low light gave them shape and illustrated distance. I used a tripod and set my aperture to its maximum, relying on hyperfocal distance to obtain the greatest depth of field possible.
1/8 SEC. AT ƒ/22, ISO 50, 24MM F2.8 LENS

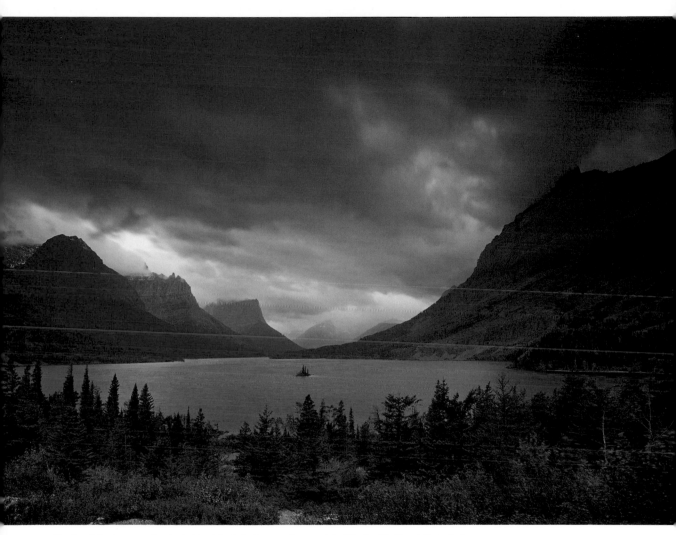

It rained for two weeks straight while I shot an assignment in Glacier National Park, but a two-hour drive before sunrise paid off. The sun broke through storm clouds to light the landscape above. Setting up my medium-format camera on my tripod and using a 50mm wide-angle lens set to the maximum aperture, I exposed for the deep red hue. I checked the rest of my scene to make sure the exposure held enough detail in other areas. The light disappeared not more than five minutes later.

1/4 SEC. AT ƒ/32, ISO 100, 50MM WIDE-ANGLE LENS SET TO MAXIMUM APERTURE

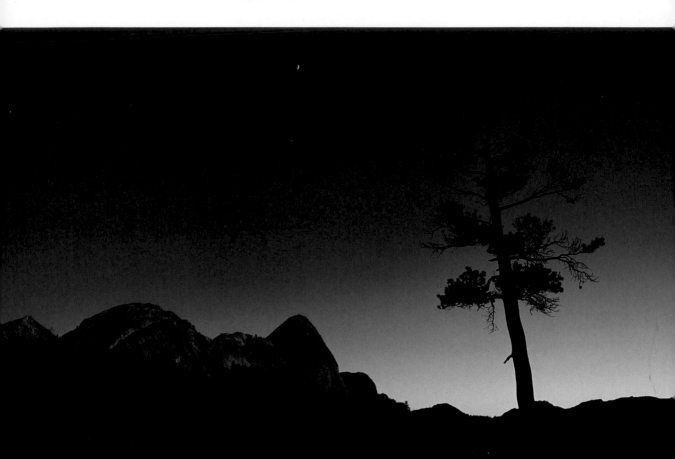

As I headed over to Pothole Dome in Yosemite's Tuolumne Meadows, I photographed a variety of scenes while the sun set. The strong yellowish-orange sunset hues turned to alpenglow, a reddish glow usually seen in high alpine settings. I set up this composition, used a tripod, and metered the granite dome and sky to find the best exposure to capture one of my favorite shots of the day.

1/4 SEC. AT ƒ22, ISO 50, 24MM F2.8 WIDE-ANGLE LENS

TIP LOOK TOWARD THE HORIZON JUST AFTER SUNSET

Just after sunset, a faint ring of cool hues appears just above the horizon in the eastern sky. It is usually distinct since, from the horizon, you see three bands of color—cool, warm, then cool again. This is the earth's shadow on the atmosphere, something wonderful to capture in an exposure.

THE MAGIC HOURS

Dusk and dawn are often referred to as the "Magic Hours" in photography due to the amazing hues that occur after and before twilight. Because exposures are much longer during these times, it is important to be aware of motion and to know how to use it to your advantage.

Pinks and purples reign during the Magic Hours, and capturing them usually entails exposing for their color. This can darken the rest of your landscape, but if you are going for drama, shape, and color over detail it can work well. Silhouettes set against brilliant skies make for good subjects, helping you take a negative—the contrast between lit sky and dark-shaded ground—and turning it into a positive.

Documenting the progression of light as it turns a multitude of colors is only one thing to consider during the Magic Hours. Always take a moment during the Magic Hours to scan the landscape around you in case there is a better angle from which to capture the light. The direction you are shooting is also important. If you are still facing west after the sun has set below the horizon, some of the best scenes are going on behind you.

Returning home from a sunset shoot along the coast, I watched the dusk sky begin to change color. I searched for a subject to set against it and came across this oak tree growing atop a ridge. I moved closer to the ridge, which helped separate the tree from the land, giving it a nicer silhouette shape, and exposed for the pink hues in the sky.
1/2 SEC. AT f/11, ISO 100, 80–200MM F2.8 LENS

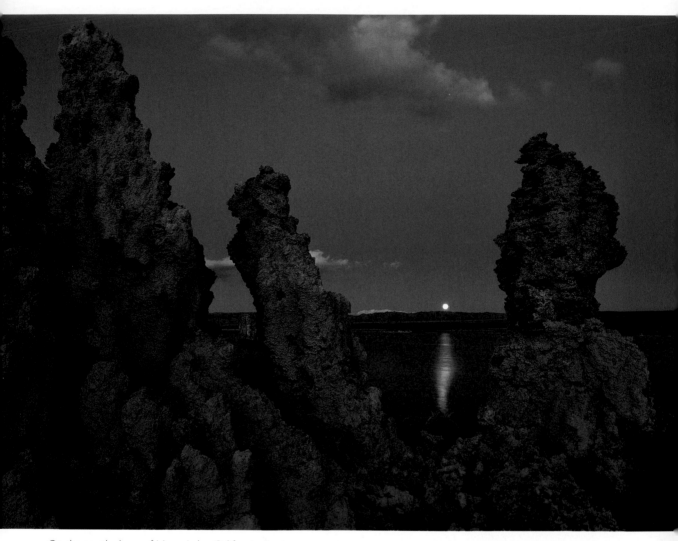

On the south shore of Mono Lake, California, I set up my camera, predicting the full moon would rise between the Tufa towers at sunset. The moon didn't crest the horizon until dawn, but the image was just as dramatic in Magic Hour's glow.
15 SECONDS AT ƒ/11, 50MM WIDE-ANGLE MEDIUM-FORMAT LENS

Twilight Exposures

There is a point during these Magic Hours, just around twilight at dawn or dusk, when your meter loses its ability to read the low levels of light and your exposures become a guessing game. At this moment, you can either use exposure value charts for your settings or continue to lengthen your exposure, estimating the light loss from your last reading. These exposures can be tough; see chapter 6 for further discussion.

ASSIGNMENT

Photograph a Side-Lit Scene and Capture a Solid Exposure in Manual Mode

Side lighting can assist your two-dimensional images in more ways than one. Find a side-lit scene to photograph. The light source must be perpendicular to the direction you are photographing, which usually occurs close to sunrise or sunset.

For this assignment, keep the following in mind:

❏ What should I meter for—the highlight side, the shadow area, or somewhere in between?

❏ Does this light add depth and dimension?

❏ Are my exposure settings appropriate for what I want to convey?

Record as many specifications and details of your selected image as possible, should you need to refer to them later.

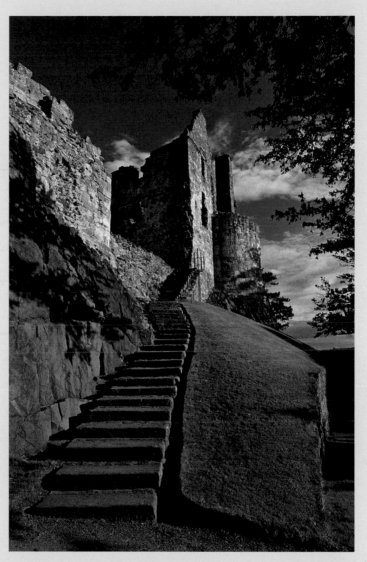

For this shot of Dirleton Castle, a twelfth-century fortress in the Scottish Borders, I waited until late afternoon to utilize the angle of the western light on the garden steps. I took meter readings of the sky, the lit side of the castle, and the grass to perfect my exposure.

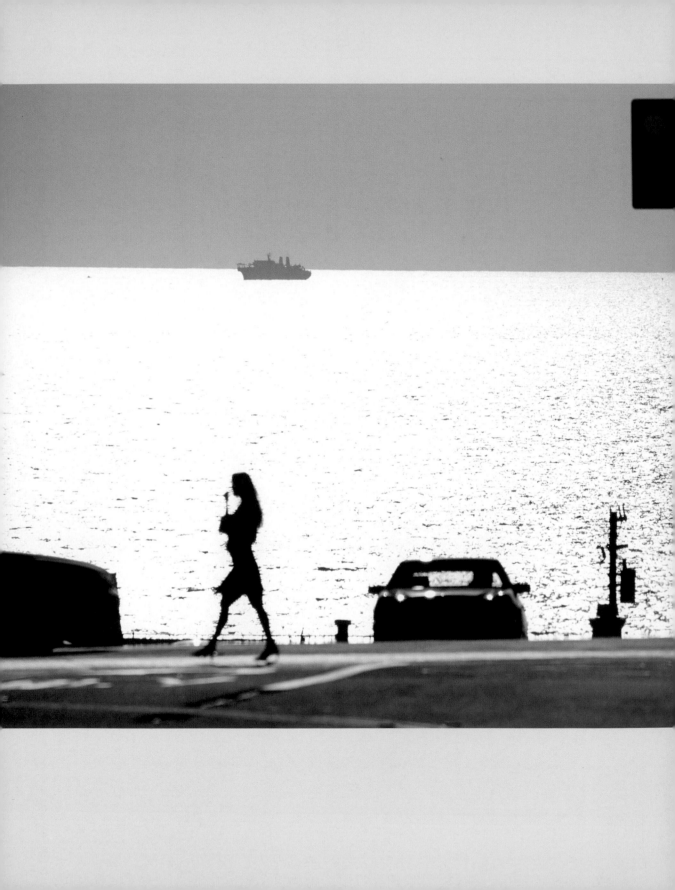

Difficult Exposures

MANY CAMERA MANUALS, websites, and photographic charts give equations or recommendations for various difficult exposures: *Use partial metering for backlit situations. Use a low ISO for daylight and a high ISO for low light.* And so on. I find that most of these suggestions are, for the most part, cookie-cutter offerings, advice too general for specific life situations. Every exposure problem must be dealt with in its own way. To build a tour de force of imagery, what helps the most is good old experience. That said, here are some general techniques I use when dealing with tough exposure scenarios. Use them as starting points for finding your own techniques, ones that will assist you in producing effective, unique imagery with your own spin on how you view the world. Abraham Lincoln once wrote, "Your own resolution to success is more important than any other one thing." Add to that experience, skill, and luck, and you can turn difficult exposures into gems.

Working Fast

In photography, it is often necessary to work fast. Whether you are shooting a portrait and have only a few minutes with your subject, whether the light is changing by the second due to the time of day or climate, or whether you are documenting a sporting event with fast-moving action and fleeting moments, perfecting your technique to move quickly and nail exposures becomes vital. Referring again to Ansel Adams, "Chance favors the prepared mind."

Working fast requires knowing how to light a subject, what to expose for, which settings to use, and what equipment to choose—a tall order, to be sure, but there are a few ways to work toward it.

It helps to develop a consistent way of photographing. This can mean deciding on a favorite metering mode, memorizing a range of *f*-stops and shutter speeds, figuring out how to meter certain tones, learning your camera menu functions and how to adjust them quickly, or setting up a system that makes it easy to find equipment in your bag.

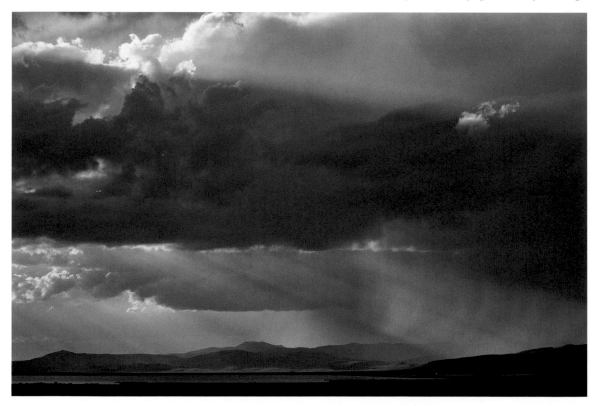

With a storm rolling into Centennial Valley in western Montana, the light was changing every second. My experience helped me choose the right lens and expose for the right tones, all the while capturing the ephemeral light. To expose the shot, I compared a number of spots in the scene, underexposing the clouds to match their deep tones while making sure the falling rain on the right was light and bright.

PHOTOGRAPHING IN QUICK-CHANGING LIGHT

One way to capture a good image in fast-changing light is to choose one area to meter, hopefully your main subject or other important part of the frame, and when the right light strikes that region of the frame, meter for it and shoot away.

Another method is to simply re-meter over and over as the light fluctuates. This seems pretty straightforward, but it's not easy to do when stops of light are changing fast and the only way to keep up is to meter repeatedly as you shoot.

> **TIP** BRACKETING
>
> Some photographers would recommend bracketing (see page 182 for a discussion of bracketing) as a way to capture good images in a fast-changing light. I disagree. Bracketing is good for some situations, but not when light is causing exposures to jump around.

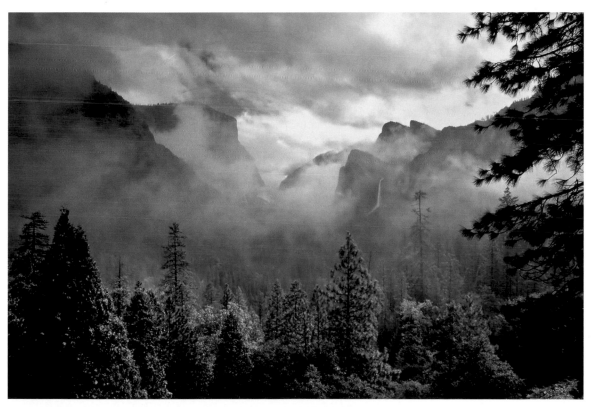

I stood for hours in the rain one October morning watching the light change over Yosemite Valley, one moment shrouded in clouds, a few seconds later dark and monochromatic from the heavy overcast light. Finally, the sun burst through, lighting the pines below me. Having predicted I'd need a graduated neutral density filter to cut the sky's exposure, I metered the scene and shot away.

1/4 SEC. AT ƒ/22, ISO 100, 24MM F2.8 LENS

CAPTURING MOVING SUBJECTS

Backgrounds and light can change quickly on a moving subject. One way to meter for this, especially if your subject is moving through a relatively consistent type of light, is to gauge your exposure from another object in the composition. Choose a tone that's easy to meter and set your manual exposure from this measurement. This will be the correct exposure for the general area.

Then you can lock in your setting and fire away at your moving subject until the light changes.

On occasions when your subject is moving fast in and out of shadows and sunlight, you may have to settle for using an automatic exposure mode, such as Program or Shutter Priority, while setting your specific metering mode. The auto metering might not produce perfect exposures every time, but it could still be the best solution.

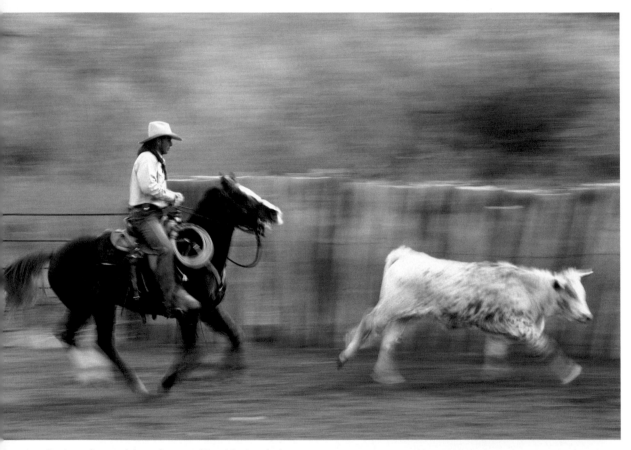

During a livestock branding at a New Mexico dude ranch, wranglers were darting in and out of sunlight as they rode around roping cattle. I couldn't meter, focus, and compose fast enough, so I chose to use Shutter Priority with matrix metering for a nice pan blur.
1/30 SEC. AT ƒ/11, ISO 100, 80–200MM F2.8 LENS, SET TO 200MM

▶ *In the Andes of South America, photographing this black and white condor in flight against a mountain dotted with dark rock outcroppings and snow was tough. I needed to set and reset my exposure, depending on the light and the area the bird flew over.*
1/1000 SEC. AT ƒ/4, ISO 100, 300MM F4 LENS

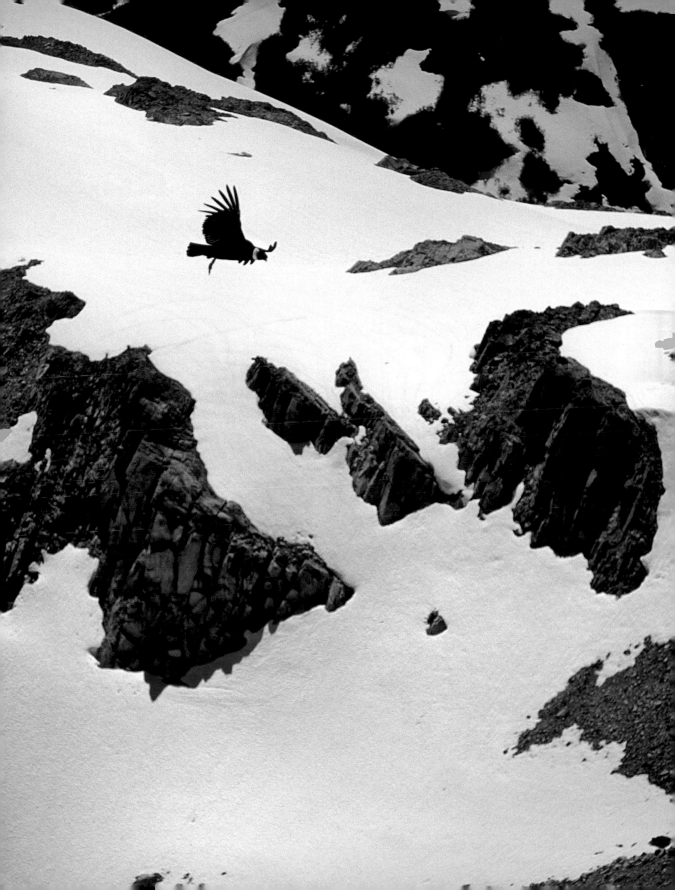

Dealing with Difficult Lighting Situations

Most photographers would list extreme contrast, snow, the moon, and bright reflections as the toughest exposures to handle (outside of artificial lighting). Every one of these circumstances can fool any photographer. Here are some general things to keep in mind when photographing in difficult situations:

❏ Find a consistent way to deal with the condition.

❏ Figure out how to use the environment to your advantage.

❏ Adapt to the circumstances and find an image that works better than the one you initially sought to capture.

REFLECTIONS

Reflections are light bouncing through angles off any shiny surface, including water, glass, metal, asphalt, and even leaves. Reflections can be your friend. They can add a spark or a glow to your image. If you expose for them, they can evoke a mood. If you underexpose the rest of the scene, as I did in the photo at bottom right, they can even become part of the subject. However, reflections can also cause hot spots on your image.

Reflections can be controlled with a polarizer, but you can often avoid or manipulate them simply by changing your point-of-view. Try to find a slightly different angle that cuts the contrast of a reflection or removes it completely. If you are photographing a small object, turn the object manually; if you are photographing a landscape, move yourself. Sometimes you can wait for something to block the reflection—a cloud briefly covering the sun and cutting the light or a person walking through the scene in front of the reflection.

Knowing how to meter a scene with reflections is an undertaking because a meter is influenced not only by the general area it reads but also by bright or dark spots close to the metered area. Many factors can cause a meter's needle to bounce around. If, for example, you are shooting sun reflections on water, every time a twinkle of reflected sunlight bounces bright light into your camera, your needle will also bounce. If you are in Manual mode, you might not know what exposure to choose. If you move to an auto metering mode, such as Program, Tv (Shutter Priority), or Av (Aperture Priority), your bouncing meter will give you different exposures every second. Generally, if there's something extremely bright, then dark, then bright again, the meter will be just as confused as the photographer.

Cutting the Weight of a Reflection on Your Meter

First, find a reference point in the same light or location you wish to expose for that allows your meter to remain steady while you determine your exposure. Take that reading, determine the correct tone, and set your exposure. Remember, however, that with this reading, if a reflection is extremely bright, the reflective surface will most likely be "blown out," or overexposed, in your image unless you change angles or use a polarizer. Re-metering the reflection to see how much brighter it is in stops can help you figure out if it will have a bright, white-with-detail tone or be a clipped highlight on your histogram. At this point you can decide whether to shoot, wait, block, polarize, or meter for the reflection.

Moments before I captured this shot, the sunset light reflecting off the Desert Princess's white paint was too harsh, creating extreme contrast. Waiting just a few seconds for the boat to turn slightly helped cut the reflection and produced a much better exposure.

1/250 SEC. AT ƒ/5.6, ISO 100, MEDIUM-FORMAT CAMERA USING A 50MM WIDE-ANGLE LENS

A bright reflection caught my eye from the summit of a peak overlooking the Salt Lake City area. Instead of trying to remove it, I used it to illustrate the flow of the highway below, underexposing the overall scene to highlight the light.

1/500 SEC. AT ƒ/4, ISO 100, 300MM F4 LENS

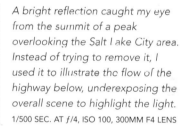

TIP PAY ATTENTION TO THE SMALL DETAILS

It's often the small things you address and correct that turn an average shot into a quality one. Great photography often boils down to the simple task of finding the right angle. Try moving a little to the left or right or up or down, or finding a better vantage point.

EXTREME CONTRAST

One of the toughest scenes to photograph is one in which contrast pushes way beyond your image sensor's dynamic range. In scenes with extreme contrast (as in this chapter's opening spread), you can't expect to maintain detail in both highlight and shadow areas, and possibly in neither if you meter for a middle tone.

Determining what to expose for always depends on the situation. Contrary to popular opinion, retaining detail in the highlights is not always paramount. When confronted with a scene containing tremendous contrast, ask yourself, "What's most important for the final image?" and expose for that.

Sometimes it's neither the highlight nor shadow detail but the overall feel of the image. In circumstances when highlight or shadow detail is most important, expose for one or the other. In the photo of the mountain goats, for example, a small amount of the highlight detail is lost at this exposure, but the overall scene works best—it just "feels right." When I shot this chapter's opening spread, I was pointing directly into the sun's reflection bouncing off the Pacific Ocean, my eyes barely able to look at it directly. If I'd exposed to maintain detail in the highlights, I would have lost separation between my middle and dark tones. Since this was somewhat of an abstract image, I chose to disregard the brightest highlight area, metered for the middle tones to silhouette backlit objects, and went for the moment. From the instant I noticed this scene occurring to the click of my shutter, I had maybe five seconds to determine an exposure.

Shooting straight up into the forest canopy, I chose to expose for a middle-tone area and sacrifice detail in the trunk and the foggy sky. This realistic way to expose the shot gives the image the feeling I had looking up with my own eyes: The tree appeared very dark, and the sky's brightness made me squint.

1/12 SEC. AT ƒ/5.6, ISO 100, 12–24MM F4 LENS SET TO 12MM

> **TIP REDUCING CONTRAST WITH ARTIFICIAL LIGHT**
>
> An alternative means to dealing with extreme contrast is to add artificial light with a flash or strobe. See chapter 7 for a discussion of artificial light.

> **TIP BEWARE OF YOUR OWN REFLECTION**
>
> Your reflection will often appear in an image when you shoot straight toward glass. A polarizer can't help, since it best cuts reflections at an incident angle of 30–40° degrees, so unless you are attempting to create an interesting self-portrait, beware that your reflection will usually distract from the overall photo. If you want to avoid or diminish your reflection, try changing your angle, wearing dark clothes, or making sure you are not in direct sunlight.

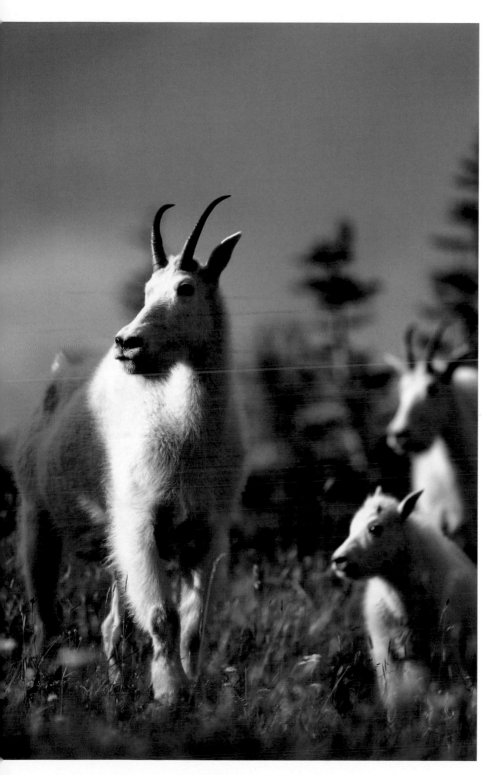

Since the mountain goats stood in shade, I felt maintaining enough detail in their shaded bodies would give me the best exposure for the image. I metered the goats' shaded chests and underexposed from the recommended exposure by 1⅓ stops. Double-checking my exposure, I metered the sky and found my setting would give it the correct tone: slightly darker than middle gray.

1/500 SEC. AT ƒ/4, ISO 100, 300MM F4 LENS

SHOOTING TOWARD THE SUN

I often look toward the sun to create dramatic, backlit outdoor images. Transparent and translucent matter such as water, leaves, or clothing practically glow when backlit by sunrays, adding an exciting, illuminant quality to a photograph. A well-defined silhouetted form offers a different look at a familiar subject. The sun can affect color in spectacular ways.

Yet, as with shooting bright reflections, shooting toward the sun causes many exposure concerns. Flare can become a major or minor issue, appearing in the photo as bright polygonal shapes and sometimes diminishing contrast to give a hazy look to an image.

Some extremely high-quality and expensive lenses give you the ability to shoot directly into the sun with very little flare, haze, or loss of color saturation. But even with these, shooting toward the sun causes an image to gain contrast while losing color saturation—a result of light directly entering the lens. You can use a lens hood or even your hand to block the light from entering the lens, but this wouldn't help if you want the sun in your scene.

Pointing into the sun causes the light meter to give a false high reading, potentially underexposing the scene. You can sometimes avoid this by blocking the sun with your hand or other object. This way, your meter is able to read the strong orange colors of the sky much more accurately, giving you the chance to expose for a saturated sky (metering the colors at or close to middle gray) or a lighter tone (overexposing from your meter's recommendation possibly by a half to full stop).

Turning your camera away from the sun can be another way to meter. If, for example, you want to expose for the sky, you can compose your shot slightly to the left or right to crop out the sun, meter the sky or your subject, set your exposure, and recompose the shot to include the sun again.

> **TIP** FLARE IS NOT ALWAYS YOUR ENEMY
>
> Some types of flare can actually enhance the artistic quality of a photo. Understanding lens flare can help you either avoid it or use it in a way that best suits how you wish to portray the final image.

I decided that the best shot of this resort location in Cabo San Lucas pointed southwest, which happened to be directly toward the winter afternoon sun. Instead of fighting it, I backed myself under a thatch roof, which allowed the sun to shine through without destroying the rest of the scene.
1/15 SEC. AT ƒ/32, ISO 100, WIDE-ANGLE LENS

The sun dropping below the clouds caused my scene to jump in contrast and, although the sun looked nice, the light became too harsh. But when the sun set partially behind the next layer of clouds, the overall scene softened in contrast, allowing me to expose for subtle colors and shadow details.

ABOVE: 1/250 SEC. AT ƒ/5.6, ISO 100
RIGHT: 1/125 SEC. AT ƒ/5.6, ISO 100

Gobos

One way to assist your exposures and reduce flare when photographing toward the sun is to search for an object—a tree, building, person, or cloud—that can obstruct the sunlight. Put yourself in the shadow of this object and you know the sunlight has been blocked. You can include this natural lens shade (called a "gobo") in your image or not; in either case, you've created an interesting exposure while removing a potential problem area—once again, taking a negative and turning it into a positive.

*For this shot along the
California coast, I lay down in
the dry grass as low as
possible and used the thistle
to block the setting sun.
Allowing it to peek out behind
the wildflower, I metered the
sky to the right of the sun and
captured the shot. The image
still gives the sense of the
light, but the scene isn't lost to
flare.*

1/2000 SEC. AT ƒ/4, ISO 100

MOON EXPOSURES

As an iconic symbol, the moon always seems to add a little something special to an image, but exposing for it is a whole different ball of wax.

Most recreational photographers overexpose the moon, often by quite a bit. This may be because their meter in an auto exposure mode is fooled by the black sky, or because they attempt to meter manually and use a longer exposure than necessary. Attempts to capture detail in the ground when shooting a rising moon after dusk often end with detail lost in one or the other.

When photographing the moon, usually the biggest problem occurs in the contrast ratio between it and the landscape or subject. Because the moon is often so much brighter than the rest of the scene, it is either very overexposed (turning it into a white ball) or well exposed with a heavily underexposed, now-silhouetted landscape. Believe it or not, a full moon is exactly the same brightness as the outdoors on a bright, cloudless day. Receiving full sunlight that it reflects back toward us, a full moon in fact follows the "sunny 16" rule (see the box on page 165). As the moon waxes or wanes, its brightness weakens, usually by 2½ stops in first- or third-quarter phases, all the way down to 10 or more stops as a crescent shape.

The moon is usually not dramatic when the sun is up, and at twilight it is too bright. Thus the optimal times to capture the moon are during dawn or dusk, usually ten to twenty minutes before sunrise or after sunset. At these times, the moon is distinct and there is still enough light on the ground to capture detail there. In the photo on page 164, if I had waited only another five minutes, the contrast ratio would have stretched outside my sensor's limits. Rising or setting full moons are some of the best moons to shoot; generally, they rise when the sun sets and set when the sun rises, sometimes providing beautiful light. Because I often shoot the moon in low light, I always bring a tripod along.

Some photographers use double exposure or Photoshop to add the moon in later, or to position it on the photograph where they wish. Unless this is done extremely well, the moon often appears fake or strange. I do this on rare occasions; when I do, the photograph turns into a photo illustration, and I label and market it that way.

Out in a cactus forest at midnight along the Baja coast to photograph the full moon, I found myself in an extremely high-contrast, not to mention creepy, situation. Since I couldn't capture the moon with detail in the landscape, I decided to backlight a cactus, assisting the scene to a stronger exposure.
8 SECONDS AT $f/3.2$, ISO 100, 125MM MEDIUM-FORMAT LENS

As the sun set over southern Baja and the sky darkened just a bit, meter readings from both the landscape and the full moon came together.
1/30 SEC. AT ƒ/5.6, ISO 100, 60MM LENS

TIP BE PREPARED
FOR YOUR MOON SHOTS

It helps to know what phase the moon is in and when it will rise and set. There are many calendars, charts, and software programs that provide you with times, moon phases, and more; these help you prepare for a scene even before it occurs.

The Sunny 16 Rule

The sunny 16 rule provides a general exposure setting you can use on a bright, sunny day or a clear, full-moon night. First, set your camera to *f*/16. Next, determine your shutter speed by adding a 1 over your ISO number; for example, if you are using ISO 200, then you'd use a shutter speed of 1/200 sec.

Knowing shorebirds often take flight when they feel the warmth of sunrise, I pointed my camera toward the setting moon, positioned myself to include the birds, and hoped for the best. The sunny 16 rule gave me my exposure for the full moon, and using an equivalent exposure allowed me to shoot fast. All I had to do then was snap the shutter at the perfect moment.

1/1000 AT *f*/4, ISO 100, 400MM LENS

Skin Tones

A face can often be the main subject in a scene, so knowing how to meter for it is essential. In automatic exposure mode, the meter would turn everyone middle gray in tone. To avoid this, I use Manual exposure and my spot metering mode.

I like to come in close to read the reflected light off of the person's face. This way, I eliminate any influence on my meter that may occur from my original shooting distance (even without focusing my lens). The same can be accomplished from a distance with a zoom or telephoto lens, although experience has taught me that different tones around the face that are far brighter or darker will somewhat influence the meter.

Although I had numerous tones to meter from in this scene, I knew I could meter this boy's face and overexpose from the recommended exposure to match his skin tone.
1/125 SEC. AT f/2.8, ISO 64, 35MM LENS

Here I had the difficulty of retaining the man's skin tone while exposing his white uniform well. Since I couldn't expose for one without losing detail in the other, I chose to bounce in light on the man's face, cutting the contrast ratio while preserving his proper tone.
1/250 SEC. AT f/3.2, ISO 100, 125MM MEDIUM-FORMAT LENS

Exposing this Malaysian woman's face wasn't difficult since her skin tone comes close to middle gray.
1/500 SEC. AT ƒ/4, ISO 100, 300MM LENS

Underexpose or Overexpose to Recreate Accurate Skin Tones

We wouldn't expose a dark brown face the same way we would a light pink face. To capture the deep skin tones of a brown face, you would need to underexpose from the meter's recommendation almost 1½ to 2 stops. To accurately reproduce a pale pink tone, you should overexpose from the meter's middle gray recommendation, anywhere from 2/3 to 1⅓ stops.

Snow

When it comes to metering, snow is one of the biggest subjects to fool both photographers and meters, with most underexposing the bright, granular material. Snow also acts as a reflective surface. This can be beneficial, bouncing light onto subjects and surroundings, but it can also bounce light into the camera's lens, adding potential flare. Generally, exposing snow comes down to tones: For snow in sun, overexpose for white with detail; for snow in shade, meter it closer to middle gray; overexpose snow when it's backlit; and so on.

Here are a few key tips for exposing images with snow:

❏ Open up at least 1⅓ stops when you begin to meter snow. At least you know you are closer to its true tone than middle gray.

❏ Determine whether the snow is truly white, light gray, or even middle gray (such as snow in shade). Use the squint test (see page 82) to compare surrounding tones for a better shot at guessing correctly.

❏ Compare your reading of snow to other subjects to make sure you haven't dialed in a setting that over- or underexposes the rest of your scene.

As I photographed cross-country skiing in a storm, my exposure jumped around from shot to shot due to the rapidly fluctuating light. When I noticed the sun beginning to appear from behind the clouds, I set up a shot to backlight my skier and, using a two-stop graduated ND filter, exposed the scene before the contrast ratio jumped sky high.
1/125 SEC. AT ƒ/11, ISO 100, 24MM LENS

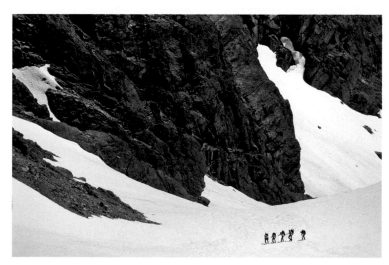

Bright overcast conditions helped to cut the contrast ratio in this mountaineering scene. Determining that the snow was closer to light gray than bright white gave me a starting point. To confirm my exposure, I compared my setting to see if I'd underexposed the rock by 1⅓ stops.

1/500 SEC. AT ƒ/4, ISO 100, 300MM LENS

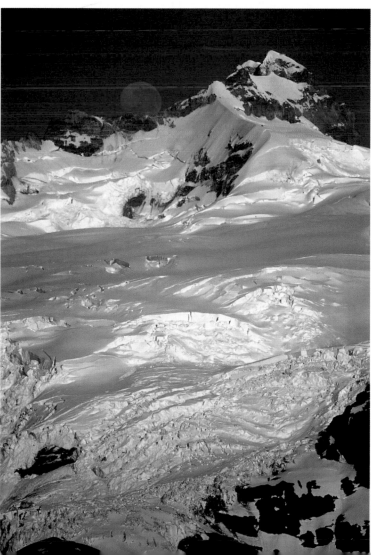

As the first rays of sunlight touched this Argentinean glacier, I had the option to meter the snow and simply overexpose by two stops; instead, I chose to determine the glacier's true tone. When I compared the final exposure to the deep, blue sky tone, the meter showed that I'd underexposed the sky by 2/3 stop, telling me that I was in the right ballpark.

1/250 SEC. AT ƒ/4, ISO 100, 300MM LENS

Fog

Fog is a wonderful facet of light and weather. It can enhance your images in a myriad of ways, from the "muddy" look of a heavy, overcast fog, to the ethereal light at the edge of fog and sun, to the heavenly mood of sunny conditions over clouds or thick ground fog. Since contrast is consistently cut way down under foggy conditions, I tend to search out monotone scenes that stress shapes and tonal differences over detail and color.

There is no one correct way to expose for fog. You might be shooting light gray fog one moment and thick gray fog the next, fog backlit with the morning sun shining through, or fog front lit at dawn.

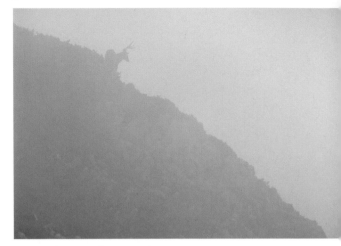

Shooting in pea-soup fog along the Point Reyes coastline, I noticed this tule elk feeding below the ridge. I waited patiently for him to crest the ridge, knowing that at that point his silhouetted shape would stand out in the landscape.
1/60 SEC AT ƒ/4, ISO 200, 300MM LENS

▼ *Forest scenes are often too contrasty in sunny conditions. The soft light of fog can cut the contrast, creating a mystical look in woodland imagery. For this shot, I set up my tripod and waited for the moment when the fog would separate the trees through tones.*
1/2 SEC. AT ƒ/22, ISO 100, 50MM LENS

Overcast

Some of my best images in photography—not to mention my finest moments in life—have come when I have taken a negative and turned it into a positive. Such is the case when photographing in overcast conditions, whether a bright overcast, when the sun's form is visible through the clouds and casting light shadows, or a heavy overcast, where both good images and shadows are hard to find. Colors are often muted in overcast light, the red barn losing its punch and the monochromatic forest turning into monotone shapes and forms.

Overcast conditions can cause a loss or heightening of contrast, depending on the direction you shoot and the sky's brightness versus the ground's exposure. Sometimes choosing a different direction to shoot or waiting for the light to change can help your exposure.

A misty morning on the California coast forced me to search for scenes complementary to the soft light. This ranch made for a perfect fit of soft tones, subtle details, and overall peace.
1/60 SEC. AT ƒ11, ISO 100, 80–200MM F2.8 LENS

Some Rules for Shooting an Overcast Scene

❑ Overexpose just slightly from your determined exposure. This adds some punch to the scene and avoids a largely dark or drab look.

❑ Avoid using a split or graduated ND filter, as the line of delineation can be easily detected in the final image. While it seems appropriate to add a two- or three-stop grad ND to darken a bright overcast sky, unless it's done in the perfect situation, the resulting image tends to look strange or unnatural.

❑ Steer clear of including a white overcast sky in your image, not only for exposure concerns, but for general aesthetics as well.

▲ The overcast light was perfect to render this velvety pastoral scene near Salinas Valley, California. I eliminated the bright sky from the composition to cut the contrast way down and used my tripod.
1/30 SEC. AT ƒ/11, 80–200MM F2.8 LENS, SET TO 100MM

▶ The heavy, overcast conditions on a beach in southern Baja eliminated most potential images. Instead of fighting this, I searched for a different direction to shoot. When, over the course of an hour, the light opened on a small patch of sky just above the horizon, I captured this ocean scene. I found a middle tone to meter, compared it to the brighter rays and darker clouds above, and shot away.
1/500 SEC. AT ƒ/4, ISO 100, 300MM F4 LENS

Bad Weather

The answer I give to students who ask me how they can capture better photographs when rough weather prevails is simple: Wait. The weather is bound to change at some point. Regardless of how well you expose a scene in heavy overcast or rain, the image will most likely look muddy, unexciting, or dreary. There are, however, a few techniques that ensure you will make the most of the situation.

During a storm, look for patterns in the weather. If you wait patiently and watch for the right break in the clouds, your odds of finding a quality image greatly improve. The light can change from average to amazing in seconds, and the contrast ratio can jump quickly as well, giving your scene new life.

If you can see the light that is about to strike an area, meter another spot that holds the same light, pick an appropriate exposure, set your Manual, and wait for the light to shift to the spot you fancy. Become part meteorologist, part photographer by trying to determine what might happen over the next few minutes.

Finally, think small. You have a better chance of capturing quality images in less-than-perfect weather conditions if you concentrate on details instead of grand scenes.

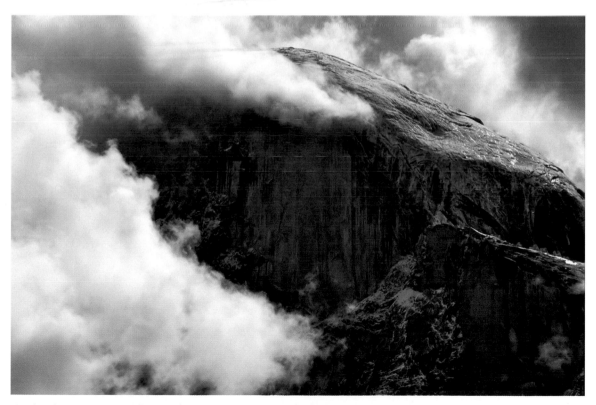

On this day in Yosemite Valley, the weather was rough and the light was as mediocre at best. My only hope of capturing Half Dome amid the clouds was to wait for an opening and be ready when it came.

1/125 SEC. AT ƒ/5.6, 300MM F2.8 LENS

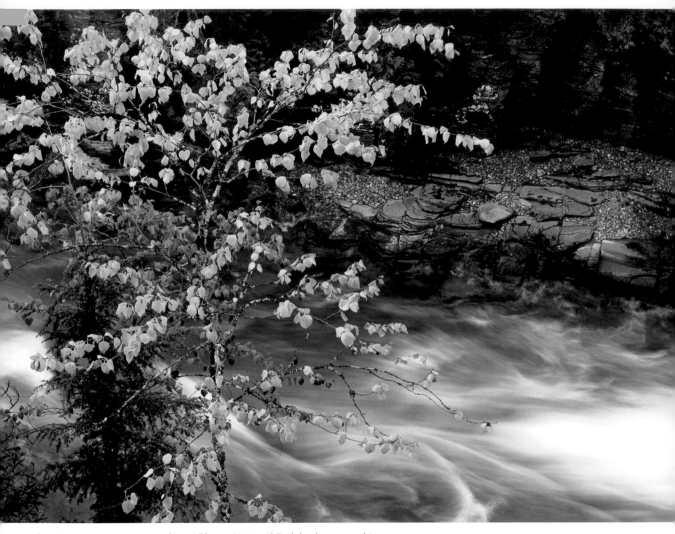

Scouting scenes on a rainy day in Glacier National Park had me searching for vignettes of nature. This detail along the banks of MacDonald Creek made it possible to capture a nice fall scene in unpleasant weather.

TIP **THE VIRTUES OF PATIENCE**

Patience is an integral part of the process of photography. Often it is patience that determines whether you capture an average shot or an extraordinary one.

The Harsh Light of Midday

As I began to document cities and towns, vacation spots and island getaways for magazines, it became clear to me I had a few obstacles to overcome. Language barriers and the rigors of travel were the obvious difficulties. A more surprising challenge came from the habit of most travelers to stroll or shop between the times of 10 A.M. and 4 P.M. This presented quite a problem, for it meant photographing town squares and shopping areas during the harshest times of day in regard to lighting. No editor wants to see images with splotchy lighting, little color, and high contrast when laying out a travel article on a beautiful location. So I needed to quickly learn a few techniques that would help my photos appear a little better than the light would allow.

For example, I found that shooting low, to include a clean sky while backlighting my subjects, could create better scenes in unforgiving conditions. Working in shade also improved my exposures, giving me better control while decreasing the contrast ratio.

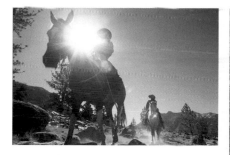

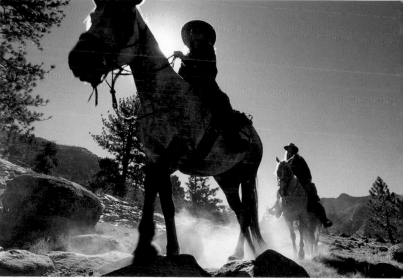

Scenes of Sierra horseback riding during the mid-morning offered little in the way of quality lighting. By lowering my angle and blocking my camera from the sun, I was able to create a more interesting composition, provide a clean background to help my subject stand out, and add a dramatic effect to the lighting. The first attempt was a miss; the next image made 1/250 SEC. AT f/11, ISO 100, 24MM F2.8 LENS

TIP COMPOSE YOUR SHOT WELL

A well-composed scene lessens the effects of poor lighting by drawing the attention to the subject matter instead of the light.

To maximize my shooting time while in Mexico, I chose to find shaded scenes in a town near Mazatlán at midday. This furniture maker made for an interesting subject, and the soft ambient light helped me expose quality images.
1/25 SEC. T ƒ/3.2, ISO 100, 50MM LENS

▼ As I drove Nevada's desolate Highway 50, I didn't expect to find a scene at high noon, but as I passed this large tire, I knew there was an image in the making. I parked my car so that it lined up with the center of the tire, set up my camera, turned on my self-timer, and jumped into the frame to capture the image and composition I was hoping for.
1/15 SEC. AT ƒ/22, ISO 100, 24MM F2.8 LENS

Color

It is a common misconception that if you capture a solid exposure, the color in the image will be the best representation of what your eyes saw. This isn't always the case. Color is controlled through exposure as well as through lighting. If you desire lighter, washed-out colors, slightly overexpose your scene. If you want stronger, saturated colors, slightly underexpose it. Reds turn pink with overexposure, bright yellowish-orange changes to a tawny hue with underexposure, and so on.

Sometimes you can expose color by converting it into a value or tone to determine if it's brighter or darker than middle gray. This works for most, but not all, colors. Extreme colors, like saturated, overpowering reds, yellows, or blues, can fool your meter, causing it to bounce all over; if you go with the meter's recommendation or shoot in automatic, the scene will be poorly exposed.

In these cases, try one or more of the following techniques:

❏ Practice and play. Experience helps you gain the knowledge you need.

❏ Reference off of another object and compare the metering.

❏ Let your histogram assist in judging whether the image sensor can handle the color you are exposing by checking the height of the pixel amount.

Some values help us expose better by their relative consistency. Such is the situation with the sky. If you're shooting a scene that consists of sky, or if the light is even across the sky, with no clouds to shade your subject, you can find an accurate meter reading for the entire scene just from part of that sky. Knowing where to read and how to keep the sun from influencing your meter are key. Northern and southern skies are usually darker than eastern and western skies, due to a natural polarization of the sky and the atmos-

phere. Eastern and western skies are often extremely close to middle gray, giving you a reference point to use if, say, you're shooting a snow scene. Take note that the middle gray reading is usually somewhere between the horizon and the apex of the sky above your head.

To capture a graphic detail from this cruise ship, I used a polarizer to cut reflections and slight underexposure to produce the deep rich hues.

By metering the various orange tones in the distance, I was able to underexpose the overall shot. This gave me saturated hues throughout the scene, as well as the silhouette I desired.

▼ Metering this backlit blade of grass had me overexposing from the middle gray recommendation by almost 1½ stops to achieve the correct tone. If I had front lit the same piece of grass, my final exposure would have been completely different.

Distinguishing Tonal Value in Certain Colors

Tonal change and contrast in a scene can come from color as well as lighting. Place a person dressed in all white against a black wall, and you have separation through contrasting hues. When you meter a color, determining its tone can be crucial to your exposure.

Don't Let Your Eyes Fool You

Consider the various tones in green grass. At a quick glance, grass may seem to have a uniform tone, but if you compare light grass to dark grass, backlit bright emerald grass to front-lit dark green grass, grass in sunshine, shade, and overcast light, you will see quite a mixture of tones.

Night and Extreme Low Light

Correctly exposing images at night is always difficult. While in some cases, an exposure can be measured virtually anywhere, there are situations where an exposure cannot be determined at all. These require either your best "guesstimate," tests, or field experience. Exposure value charts (see chapter 1) can be good starting points, but these do not give accurate measurements for every night scene. Bracketing (see page 182) can be useful, but only in situations where the light doesn't fluctuate a great deal.

Through trial and error, I discovered that the balance of ambient light and artificial lights (street lamps, restaurants, office building interiors, etc.) usually occurs roughly thirty minutes after sunset. Of course this depends on the brightness of each artificial lighting situation, but again this can give you a general place to start.

Low-light situations can create wonderful photographs, but they also present a mix of exposure concerns. There is a point when light gets so dim, such as the minutes while twilight turns to night, that our meters cannot take any measurements to recommend an exposure. Once again, at these times, you can turn to educated guesses, EV charts, or bracketing.

The reason we don't see colors well at night begins, of course, in our eyes. Rods and cones are the two forms of photosensitive cells in our retinas that are key to vision. Rods, highly sensitive to light, function best in low light and allow us to see at night, but they don't give us the ability to detect color. Cones react to separate wavelengths of light and facilitate our ability to see color, but they work best in high levels of light, not at night. Our eyes contain roughly twenty times more rods than cones.

Fortunately, when it comes to color, image sensors and film don't have this limitation. They see color regardless of the levels of light available, and they document the color through exposure.

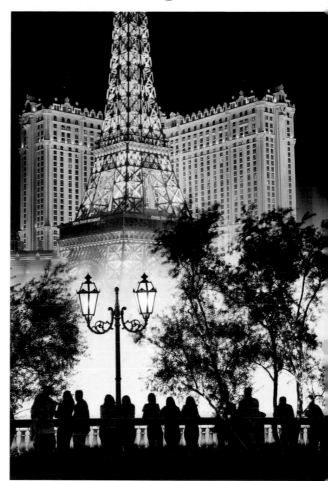

The large light source of the Paris Las Vegas Resort along the Las Vegas Strip allowed me to get a general meter reading to apply to this scene. Although the exposure from the Bellagio water show was brighter than the rest of the scene, the trees helped to block some of that light, giving me a nice overall night exposure.
8 SECONDS AT *f*/4, ISO 100, 125MM F3.2 MEDIUM-FORMAT LENS

Waiting more than half an hour after sunset let me balance the light from the resort with the ambient light of dusk to create this grand scene overlooking the Sea of Cortés.

15 SECONDS AT $f/5.6$, ISO 100, 50MM WIDE-ANGLE MEDIUM-FORMAT LENS

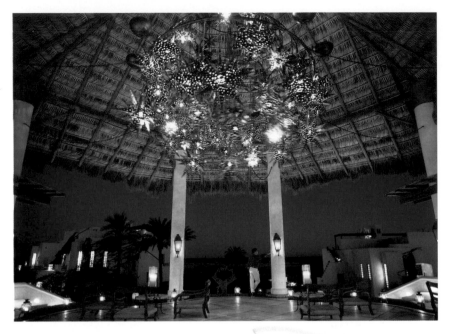

Shooting the Stars

If you want to capture star trails in the night sky, the light is often so dim that any time exposure at a large aperture can result in a decent exposure. If you want the stars and the Milky Way to appear as pinpoints, as opposed to star trails, here is a great equation from Jennifer Wu, a wonderful landscape photographer:
Divide the number 500 by the lens millimeter length. This equals the shutter speed in seconds, using ISO 1600 and a wide-open aperture such as $f/2.8$ or $f/4$. In equation form, *500/lens = seconds at ISO 1600 at maximum aperture.*

So, if you're using a 50mm lens, your shutter speed would be 10 seconds at $f/2.8$ using ISO 1600. If you use a 24mm lens, your exposure would be approximately 21 seconds. Of course, you can lengthen the exposure if you wish, but you risk movement in the stars.

Reciprocity

Those of us who once used film for nighttime photography are aware of what is known as reciprocity failure, a condition in which film, in combination with long exposures, behaves differently from its normal state. This would necessitate that the photographer use a longer exposure to compensate for the loss of light exposed onto the film. Digital cameras do not suffer from reciprocity failure. Long exposures in dark conditions tend to create only minor digital noise or random blank artifacts in the final image.

▶ *Unable to meter the full moon's light illuminating El Capitan in Yosemite, I set up my 24mm lens and guessed at the best exposure. I exposed the scene for five minutes at $f/4$ using ISO 100 and captured the lit monolith as well as some short star trails rotating around the North Star.*

5 MINUTES AT $f/4$, ISO 100, 24MM LENS

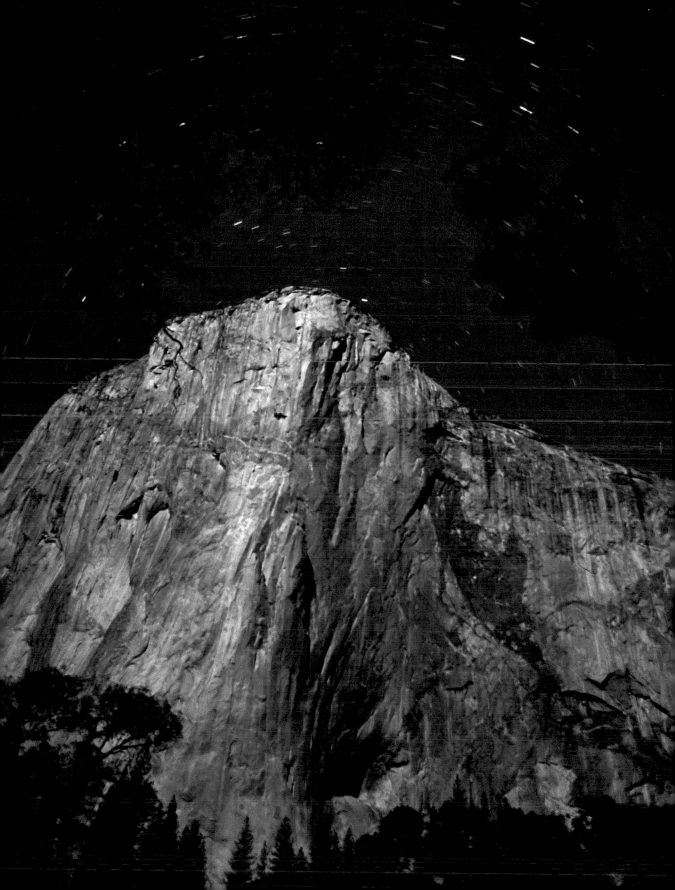

Bracketing

Bracketing is a technique in which you use a number of separate exposures to capture one scene. Usually, you start with a middle exposure and follow this with a dark and light one on each side of that first setting. Many photographers take three shots, although you can bracket as much as you wish, and some bracket in 1/3-stop, 1/2-stop, or 1-stop increments. But it all depends on how extreme the scene is and how much of a range there is to consider.

Bracketing is great to use in high-contrast scenes because it gives you the chance to compare shots and determine which exposure works best—whether the exposure that included detail in the highlights, the one giving detail in the shadows, or one somewhere in between. Bracketing may also be helpful in a backlit situation where you can't get close to your subject or when a strong light source is influencing the meter.

Here are a few other circumstances for using bracketing:

❏ When photographing a scene for which a number of exposures could work, each one giving a different feel or exposing a different aspect of the frame

❏ When capturing a scene with extreme color (always a difficult exposure to determine), in which subtle bracketing, by 1/3 or 1/2 stops, can help find the best exposure

❏ As a tool for learning about exposures—by comparing each image setting after the fact—and as a way for finding a consistent method to expose certain scenes

❏ When you are creating a High Dynamic Range (HDR) image (see page 216), where bracketed exposures are combined to stretch the range of detail between highlights and shadows

❏ When traveling in a beautiful place that you won't be coming back to, as a nice insurance against missing a great shot.

Many photographers rely too heavily on bracketing. There are so many cases where bracketing may mean missing a crucial moment. In many situations, the best shot can be captured only in one frame, such as when shooting wildlife, sports, or any fast-action subject matter. When the light is changing fast, as when clouds move in and out of the sun in seconds, bracketing may prevent you from coming up with any correct exposure. There are other drawbacks, too. Bracketing distracts the amateur photographer from important aspects of photography, such as lighting, composition, and subtle details. Also, too much bracketing fills up your memory card with bad exposures, and you end up spending too much time reviewing too many images.

With the low light causing my meter to fail, and faced with the contrast between the bright dusk sky and dark rock, I was forced to bracket three images of Hoover Dam. My main exposure turned out as I'd hoped; even so, having brighter and darker exposures to compare was helpful.

45 SEC. AT ƒ/32, ISO 100, 50MM MEDIUM-FORMAT WIDE-ANGLE LENS

Double and Multiple Exposures

In double and multiple exposures, one or more captures are combined to create a single well-exposed image.

In chapter 1, you learned that one stop of light is either half or double the amount of light entering the camera. Part of the process of creating double or multiple exposures is to use this information in combination with a little math to create a solid exposure. In reference to exposure settings, one stop cuts the light by a factor of half. Thus, if you want to create a double exposure, you must shoot two images, both underexposed by one stop, and combine them to get a correct double exposure. If you choose to create multiple exposures, such as four shots on one frame, then you must underexpose each of the four shots by two stops and combine them to get one solid exposure.

There is an important aspect to note about double and multiple exposures: Once an area is fully exposed to white, it cannot be exposed with any other color. This is one reason why you don't see multiple exposures shot in snow. On the contrary, if your subject is against a black background and on the move, underexposure won't work. In this case, exposing for the scene as in any other normal setting is the way to go. Why? Because the dark or black background never becomes exposed in all of the shots and therefore can't be added to another to create a correct exposure.

While teaching a workshop along the California coast, I exposed two scenes onto one frame. The first was a macro shot of the wildflower; the second was a detail of the plant itself. Since both images had dark areas, to the right of the macro image and to the left of the plant, no underexposure was needed.

1/60 SEC. AT *f*/3.2, ISO 200

ASSIGNMENT Document a Solid Exposure Including the Sun

The sun is the brightest object in the sky, and its influence on your meter can be great. For this assignment, find and capture a well-exposed scene that includes the sun, whether at sunset or during the day, when you would use an object to block the light.

When you are exposing your scene:

❏ Consider the sun's influence on your meter reading.

❏ Recognize the potential for flare.

❏ Make sure your subject is well lit.

As always, record as many specifications and details of your selected image as possible (including specifics of the filter you use, metering mode, shutter speed, *f*-stop, lens, filter, and exposure mode), in case you need to refer to them later.

I found this dock framing Jenny Lake in the Grand Tetons and decided to shoot a canoeing scene. When I returned with my models, I realized I would have to shoot directly toward the late afternoon sun. By stepping back a bit and using a small aperture, I was able to partially block the sun and give it a star effect, adding a spark to the shot. Since my main subjects were in the canoe, I metered the water around them and used that reading as my middle gray guide.

Flash

ON A PLANET with only one light source, the range of light can be so large that it far exceeds the latitude of a camera's image sensor. Even early on, all the way back to the mid-1800s, flashes and strobes played a huge role in compensating for this limitation, although then they were cumbersome and difficult to use. Fast-forward 150 years. Although flash has made leaps and bounds in regard to the ease of implementation, it is still a difficult device for most photographers to control. Artificial light used improperly causes an image to have an unnatural look. Like any other technique in photography, using flash requires knowledge, practice, and analysis of your mistakes and successes.

How Flash and Alternative Light Sources Add to Your Exposures

For the most part, flash is used indoors to light an otherwise dark room, but this doesn't mean you can't use it in bright daylight, with a long time exposure, or even in the middle of a snowstorm. Flash is simply a tool that lights an object or subject—anything from as large as an elephant to as small as a shadow below your cheek. Flash can make an object stand out or it can add just enough light to show its detail.

Our camera's image sensor only carries a five- to six-stop range of detail. Alternative sources of light—such as flash, strobes, fill cards, and reflec-

tors—can fill in the gaps to "fix" otherwise poor-looking exposures; they are, in effect, extensions of your sensor that allow you to add to or modify the lighting and fine-tune your exposures.

Some may say, "Yeah, but I can do this almost as effectively by using Photoshop." This may be possible in some cases, but even then I prefer to get as much as I can in camera first. This cuts my post-capture computer time and adds a unique quality to my final imagery. In some cases, Photoshop effects can have degrading consequences, such as additional noise or an unrealistic look.

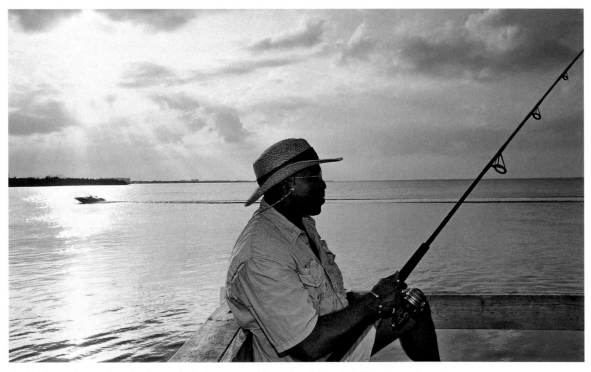

Backlighting this angler, who has a dark skin tone, while maintaining detail in the surrounding scene was only possible through the use of flash. I metered the background, overexposed it slightly to match the feel of staring into the bright light, and then dialed my flash power down to create subtle light in the shadows.
1/25 SEC. AT ƒ/16, ISO 100, 24MM LENS, WITH ON-CAMERA FLASH IN TTL AT –1⅓ STOPS

I utilized three sources of light to expose this sixteenth-century Bellarmine jar at the Tropical Crane Point Hammock Museum in the Florida Keys. My main "key" light lit the right side, a gold fill card "kicked" light in on the left, and a second strobe lit the background. Attempting this shot with my on-camera flash or the available light wouldn't have given me the quality results I achieved.

1/250 SEC. AT ƒ/4, ISO 100, 125MM MEDIUM-FORMAT LENS

Artificial Light in Motion Pictures

Cinematographers routinely employ hot lights (large lamps that offer continuous light) to illuminate a scene. This gives them the ability, for example, to show detail in an actor's face even when it's backlit, or to show at once both the interior of a room and a well-exposed exterior, which are normally far apart in their respective exposures.

I wanted to capture the wonderful view from my window and at the same time give the viewer a sense of where I was. This required including part of the room's interior in my composition. I metered for the landscape and used my on-camera flash to expose the much darker room.

1/30 SEC. AT ƒ/11, ISO 50, 24MM WIDE-ANGLE LENS

Types of Flash

When it comes to extra bells and whistles in photographic equipment, some are more important than others. A high-quality flash with full control is one of the best. Built-in or pop-up flashes can be useful for creating nice exposures, but they do not usually offer enough control.

A flash meter allows you to measure the light directly from a flash by placing the meter in front of your subject, pointed toward the strobe, as you test fire it. (This is similar to incident metering, discussed in chapter 3.) Since most flashes fire at an extremely fast rate, the brightness of a flash is usually measured through the aperture reading on the meter, not through the shutter speed. If you

An overhead strobe gave shape to this replica of a Homo sapiens skull, and I was able to add dimension to the shot by using a large aperture with minimal depth of field.

1/250 SEC. AT ƒ/3.2, ISO 100, 125MM MEDIUM-FORMAT LENS

meter the flash at ƒ/8 yet want to shoot at ƒ/4, then your options are either to decrease the power or intensity of the flash, move the flash farther away from your subject, or a combination of both. The same theory applies to subjects and distance. The farther away the subject is from the camera, the larger aperture and/or ISO you need, since flash or strobe light diminishes with distance. The actual aperture or ISO depends on the power of your flash system.

DECIDING HOW MUCH FLASH TO USE

A flash light comes and goes fast. The biggest difficulty when working with flash is the ability even to see its light, let alone scrutinize it. With the advent of digital and an LCD screen, you can check after the fact to determine whether the flash was too strong or too weak. However, I don't recommend that you verify if the exposure is dead-on while you're taking the shot. Adjust your flash at this point and the light and your subject may move or disappear. Most end up playing the guessing game when deciding how much flash to use.

FLASH SYNC SPEED

Even though flash isn't measured through shutter speed, all cameras have a flash sync speed, which defines the shutter's limit. Flash sync speed allows enough time for the shutter to open, the flash to fire, and the shutter to close; on most cameras, it is about 1/250 second (refer to your camera's manual). Choose a higher shutter speed than the flash sync speed, and most likely not all of the flash will show up on your final image.

Why might this be a concern with exposures? If you are photographing fast action or shooting in a brightly lit condition where you wish to use a large aperture such as ƒ/2.8, you may require a shutter speed faster than 1/250 second. If you

Common Basic Flash Modes

Icon	Flash Mode	Description
⚡AUTO	Auto-Flash	Auto-flash is the default mode in most camera systems, automatically firing if the camera thinks a scene needs more light. It is similar to automatic exposure modes in that you are depending on the meter to determine the intensity of the flash.
⊘	Disabled Flash	In this mode, you can disable your flash and shoot in low-light situations where it would otherwise go off automatically. Consider this mode on occasions when flash can ruin the mood of dramatic natural light.
⚡	Forced Flash	Regardless of the lighting situation, if the flash is in this mode, it will fire on every press of the shutter (unless it cannot charge fast enough, such as in a rapid-fire sequence). I like to use this mode when I know I want flash but recognize that the camera may not fire it due to available light.
⚡SLOW	Slow-Sync Flash	This is a semiautomatic mode that allows a longer shutter to expose the background, which is usually not lit by the flash. It's good to use when shooting moving subjects: The slow shutter shows movement while the firing flash stops the action, making for a potentially nice combination.
⚡👁	Red-eye Reduction Flash	Red-eye occurs when our eyes are dilated in low-light conditions and the light reflects off the back of our retinas. In this mode, the flash "pre-flashes" a few times before firing, to contract our eyes and reduce any red-eye effect. The same effect occurs in animals, usually in a different color, but using this feature may scare them away.
⚡REAR	Rear-Sync Flash	Flashes usually fire at the start of an exposure, when the shutter first opens. In this mode, the flash fires at the end, right before the shutter closes. This is useful to show forward movement of subjects in action.

want to use your flash in these situations, you must do one of the following: Close your aperture to help lower your shutter speed to the flash sync speed or below, use a lower ISO, attach a neutral density filter to cut the light, or simply turn off your flash.

ON-CAMERA FLASH

On-camera is self-explanatory, referring to any flash attached to your camera. Most on-camera flashes or flash systems carry a range only of 20 to 60 feet; once your subject is beyond these maximum distances, it receives too little light for proper exposure.

With on-camera flashes the light comes directly from the camera, a front-lighting scenario that often causes the subject to take on a flat look. Due to the flash's small direct light source, the subject blocks the flash from hitting any background object, which casts a strong shadow behind the subject. In flash shots of people in front of a wall, their shadows are often very apparent to the left or right.

There are a variety of ways to use on-camera flash to your benefit:

❏ Come in close to the subject to negate some of the shadows, and focus on the composition instead of the light.

The low light of the pigpen didn't allow me to shoot this Vietnamese potbellied pig without flash, and because of time constraints I needed to use my on-camera flash. Knowing the direct light would cause my subject to take on a flatter look, I chose to zoom in and go for symmetrical detail of the pig's large head and body.
1/250 SEC. AT ƒ/11, ISO 100, 80–200MM LENS SET AT 100MM, WITH FLASH EV DIALED DOWN –1/3

This Pacific tree frog hopped onto my brother's boot as we were backpacking through Yosemite National Park. To photograph the small frog using a macro lens, it was best to "pop" in a little flash to brighten up the hand in shade, exposing the frog with even light while stopping any potential movement during the exposure.

1/250 SEC. AT ƒ/4, ISO 100, 60MM MEDIUM-FORMAT MACRO LENS, FLASH MODE IN TTL

❏ Backlight the subject using the sun and fill in the shadows with on camera flash. (This is referred to as fill flash, expanded on later in this chapter.)

❏ Situate your subject away from any background, whether by shooting outdoors from down low to include the sky or indoors away from a wall or object.

Advanced flash modes in speedlights or strobes offer much more control from basic or built-in flash systems. The two main modes are TTL and Manual. Before the early 1980s, every time a subject moved closer or farther away from the camera, the flash would have to be adjusted accordingly. With the invention of TTL, *through the lens metering*, this became unnecessary. In TTL, flash output is controlled by the flash sensor, which measures the amount of illumination reflected back into the camera. TTL revolutionized the way photographers use flash. I may not recommend using many automatic modes, but TTL is one I advocate for photographing scenes on the go. It requires a lot less time and thought in regard to regulating the strength of your flash. It's probably the automatic mode I use the most.

TTL, like your camera's internal reflective meter, can be fooled by tones, light, reflections, and subject matter. Use flash TTL on a bright object, and the flash sensor may decrease the power of the flash in an attempt to make it middle gray. Use flash TTL at night or on a dark subject, and the flash sensor will increase the intensity of the flash. In these cases, control the flash through the EV setting. If you want less power, set your EV in the negative, by 1/3 stops, to lessen the brightness of the flash. Alternatively, increase the power by setting the EV in the positive, although most systems only allow up to plus one stop. If at any point you need to override the flash when exposing a scene, Manual mode is the way to go. In Manual mode, your flash does not discriminate

> ### TIP FLASH METERS ARE NOT FOR EVERYONE
>
> A flash meter can give precise control of flash exposures, but I recommend these more for advanced amateurs or pros who may use flash on a regular basis. A flash meter is useful when circumstances allow for the additional metering time or in setups using more than one strobe.

against tones, colors, reflections, or subject matter. You control the brightness of your flash, usually through ratios—1/1 being full power, 1/2 being half power, and so on. This mode is difficult to master, but it gives you full control over the specific strength of your flash. Manual mode is often best for situations in which time, capturing the moment, or focus isn't a factor, such as when shooting inanimate objects or still-life setups.

OFF-CAMERA FLASH

Time and again, when photographers attempt to use on-camera flash to expose indoor scenes, the harshness of the flash creates a poor lighting scenario. To give a better quality to indoor lighting, many advanced amateurs and pros employ off-camera flash techniques whenever possible. Off-camera flashes require additional equipment, whether through a cord attached to your camera via the hot shoe or a remote device such as a radio slave (which sends a signal to the strobe at the moment you press your shutter). But they allow you to take flash off of your camera to create top lighting, side lighting, or any angle or distance you wish to use.

OFF-CAMERA STROBES

One or more off-camera strobes allow you to control the overall lighting of a scene and add dimension to your subject. Photographers often use them in studio setups, whether for portraiture, architecture interiors, still lifes, or product shots. Strobes are also useful in macro shots when the camera is extremely close to its subject or when there is something between camera and subject, such as a leaf or branch.

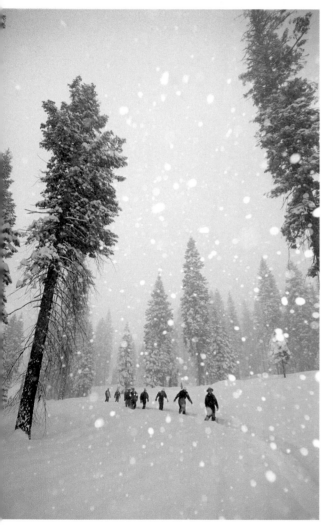

To photograph snowflakes in mid-air, they must either be backlit by a strong light source or set against a dark background. Neither was the case as we snow-shoed in a winter storm through California's Sequoia National Park. I was able to add the element of falling snow in this photograph by using my flash, not only stopping the flakes in mid-fall but separating them from the light-toned sky.

1/60 SEC. AT ƒ/8, ISO 100, 24MM LENS, TTL FLASH MODE AT -2/3

TIP CHECK THE POWER
OF YOUR FLASH

If you are curious to know how powerful your flash is, check its guide number—a measurement for the power of each strobe, usually with a conversion table shown in either meters or feet at ISO 100. My built-in flash has a maximum distance of 39 feet, and my speedlight goes all the way to 66 feet.

I set up my lightbox, a strobe attached to a large diffused cloth container, to the right of my camera to light this boy for the cover of a catalog. The better direction of the flash light gave his face more shape and dimension.
1/400 SEC. (THIS CAMERA'S MAXIMUM FLASH SYNC SPEED) AT ƒ/5.6, ISO 100, 125MM MEDIUM-FORMAT LENS

▼ *Setting my strobe on the tarmac, a distance away to the right of my camera, I was able to create a nice sunset portrait of this search-and-rescue team in Fallon, Nevada. I used a radio slave to fire the flash during the exposure.*
1/125 SEC. AT ƒ/11, ISO, 125MM MEDIUM-FORMAT LENS

FEATHERING YOUR LIGHT

When your flash is closer to one subject than another in your frame, the fall-off of light can create an unnatural-looking exposure because the closer subject is so much brighter than the farther subject. The feathering effect can lessen the difference between the subjects to create better exposure and a more natural-looking image.

The basic principle of feathering is to point your flash away from the closer subject and toward the farther one, sometimes so much that it appears that your flash isn't even lighting the closer subject. You can do this vertically, horizontally, or both ways, depending on the placement of your subjects.

BOUNCE FLASH

Bouncing your flash off other objects to light a scene is similar to using off-camera flash and feathering your light. Instead of relying on a direct light source pointing directly at your subjects, you make use of your surroundings, and by doing so, you cut the harshness of your on-camera flash. With bounce flash, the light comes not from your camera but from above, similar to the sun. This creates a more natural feel to an interior shot.

Bounce flash diffuses the light, turning it from a specular to a broader source, such as a white ceiling, and evens out the fall-off between distant subjects. It also helps diminish direct shadows created by straight on-camera flash methods.

Attempting to capture a solid exposure of these modern-day gold miners having a good laugh in a dimly lit local bar, I feathered my on-camera flash up and to the right to balance the fall-off of light.
2 SECONDS AT ƒ/5.6, 24MM LENS, FLASH SET TO TTL MODE USING A −1 STOP EV SETTING

I wanted to use a reportage style to document these gold miners. I bounced my flash off the ceiling to light the dark room more evenly and, attaching a 24mm lens to capture a wide field of view, I exposed the scene with full-power flash in TTL mode.

1/15 SEC. AT ƒ/4, ISO 100, 24MM LENS

REAR SYNC

Rear sync is a process in which the flash fires at the end of an exposure—that is, right before the shutter closes—rather than at the moment the shutter opens, as it usually does.

Rear sync is useful to illustrate the forward motion of a moving subject. If you capture a slow-shutter action image when the flash fires at the start of the exposure, it will appear as if the subject is moving backward: The subject is frozen in time (consequence of the flash) with a blur in front of him created as he moved through the scene with the longer exposure. If you use rear sync, the blur appears behind the subject, and the frozen image from the flash is last to be captured.

This technique is best used in low-light conditions, or in cases where the background is dark, since a ghost effect from the slow exposure can add to or subtract from the final image.

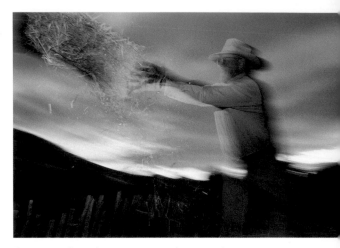

Rear sync allowed me to capture this wrangler tossing hay as he fed his cattle at sunset. I used the longer exposure to expose the surrounding landscape and capture movement; forward motion created by the rear sync gave the photo a better feel.
1/15 SEC. AT ƒ/4, ISO 100, 24MM LENS

My goal in this image was to capture the surreal feeling of running through Death Valley at night. I drove ahead of the ultramarathon race and set up a time exposure with my flash in rear-sync, hoping to capture the athlete as he passed in front of my camera. The 45-minute time exposure captured the stars in motion, the rising moon lit the landscape, and the additional light from the flash exposed the pitch-black foreground, stopping the runner in motion.
APPROX. 45 MINUTES AT ƒ/5.6, ISO 100, 24MM LENS

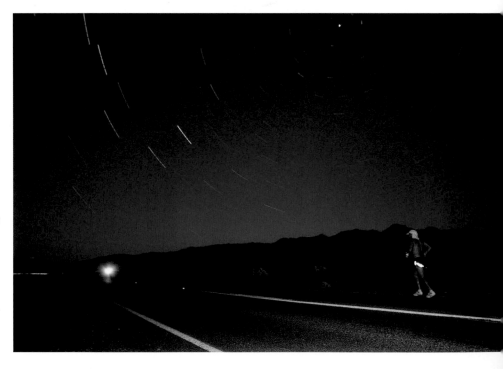

Assisting Outdoor Exposures with Fill Flash

All flash photos balanced with ambient or outdoor lighting are basically considered fill flash images.

The key to using fill flash in general photographic situations is to set the power so the additional light looks natural, hardly noticeable, and not overpowering. One way to accomplish this is to use a variety of strengths from your flash, usually less than full power, depending on the detail and tone you want in your subject. There is no "set" way to use fill flash; techniques vary, depending on the subject matter.

Sometimes, to balance the white, artificial look of flash you can add gel (whether plastic or cellophane) that is color balanced to the scene you are capturing. If, for example, you use white, daylight-balanced flash light to fill in at sunset, the result won't appear as natural as it would if you use an amber or orange gel.

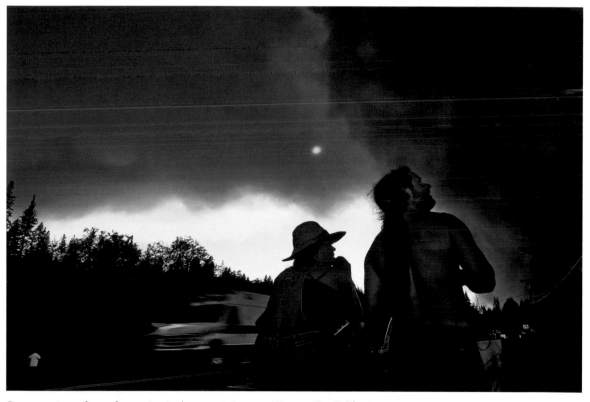

Documenting a forest fire raging in the mountains near Weaverville, California, I exposed for the surrounding sky, clouds, and sun and used fill flash to light my foreground subjects.

1/30 SEC. AT ƒ/11, ISO 100, 24MM WIDE-ANGLE LENS, TTL FLASH AT −1¹⁄₃ EV

LANDSCAPES

The goal of landscape photographers is to make a scenic image that creates a flow with the viewer's eye, one that looks as natural as possible (unless they are going for an abstract or unique look). So, when flash is necessary in a shot, the trick is to add just enough but not so much that the artificial light can be instantly recognized. Using your flash on normal, at 0, or full power can cause the additional light to look strange or fake. For this reason, when I shoot landscapes, my flash is rarely on full power, and I use strobe units, such as speedlights, which offer more control than a pop-up flash.

Illuminating the Shadows

A main function of flash, besides lighting subjects and stopping them in motion, is to illuminate shadow areas in your photographs. In a way, a flash expands your image sensor's capability. How so? If you decide to expose for shadow areas instead of bright highlights in a scene, you tend to lose detail in the highlights; but expose for the highlights instead and fill the now-silhouetted shadows with light, and your lighting ratio has decreased.

Shooting a backlit landscape with foreground subjects, I decided to pop a little fill flash into the scene by using a strobe off-camera to the right. This gave the kayakers more color and retained detail on their faces while keeping a natural look to the overall scene.
1/30 SEC. AT ƒ/11, ISO 100, 50MM MEDIUM-FORMAT WIDE-ANGLE LENS

TIP LESS IS BETTER

Just some minor fill is all you need. Setting the flash even as low as −1²/₃ stops EV can still give detail while hiding the additional light from the viewer.

PEOPLE/PORTRAITS

Fill flash is great for portraits, because you can easily and instantly create a two-light setup. Position your subject away from the sun and use your flash as your main source providing the face with even light. The backlight from the sun works as a rim light, or hair light, separating your subject from the background.

Filling in shadows on faces can be complimentary in many outdoor situations, such as at weddings or family events. The fill of the flash hides blemishes and other minor skin imperfections. It also softens the direct harsh sunlight, which can cause unflattering deep shadows in prominent areas such as the eye sockets, under the cheek-bones, and below the nose. The addition of "catch lights," little twinkles of light from the flash reflecting in eyes, gives life to otherwise dark, round pupils.

> **TIP** HOW MUCH FLASH TO USE IN PORTRAITS
>
> When using fill flash outdoors on the shaded face of a medium-toned person, a good general starting point is –1 stop EV using TTL flash. Cutting by one stop makes the light less noticeable and more natural looking: The face still appears to be in shade but maintains detail.

An open front door provided windowlike light on my daughter's face to give a soft feel to the overall scene, but my shadow blocked some of that light. I added a little fill flash, which removed any shadows from her face and also added catch lights in her eyes.
1/200 SEC. AT ƒ/4, ISO 100

Having very little time to set up this early afternoon portrait, I placed my subject away from the sun. The sunlight highlighted his beard and hat, and I filled in his shaded face with my flash.
1/1000 SEC. AT ƒ/2.8, ISO 100, WITH FLASH ON TTL AT −1 STOP EV

In this photograph, the snow provided some fill, but not enough to diminish the shadows from the midday sun, so I added fill flash to cut the contrast. The additional light gives the backpacker's face a smoother look, yet it is subtle and likely to be overlooked by most viewers.

ACTION

Fast-moving subjects are very difficult to compose and light, let alone expose. Fill flash, balanced with ambient light and a slow shutter, can create the feeling of motion. Even so, due to the quick and fleeting moment when you fire your shutter, you just never know what you going to get. But that in itself is half the fun.

I love using fill flash in action scenes because when you do get lucky, it gives the image a feeling of stop-action and motion all at the same time—a unique look in still photography.

Mounting my camera to my bike and using fill flash combined with a slow shutter gave the feel of what it's like to mountain bike through a forest. The slow shutter not only exposed the forest but also gave motion to the trail; the fill flash added a little light to my bike and hands.
1/4 SEC. AT ƒ/5.6, 24MM LENS

> **TIP** GHOST IMAGES
>
> When you use fill flash to photograph action scenes, ghost images can appear. These sometimes work for the photo, sometimes against it.

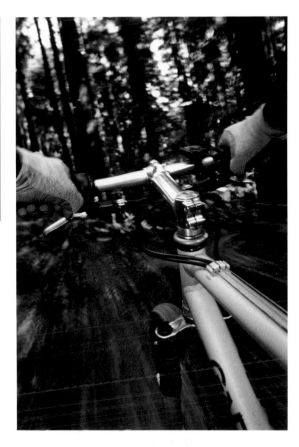

As the winning adventure racing team arrived at the finish at 10 P.M., my goal was to capture them in celebration without the typical boring black background. Video cameras provided some ambient light. I handheld my camera for a two-second exposure while using fill flash to freeze them in motion. The resulting image gives a feeling of chaos and exuberance—a perfectly lucky shot.
2 SECONDS AT ƒ/5.6, 24MM LENS

WILDLIFE

In photography you can't always control a situation. This is definitely the case when it comes to photographing animals. Sometimes, the most important aspect of wildlife photography is to get close to the subject, and this often means sacrificing lighting for the sake of composition and detail. With fill flash, you can add light to deep shadows, fixing otherwise poor exposures. In many cases, the animals are hardly affected by the strobe.

Editing Away Red-eye

A big concern in the past were the red-eye–type reflections that result when using flash while photographing animals. Now, image-editing programs such as Photoshop correct these potential throwaways simply and easily, without changing the integrity of the image.

Here is a comparison of natural light only and natural light balanced with fill flash on a great horned owl in captivity.

1/250 SEC. AT ƒ/8, 300MM LENS; TTL FLASH SET TO –2/3 STOP EV FOR PHOTO AT RIGHT

Reflectors and Fill Cards

Reflectors and fill cards work through basic geometry, reflecting the sun's beams or other light source at a certain angle back into your scene. They can be anything from commercial versions made for photography to white paper, a bright T-shirt, a piece of metal, or a mirror. Commercial reflectors and fill cards usually have more consistency and control, but many things can be used to fill light into shadows. With the exception of mirrors, all reflectors and fill cards add less light than

Previsualizing the Light

Recognizing the available light in combination with the artificial light you may be using and the intensity and direction of both are important steps toward producing successful imagery. Reflectors and fill cards make this difficult process a little easier.

A drive along the Mexican Riviera landed me in the small town of La Mira, where I found this young man. Not having enough time to set up lights, I used my silver reflector to kick in enough light to cut the contrast between his sunlit hat and shaded face. The silver card not only provided additional light but also balanced with the neutral noon sun.

1/400 SEC. AT ƒ/8, ISO 100, 125MM MEDIUM-FORMAT LENS

Capturing scenes of visitors panning for gold along the American River, I noticed a young docent backlit by the late afternoon sun. As I set up to photograph him, I noticed light reflecting onto his face, which was the sun's light bouncing off of his pan. Waiting for the right moment, I metered the scene and snapped the photo at the brightest reflected fill.

1/500 SEC. AT ƒ/4, ISO 100, 80–200MM SET AT 125MM

the original light source, but the light is often sufficient to cut the contrast ratio considerably. The amount of light they may bounce back into your scene depends on the reflective qualities of the object or equipment you are using.

Reflectors and fill cards are great for both portraits and macro shots. These devices not only allow you to see the amount of added light casting on your subject, but (by turning them slightly) to increase or decrease the light's intensity. However, there are drawbacks to using these reflectors and fill cards. Because they bounce light back toward your subject, if you are photographing a person, squinting can become an issue. In addition, they require that you employ the aid of an assistant or set up a stand with a clamp. A cable release or your self-timer may allow you hold the reflector yourself, but you will not necessarily be able to do so when you are looking through the viewfinder.

To photograph this portrait of a young Pony Express rider reenacting a nineteenth-century ride, I used a gold reflector to kick light back into his shaded face, emulating the light reflecting off his horse's body. 1/750 SEC. AT ƒ/2.8, ISO 100, 180MM LENS

Choosing the Tone of Your Fill Card

When well chosen, the tone of a fill card and reflector can enhance your image. Fashion photographers regularly use silver reflectors, as a shiny source of fill, to highlight or accent a certain body part with neutral white light. Gold cards offer a similar look but give slightly more warmth. White cards are less intense and harder to notice in images. I prefer gold reflectors that mirror the sun's color temperature, but it's all a personal choice.

ASSIGNMENT Add Fill to One of Your Images

Create three images of the same scene—the first using no additional light other than the ambient or direct sunlight, the second using fill flash, and the third using any type of reflector card. All three images should be properly exposed, but the additional light in the second and third exposures should illustrate the benefit of the additional light. When lighting your scene, consider whether you wish to use your additional light to fill shadows or to highlight your subject, and choose a flash setting and exposure accordingly. Make sure to record as many specifications and details of your selected images as possible (whether you feathered your flash, used bounce, etc.), should you need to refer to them later.

To photograph this group of men who restore vintage locomotives in Ely, Nevada, I considered whether to shoot with available light, flash, or fill from a large door. Deciding to use a combination of both ambient light and strobe, I metered the scene to maintain detail in the rays of light shining down and used my strobe to add light onto my subjects.

Using Fill Light in Macro Photography

Fill light is an excellent tool in macro photography. Unless you have the proper macro equipment to light your subject, flash can be harsh to use in confined spaces. Fill light, usually not nearly as bright as flash, is subtle and pleasing, adding just enough detail to a dark area.

Editing & Cataloging

SOME FEEL that with the advent of Photoshop and other image editing programs, exposure isn't all that important to learn. This assumption is not true, a fact that, to many, unfortunately becomes clear only after extensive computer time and disappointing results. When you get as much as you can in camera, the information contained in your original image file will hold the maximum detail possible for your image sensor, and your post-capture editing will be easier and more efficient. I make the analogy of a camera exposure being the recipe or items you carefully select and mix together and Photoshop the oven you cook it all in. You need both to make a high-quality final creation.

Calibrating Your Monitor

Monitors are like televisions. Look at a hundred televisions and you will see that they all display color and contrast in slightly different ways. Before reviewing your images on your computer, you need to calibrate your monitor to ensure that you get the most accurate color rendition, brightness, and contrast. It is here where you first truly see the specific exposure you captured, so it's critical to have it appear right. As one industry person put it, color management is like a digital darkroom thermometer; if you don't use one, you have no idea if your colors are accurate from the start.

There are a variety of calibration software and hardware programs on the market. I prefer X-rite's Eye 1 Photo series or Eye 1 Display, which are quick and easy to use and priced at all ranges. They allow you to calibrate your monitor and printer so that your onscreen images match your printed images. (ColorVision also makes software/hardware combinations to calibrate your monitor.)

Using a colorimeter directly on the monitor, X-rite's version allows you to set the contrast, channels, brightness, and gamma of your LCD or CRT monitor. This starts you off with the best quality possible, allowing you to then set your White point (6500°K is always a good place to start), gamma (most everyone uses 2.2 these days), and luminance (120 when using LCD monitors). The hardware in combination with the software then calibrates the color through the RGB channels, initially taking your monitor to neutral and to a known standard. Once this is complete, you are ready to roll.

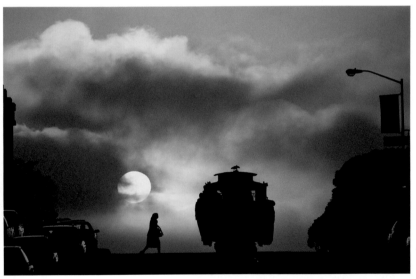

When I captured this silhouetted cable car scene in San Francisco, my hope was that the setting sun would appear behind my subjects. I wasn't lucky that day; the angle of the sun and the weather left me with a dull sky. However, using my understanding of lighting, exposure, White Balance, and Photoshop post-editing techniques, I took a sunrise image I'd shot a year earlier and sandwiched it with the first scene to give me what I'd originally hoped for. I may not be able to sell the created image to National Geographic, but it can work for travel clients producing conceptual ads.

Your Digital Workflow

Establishing a set method for performing and repeating functions is key to mastering your digital workflow—from uploading and reviewing your images in a consistent way, to creating Photoshop actions for repeating simple editing tasks, to cataloging and storing your photos in specific locations. Effective working methods can help you keep your image files consistent and your post-capture time to a minimum. Lewis Kemper, a wonderful outdoor photographer and a Photoshop teacher, says he has three main criteria for his digital workflow—that it be easy, time efficient, and flexible. I couldn't agree more.

REVIEWING AND EDITING

I review my images either in Apple's Aperture or Adobe's Photoshop Lightroom. Both programs allow quick comparisons of similar expressions, lighting, and exposures among the photos, making it easier to rate the highest quality shots and move into editing. The jury is still out on which program is better; Lightroom flows well with Photoshop and is extremely functional, yet Apple has a knack for creating user-friendly software. Both offer quick ways to view numerous raw image files, review histogram and EXIF metadata, make minor exposure adjustments, and mark, keyword, and separate images into folders or collections. Adobe Bridge, Photoshop's stand-alone program (bundled into Creative Suite 3, or CS3), offers an alternative method for reviewing images, although you cannot make image adjustments until you open it in Photoshop.

As of 2008, I edit my images in Adobe Photoshop CS3 Professional. Photoshop is the standard in the industry, and its capabilities are extensive. The program is jam-packed with options, it works seamlessly with all file formats, and the software allows you to perform minor or major alterations depending on your personal preference. Lighter editing versions, such as Adobe Photoshop Elements, are also available.

Importing Your Digital Images

A frustrating aspect of raw in the past was the long delay as the camera or card reader offloaded digital images onto the hard drive. With the advent of UDMA (Ultra Direct Memory Access) memory cards and UDMA card readers, transfer times have been cut considerably, in many cases by half. With transfer speeds up to 50MBs per second, moving raw image files off a full 8GB card from a 12MP camera takes only a few minutes.

My first step when importing digital images from camera to computer is to back up all the image files immediately. Only after I know I have safely stored copies of my original shots do I move on to reviewing the images I've captured.

A screenshot of Adobe's Lightroom.

The Main Post-Capture Exposure Functions

Photoshop has come a long way. I first started using version 3.0 way back in the mid-90s, mainly for minor dust removal, color corrections, and preparation of files for printing and publishing. Today's version is mind-blowing, offering many wonderful ways to adjust your exposure. I use Photoshop not only to fine-tune exposures but also to stretch their dynamic range by pulling out of the information stored in the image—something I can't do in camera.

MAKING EXPOSURE ADJUSTMENTS

Usually, the main post-capture objectives for exposures are to correct over- or underexposure, to fix problem areas such as blown-out highlights, and to adjust color shifts through White Balance or photo filters. You may also choose to enhance the general overall scene of your original image by adding contrast or saturation, or by converting a color image to black and white.

When editing images in Photoshop, the first thing to do is to set your color space. Under the Edit menu, go to Color Settings and the first item in the pull-down menu entitled Working Spaces, where you can set your RGB (red, green, and blue channels). Most photographers consider Adobe RGB and ProPhoto RGB to be the best current working spaces for images. (Some prefer Adobe RGB for monitor viewing and ProPhoto RGB for printing; see chapter 2).

Every post-capture adjustment you make—from color to exposure, recovery to shadows and highlights—tends to alter your original exposure. The best rule of thumb is to make small, subtle movements in your digital workflow. Beginning photographers often augment their images so much they take on an odd digital look instead of a realistic photographic feel.

OPENING RAW FILES

When I talk about exposure functions in Photoshop, I will refer mostly to opening raw image files. When you first open a raw file in Photoshop CS3, Adobe's Camera Raw (or ACR) window pops up, offering you a variety of choices for viewing and converting the image. In CS3, you can arrive at ACR either directly through Photoshop or through Adobe Bridge. I prefer to open my images through Bridge, which allows me to view all of my files quickly as thumbnails and also offers additional functions, such as attaching Camera Raw Settings to similarly exposed files.

A wonderful aspect of raw files is that they're unprocessed inside your camera. This lets you correct a variety of exposure miscalculations and also determine various settings, such as color space (located in the bottom middle of ACR's

Protecting Your Work

With new innovation comes more options and controls, but also potential pitfalls. You can avoid most of these by following a few simple rules:

❏ Never work on master files. This way you can always go back to extract the original information stored by your image file.

❏ Save your images as TIFFs or PSDs, preserving all of your layers and working in an uncompressed format.

❏ Back up as often as you can. Once your original digital file or the one you worked on so hard is gone, there isn't much you can do to retrieve it. You can back up on a separate hard drive or on Apple's new Time Machine.

window as a blue link) and White Balance (a tool in the upper right row). Once you've made your exposure changes in ACR and clicked Done or Open Image, they'll be saved as Camera Raw Settings for that image.

WORKING WITH JPEG FILES

JPEGs are considered a "lossy" format—that is, a format in which information is lost every time the image is opened and resaved. Thus, it is best not

TIP REMEMBER TO OPEN THE RAW FILE TO SAVE YOUR WORK

In Aperture, Bridge, and Lightroom, the original "master" file doesn't actually change until you process the image in Photoshop. The information is stored as metadata for later use. Once you open the raw file in Photoshop, you can save the adjustments as a new PSD or TIFF file.

A screenshot of Adobe's Camera Raw, part of Photoshop CS3.

A screenshot of Adobe's Bridge, a stand-alone application included with Photoshop CS3.

A Quick and Easy Fix

Imagine you've shot a series of images at the same exposure and realized upon reviewing the first one that you underexposed by a stop. You can make the initial exposure adjustments in ACR and then use Bridge to apply the changes to all of the other images without even opening them in Photoshop. Simply go to the Edit menu, then Develop Settings, then Copy Camera Raw Settings, and paste the settings to another selected image. You can use Bridge to correct everything from White Balance to spot removal—a great function when, for example, you have a piece of dust on your image sensor that you discover only after shooting a few hundred images.

to save your altered JPEG file as a JPEG. Instead, save it as a separate TIFF or PSD file. This way, you archive the JPEG, which is best to do anyway with original files, and work in an uncompressed format. Remember, though, that an original JPEG file is much smaller and more processed than an original TIFF or raw file (which contains 2,000 times more information than a JPEG) and therefore will not contain the original file's quality.

FIXING EXPOSURE ERRORS

You can perform many of your exposure modifications in Adobe Camera Raw (ACR) before even entering Photoshop.

The preview button in ACR lets you check your original raw file against the adjustments you've made in each tab (located below the histogram as square icons), including Basic, Tone Curve, Detail, HSL/Grayscale (the HSL standing for Hue, Saturation, and Luminance), Split Toning, Lens Corrections, Camera Calibration, and Presets. You'll make most of your improvements in Basic via the sliders, which include Recovery (for highlight areas), Fill Light (to pump

up shadow detail), and Vibrance (similar to Saturation but with limits to protect against color buildup). Another main tool you'll utilize is White Balance, with its tool in the upper left toolbar and its Temperature and Tint sliders on the right.

As you preview a raw image in ACR, your histogram becomes an integral part of exposure edits. On each side of your histogram in ACR there are clip warnings. Select these warning arrows—shadow on the left and highlight on the right—and your image preview will show you what detail might be missing. At this point, you can use the Recovery and Fill Light sliders to bring detail back to the areas. Keep in mind, though, that many images look strange without areas that lack detail. A shot with no loss of detail will not necessarily look like a well-exposed image. Remember, there is no such thing as a perfect histogram.

Once you've completed your adjustments and opened the image in Photoshop, you can continue to fine-tune and modify the exposure through the Image menu under Adjustments, which includes such functions as Levels, Curves, Shadow/Highlight, and Exposure. There are also many other ways to extend your exposures through Layer Masking, Blend Modes, and Burning and Dodging techniques.

COLOR CORRECTING

There are a variety of ways to correct the color of your image files after the capture. If your eyes have begun to notice the subtleties of color, you can make the adjustments fast.

A tasty piece of information I learned from Photoshop guru Lewis Kemper is the benefit of setting your White Balance when dealing with cool-warm relationships (he was referring to a situation in Death Valley, where there were warm sand dunes in the sun and cool sand dunes in the shade). Kemper suggests going back to ACR's White Balance tool and sliders and the goal of color correcting to fix any shifts through temperature and tone. You can do this in one of three ways:

❏ In the field, place the WhiBal card in the first or last shot of a scene, use the preset to set the White Balance, and use this setting as you photograph that particular scene.

❏ Place the WhiBal card in the first or last shot and photograph the scene, but don't change your White Balance setting. Later, open the raw file in Photoshop and, using the White Balance tool, click on the gray card you photographed and use the WB Camera Raw Setting for all of the images shot for that scene.

Cropping

Cropping removes major and uncorrectable problem areas. You can crop through both ACR and Photoshop, but when you do, keep in mind that the more you crop, the smaller your image file becomes. Too much cropping reduces your odds of successfully blowing up your image to its maximum size.

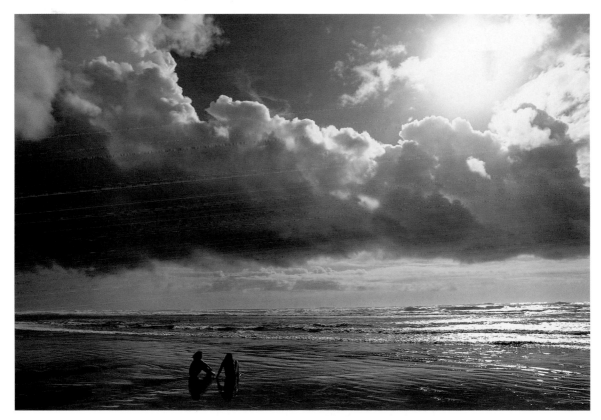

Happening upon this scene along Washington's coast, my initial feeling was that the final image would look best in black and white; however, I shot it in color. Back at my office, I converted the raw file into black and white through ACR's HSL/Grayscale tab. (With the dynamic range pushing my image sensor to its limits, the images might have been a good candidate for HDR (see page 216) had the two girls sat there a few seconds longer before running off.)

❏ If you don't have a WhiBal card, the next best thing is to find a neutral area of color (preferably white or gray) and select it with the White Balance tool; your image will shift in temperature and tone.

Photoshop offers other methods to color correct images through Color Balance and Hue/Saturation (in Adjustments, under Image).

PHOTOSHOP FILTERS

If you come from the old school of using photographic filters and are familiar with their numbering system, you may prefer to use the Photo Filter option in Photoshop (in Adjustments, under Image). Photo Filter offers three types of warming and cooling filters in varying degrees of density and also allows you to change to any color you prefer. (This option is also available in Photoshop Elements.) I use these filters on old and new images in which, during the capture, I may have missed a color temperature shift or didn't have the proper filter handy.

HIGH DYNAMIC RANGE

Beyond using a graduated ND filter while shooting or dodging and burning a black-and-white print in the darkroom, there haven't been many ways in photography to produce solid exposures in situations with wide-ranging exposures. Photoshop's Merge to HDR (High Dynamic Range) function is the true replacement of these older (although still valid) techniques.

High Dynamic Range imagery, introduced in Photoshop CS2, is digital's beefed-up version of the Zone System. It is not so much a way of fixing bad exposures as it is a process of squeezing extreme ranges of stops into a single full tonal range image. HDR looks to revolutionize the way we see exposures through the camera (see, for example, the chapter opener, an HDR-created scene in Chicago's busy O'Hare International Airport).

Once uploaded, in Adobe Bridge, select the raw 16-bit images you wish to merge, go to the Tools menu and select Photoshop and then Merge to HDR . . . and watch the magic happen.

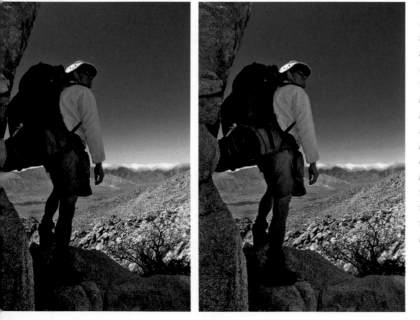

While on assignment in California's Anza-Borrego Desert State Park, I was forced to shoot fast and on the fly to capture a series of images throughout a day in the life of a backpacker. On the scene, I used fill flash to brighten my shaded model, but I wasn't completely satisfied with the result. I edited a copy of the original in Photoshop, which gave me better results by allowing me specific control of minor details not possible in camera. Both backgrounds match, yet in the photo on the right, detail and brightness in the foreground are increased, a shadow on the left rocks caused by the flash is removed, and the overall image is better.

Because I was shooting with film in Florida's Ringling Museum, I wasn't able to use White Balance. In addition, the mixture of artificial lamps and natural light discouraged the use of a filter. Back at my computer, I scanned the images in, loaded this original into ACR via Bridge, and used the White Balance tool to color correct the scene.

Photoshop will begin to merge and align the images. This takes some time, but when it's complete, you'll see a Merge to HDR screen showing your images on the left and the histogram on the right displaying stops of light as red lines (often containing ten to fifteen stops, a range way outside our image sensor's capability). Select a Bit Depth of 16 bit and click OK for the image to fully open in Photoshop.

You'll see an HDR Conversion dialog box appear next to your image. Under the Method pull-down menu, select Local Adaptation and then toggle open the Toning Curve and histogram arrow to see the curve. Don't worry about how your image looks at this point. Grab and drag the bottom part of the curve until it touches the left end of your histogram and you'll begin to see the shadows deepen. Then compare the steepness of your Toning Curve line to the two markers on the Radius and Threshold lines. If they don't match, drag the Threshold marker until there is a similar angle of steepness. I like to use my hand, but if you want to be precise, use a ruler. Click OK for Photoshop to process the image.

Creating an HDR Image

To create an HDR image in Photoshop, you have to think about it while you shoot. First, search for a high-contrast scene, one that wouldn't hold the entire highlight-and-shadow detail in just one frame. Then, bracket that scene in one-stop increments, through your shutter speeds only, with your aperture fixed to one *f*-stop, using manual focus and manual White Balance. Shoot anywhere from three to nine images. You'll later merge these in Photoshop.

When it opens again, select your Curves in the Image-Adjustments menu, and click on the line to anchor or lock in three points—one at the high right side to maintain your highlights, one near bottom left for your shadows, and one in the middle for contrast. Click on the lower left anchor of the curve and drag it down until the shadows look nice and realistic. Drag the middle anchor up until contrast feels nice. Leave your highlights where they are. Click OK again and you have your HDR image in full tonal range, from deep shadows to bright highlights.

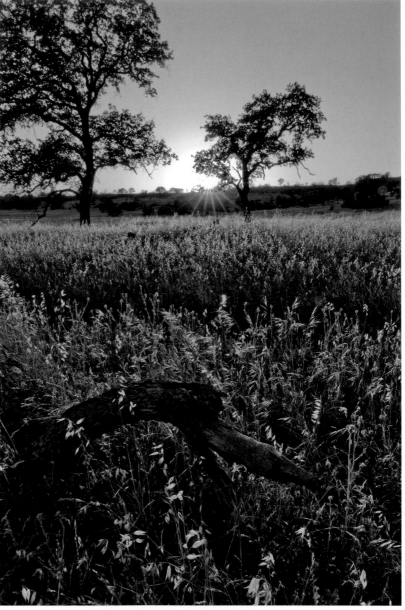

The three images on the left are the bracketed in-camera sunset scenes of Bidwell Park in Chico, California. The final image (above) is the completed HDR scene from all the merged image files.

Organizing and Cataloging Your Digital Files

A great characteristic of digital images is that the files are simple—made up of zeros and ones—and therefore suffer no generational loss from copy to copy. On the other hand, hard drives do deteriorate and fail over time, so it's important to back up your files. I back up my images on two separate external hard drives as well as gold archival DVDs and store everything in separate locations.

Cataloging is a chapter in itself. There so many ways to file and reference your images. Probably the best way to learn how to it catalog efficiently is to study various library methods. I use a software program called Extensis Portfolio to catalog all of my digital image files. This, in combination with a numbering system, folder locations by geography, and captions for each file, makes cross-referencing and retrieving any image in my collection of 350,000 images fairly easy. It took an investment of time to set up, but it has paid off in the long run. Remember to choose a system that is easy to understand and can expand over time.

A screenshot of my image collection cataloged in Extensis Portfolio.

A client called me one day searching for a wildlife image with the moon a main part of the scene. "It doesn't have to be real," he said, "just realistic." I had a few images for him to consider and showed them to him online, but nothing struck his fancy. So I decided to create one. I searched my files for moon and wildlife imagery and came across two images, taken ten years apart. I combined them in Photoshop to create this photo—a realistic scene but one I didn't capture in camera.

ASSIGNMENT Edit a Well-Exposed Image to Correct Problem Areas

You might have reached the point of creating well-exposed images by now, but your image sensor still can't cover the range of light in all of your scenes. Choose an image with a solid exposure and make adjustments in an image-editing program to fix areas in the image that do not maintain enough detail. Record as many specifications and details of your selected image as possible (saving the specific Camera Raw Settings, History states, and any post-capture information that will help you perform similar functions on another image).

While shooting in a small northern California town at sunrise, I came across these two children hanging out at a church. The scene presenting itself was nice, but the dynamic range between the white church and the deep shadows was too much to capture on one image file. So I produced the best exposure possible and recovered the highlights and opened the shadows in Adobe Camera Raw.

TIP NEVER TOUCH YOUR ORIGINAL FILE

Work from copied versions of the originals. Copies allow you the same qualities of the original image and ensure that you will never alter the original, whether by accident or on purpose. When better software or more optimal ways of working with your image files come along, and they always do, you'll be able to go back and work from the same original again.

Resources

Here are some of the companies and products I use on a regular basis.

CAMERA AND GEAR MANUFACTURERS

FUJIFILM USA, Inc.
Camera equipment and film
Fujifilmusa.com
200 Summit Lake Dr., Valhalla, NY 10595
800-800-FUJI

Hoodman Corporation
Hood loupes, memory cards, digital camera accessories
Hoodmanusa.com
20445 Gramercy Pl., Suite 201, Torrance, CA 90501
800-818-3946

Joby
"GorillaPod" lightweight and flexible tripods,
 compact and bendable
Joby.com
1535 Mission St., San Francisco, CA 94103
888-569-JOBY

Lightware
Portable and shippable photo cases
Lightwareinc.com
West Byers Pl., Denver, CO 80223
303-744-0202

Lowe-Pro Worldwide
Photo backpacks
Lowepro.com
1003 Gravenstein Hwy. N., Suite 200, Sebastopol, CA 95472
707-827-4000

Pelican Products Inc.
Photographic cases, tripods, memory cards, digital media
 and accessories
Pelican.com
Early Ave., Torrance, CA 90505
800-473-5422

Sekonic
Photographic light meters
Sekonic.com
8 Westchester Plaza, Elmsford, NY 10523
800-462-6492

Singh-Ray Corporation
Filters, polarizers, and more
Singh-ray.com
153 Progress Circle, Venice, FL 34292
800-486-5501

Think Tank Photo
Photo backpacks, luggage, and accessories
Thinktankphoto.com
3636 N. Laughlin Rd., Suite 170, Santa Rosa, CA 95403
866-558-4465

CAMERA AND GEAR RETAILERS AND SUPPLIERS

Bogen Imaging Inc./ Gitzo/ Manfrotto
Tripods, light stands, filters, video equipment
Bogenimaging.us
565 East Crescent Ave., Ramsey, NJ 07446
201-818-9500

Calumet
Photographic equipment and software
Calumetphoto.com
1111 North Cherry St., Chicago, IL 60622
800-CALUMET

Hunts Photo and Video
Store for all your photographic equipment needs,
 around since 1889
Huntsphotoandvideo.com
100 Main St., Melrose, MA 02176
800-221-1830

DIGITAL WORKFLOW AND EDITING

Adobe Systems Inc.
Software: Photoshop CS3, Photoshop Elements,
 Lightroom, Bridge, Adobe Camera Raw
Adobe.com
345 Park Ave., San Jose, CA 95110
800-833-6687

Apple Inc.
Computers and software: Aperture, iLife (includes iPhoto),
 Mac desktops and laptops
Apple.com
1 Infinite Loop, Cupertino, CA 95014
800-676-2775

Epson
Color printers, ink jet paper, scanners and supplies
Epson.com
3840 Kilroy Airport Way, Long Beach, CA 90806
800-463-7766

Extensis
Digital image management software
Extensis.com
1800 S.W. First Ave., Suite 500, Portland, OR 97201
800-796-9798

Lacie
External desktop and portable hard drives
Lacie.com
22985 N.W. Evergreen Pkwy., Hillsboro, OR 97124
503-844-4500

Neat Image
Digital noise reduction software
Photoshop Plug-in Software
Neatimage.com

PROMASTER Digital
Memory cards, digital media, and other equipment
Promaster.com
360 Tunxis Hill Rd., Fairfield, CT 06825
203-336-0183

Rawworkflow.com/ a division of PictureFlow LLC
WhiBal® certified White Balance reference cards
Rawworkflow.com
4068 Chastain Dr., Melbourne, FL 32940
321-752-9700

SanDisk Corporation
Memory cards and flash drives
Sandisk.com
601 McCarthy Blvd., Milpitas, CA 95035
866-SANDISK

X-Rite
Color Calibration hardware and software
Xritephoto.com
8 Westchester Plaza, Elmsford, NY 10523
800-462-6492

PHOTOGRAPHY INSTRUCTION

Arbabi Imagery/ Sean Arbabi Photography
Photo workshops and online courses
Seanarbabi.com, Arbabi.org, Photoguru.tv
508 Old Farm Rd., Danville, CA 94526
925-855-8060

BetterPhoto.com
The leader in online photographic workshops
Betterphoto.com
16544 N.E. 79th St., Redmond, WA 98052
888-927-9992

Lewis Kemper Photography
Photoshop expert, BetterPhoto instructor, developer of DVD
 series "The Photographer's Toolbox for Photoshop"
Lewiskemper.com

Index